MORNING WOOD

Gingko Press in Association with R77

Gingko Press Inc.
5768 Paradise Drive, Suite J
Corte Madera, CA 94925
USA

Telephone: 415.924.9615
Telefax: 415.924.9608

books@gingkopress.com
www.gingkopress.com

R77 Publishing
PO Box 34843
Bethesda, MD, 20827
USA

Telephone: 301.493.9553
Telefax: 301.493.9554

info@graffsupply.com
www.r77publishing.com

Compiled and Edited: Roger Gastman
Art Direction: John LaCroix
Artist Bios: Ian Sattler
Copy Editing: Laura Bennett
Cover: logo by Chris Yormick, carving by Ben Woodward,
photo by Adam Wallacavage

Published in 2003 by R77 and Gingko Press
© 2003 R77, All Rights Reserved

Printed in Hong Kong
ISBN: 1-58423-159-9

Ali Calis Dave Schubert Chris Lindig Neasden Control Centre REVOLT

Adam Wallacavage Andrew Jeffrey Wright Anthony Ausgang

Anthony Yankovic III Ben Loiz Ben Woodward Carlos Batts

Chris Capuozzo Cynthia Connolly DALEK Estevan Oriol GIANT GREY

Jamie Reid John Pound JOKER Shane Jessup Michael Delahaut

Mitch O'Connell NEWA Ricky Powell Sam Flores Shawn Wolfe

UPSO ZEPHYR Anton Lopez AXIS BIGFOOT Chris Yormick

Clark and Hogan CYCLE EKLIPS ESPO Graphic Havoc Jim Houser

Joseph Whiteley KR Mikkel Groennebaek Rebecca Westcott

Richard Colman Ron English SABER Shepard Fairey STAK WK INTERACT

TABLE OF CONTENTS

INTRODUCTION

Art appreciation isn't a point of interest for the vast majority of the American populace. As funding for the arts in public education continues to dry up, those with an interest in taking the artists' path tend to be ostracized and ridiculed for pursuing an interest outside of the mainstream. It's little wonder that art school is often perceived as being a last resort. In high school art is for losers, sissies, and stoners and "Artist" is at the bottom of the list of ideal professions your future in-laws have in mind for you.

Common perceptions like these have been the undercurrent of thought among non-artists in America for recent memory. Simultaneously, the more subversive creative outlets such as graffiti, tattooing, and skateboard graphics have been viewed by many as vulgar and outright criminal. In the past few decades however, a confluence of events has thrust these florid offerings into the public eye. As art cannot be suppressed by mere economic constraints it has infiltrated the capitalist system like a virus. This New World order is the result of dedication, talent, spirit, and a few auspicious trends. Graffiti culture was strong enough to survive over two decades of police task forces and search warrants and thousands of kids took inspiration from its attitude and designs. Undaunted by the snobbery of uptight galleries, the new generation took to the streets, drawing larger audiences in open public spaces than any gallery could ever corral. These artists worked anonymously until their abilities were fully honed and the mystique surrounding their work reached epic proportions.

Extreme sports, and skateboarding in particular, took off to become a multi-billion dollar industry while retaining their integrity and sense of community. At the same time alternative rock music and hip-hop became dominant forces in the entertainment industry. These seemingly different pockets of subculture share many of the same ideals and more importantly an across the board respect for art. As these ideas continue to spread, the lines between cultures have blurred; it seems that the subculture has subverted popular culture entirely. At the same moment in history, professionals in each of these areas drafted urban artists to lend street credibility to their products, hiring them to provide direction for their advertising campaigns. Artists who would have once had a hard time finding an outlet for their work are now creating art for platinum selling albums and logos for events seen by millions of people worldwide. When the dust cleared, these urban art styles were everywhere, from highway overpasses to the Superbowl. Street art has a higher profile than ever and the momentum is still building.

The most rewarding thing about this transformation in the public's perception is that none of the artists at the forefront of the movement has changed the way they create their work. Many of the artists featured within Morning Wood have amassed impressive arrest records honing their skills on the street, and developed an attitude through those trials that is still at the surface of their work today. The graffiti writers, skate company's graphic designers, and the clothing designers kept their focus and when the time came, seized the opportunity to work the system over from the inside out. For each artist that got over with his or her ideas, another would come along and reset the bar even higher.

Featuring groundbreaking work from several generations of talented "outsiders" I can honestly say that there has never been a collection that is as inclusive as Morning Wood. Jamie Reid initiated the punk rock aesthetic and polarized an entire social movement with his work for the Sex Pistols. John Pound subverted pop culture and introduced an entire generation to non-traditional art through his disturbing Garbage Pail Kids trading cards. Photographers Ricky Powell and Estevan Oriol changed the way that the streets and popular music were shot and viewed. Shepard Fairey took a grotesquely oversized professional wrestler and leveraged his image to create the greatest guerrilla marketing campaign ever. Graffiti legends such as REVOLT, ZEPHYR, ESPO, and SABER helped elevate the graffiti culture to an astounding level of acceptance within popular culture worldwide. It's amazing to consider that these artists have succeeded not by selling what they think the public wants, but instead by offering up a true and honest vision. Each of the 50 artists in this book present not only something to look at, but also something to think about. This collection is indeed something very special and unique.

By sleight of hand, or just by getting up, the contributors to this book have used their art to change the way the system works and the way people think. Almost all of them have been told at some point that art would get them nowhere, yet here they are presenting their work everywhere. The artists in this book continue to vigorously develop their craft, ensuring that their form remains vital and creative while simultaneously pushing the envelope of the commercial art world. Their innovation and vision is without limit, and in this collection you are seeing only the beginning of what they can do. I encourage you to seek these artists out and digest more of their work. You won't be disappointed.

Enjoy,
Roger Gastman
August 2003

ƐSPO:

ESPO was born and raised in Philadelphia, and then moved to New York in 1994. After stints as publisher of On The Go Magazine, the author of the graffiti retrospective The Art Of Getting Over, and as a full time graffiti writer, ESPO opened his studio practice in July of 1997. All of these experiences aside, for a while ESPO was consumed by America's real national pastime.

"For a year or two my art was all about scams. Originally, I was doing a series of paintings that were examining the back and forth between a con artist and their mark, in terms of street hustles. Some of the stories were autobiographical and some of them were from hearing these tired shop worn scams that were neat because they have a beginning, middle and end. The stories unfold in a really short span of time. It was really fresh to have a bad guy and a good guy, or two bad guys trying to play each other, or a guy who starts bad but gets outdone by his mark. These stories of interactions between two people and the way they would relate to each other were compelling to me. I love the story one person says to another on the way to work, its brevity and relevance to daily life. When I first started doing graffiti, I would paint things people would see everyday on their way to work. And now my art has progressed to the point that I'm interested instead in painting the things people talk about on their way to work."

"Here, I've created an extension of what I was doing before. It's the stripping down of a conversation to just sentences and expressions of emotions…fear, or hope, or love, or hate, sometimes all of those emotions at once. I'm just trying to find the smallest molecules of character and the smallest molecules of conversation to really form some insight into what people are going through and the troubles they are having. I think I'm basically creating a new form of cave painting. With the species looking as endangered as it is now, it's probably a good time to encapsulate the experience in the very traditional format of paint on a surface."

papaes@aol.com

Comfort

HOLD ME DOWN

LOVER

FRIEND

ISSUES

I ALWAYS CRY AT WEDDINGS

PROBLEMS

WANTS v. NEEDS

ONCE AGAIN IT'S ON

FRIDAY

thank you for your

input

THE UNEXPECTED

DON'T ACT SUPRISED

HEART CAULK

FIEND

FILLED

MEMORY

NICE WHILE IT LASTED

HOLLER
BACK

Michael Delahaut:

"I started writing graffiti in 1984 and I think anyone who ever writes graffiti really receives an art education like no other. Most writers spend at least 10 years crafting their work…that's the equivalent of a doctorate degree in time spent on graffiti." With a career that would make him a tenured professor at Graffiti University, Michael Delahaut, a.k.a. WISE, would be ready to step up to the podium in any art history class. "My favorite piece is 'Children Of The Grave Again Part 3' by DONDI. It's so clean, bold and simple. I think I take a lot of my own work and push in that kind of direction. Growing up with that piece set the entire direction for my career. In like '84 this girl Stacy from New York came out and started going to my high school. She had a copy of Subway Art with her and I had never seen it before. Just seeing that book changed my direction. We didn't have the Internet or ways to see anything back then, and progression was really slow. At that point a book like that on the West Coast was a total eye-opener. But that one piece stood out and DONDI was so inspirational."

His inspiration firmly in place, Michael was off and running through the Los Angeles graffiti scene, which in the late 80's could be a pretty dangerous place. "The LA graffiti scene has always been dominated by gangs. The black and Latino gangs have their own cultural style, and you crossed that kind of graffiti at a lot of the yards. Overall it was just dangerous to be around. My heart just about gave out this one time at the Jefferson Yard. It was in this back alley by the DELO piece from Spray Can Art and the Projects were right over the wall. This dude, I don't know if he had jacked someone or what, flew right over the wall that I was bombing and landed right next to me in this dark alley and got up and started running. I thought my life was going to end."

Created in Adobe Illustrator, these pieces represent Michael's post-graffiti work and are simple, clean, and somewhat symbolic. "They're intended to be one piece. The text is the title…'You Lose, You Win, You Win, You Lose.' It's a play on a game show/carnival-like view of our lives. Sometimes you lose, sometimes you win, and right when you win it seems your next step is to lose. They're inspired by my fascination with architecture and design and by my love of old game shows and amusement parks."

www.guerillaone.com

YOU WIN

WK INTERACT:

WK is a French artist living in America who has humbly created a style and vision all his own. For WK, his unique stretch motion art is a life moving force that he's dedicated himself to 100%. "It's been 16 years that I've been following the same move. The stretch motion art you see up on the streets is the reason why I came to New York. The whole idea was to collaborate with the environment. Taking the old to bring something new. I loved the fact that it was free and available for everybody; it was an exciting dialog and a big challenge to collaborate the art, the streets' architecture and the public. I didn't speak any English at the time, I hardly knew anybody, slept on the streets for almost a year, and struggled for about five years before I made it. It was a challenge."

Given the fact that WK presents his art publicly on the street, it's only natural that people would compare him to a certain other art form that finds its way onto walls and other parts of the public domain. "I don't consider myself a graffiti artist. I know most of the old and new school graffiti artists and have great respect for many of them. I think they have a different way of doing things. I put up images that don't imply my name first. My art is part of the street. The street is the medium. A story I'm applying over the buildings. I consider myself a 'street interact graf.' I can't really say I'm far from graffiti, but I don't belong to any group. I hope in 10 years I will be recognized as part of a certain group, but it takes a long while before you can title a movement."

The process of creating stretch motion art is a complicated one for WK, involving many different steps before he arrives at the finished product. "First I find the location and think about the type of story that could fit its physical motion. The subject comes to mind from the street itself. I sit and look at the traffic trying to figure a situation that can come about at that exact location. Next, I'll be searching for real characters to fit the story. For example, the martial arts story. I was searching professional martial arts schools where I found this mentor who has been training for 20 years. Before I get to the black and white stretch, there will be storyboards, subjects, characters, and costumes. It's never just a hand drawing. A photo shoot will follow sketches, and the photos are then manipulated and translated into motion. I calculate the size of the stretch based on the size of the wall. The larger, more complex angled the wall is, the more powerful and interesting the piece is going to be."

www.wkinteract.com

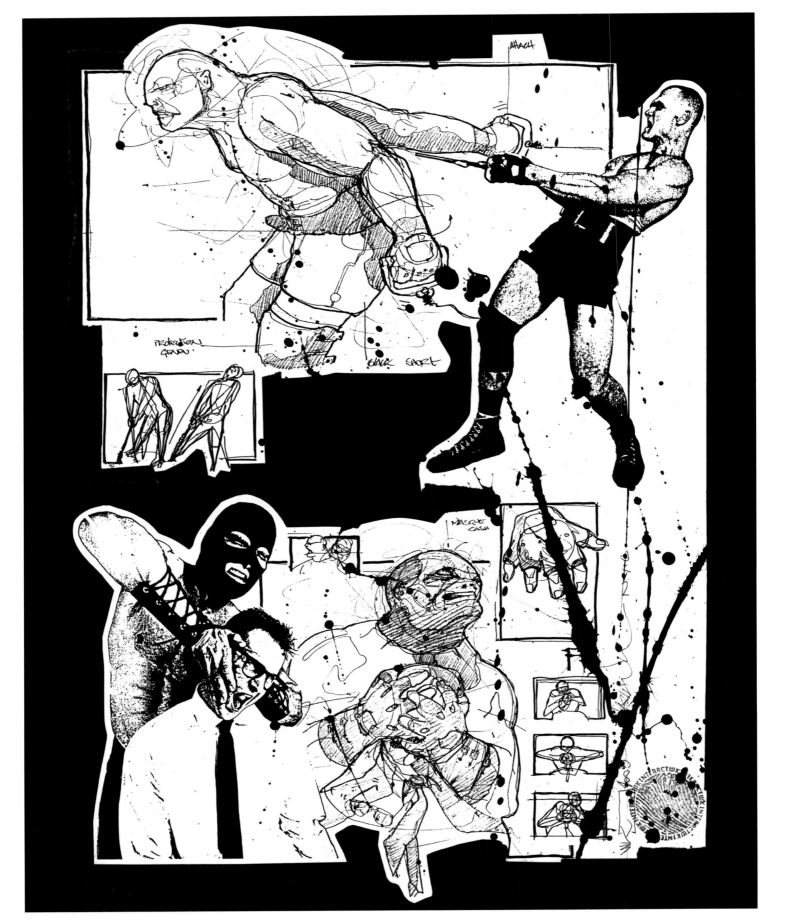

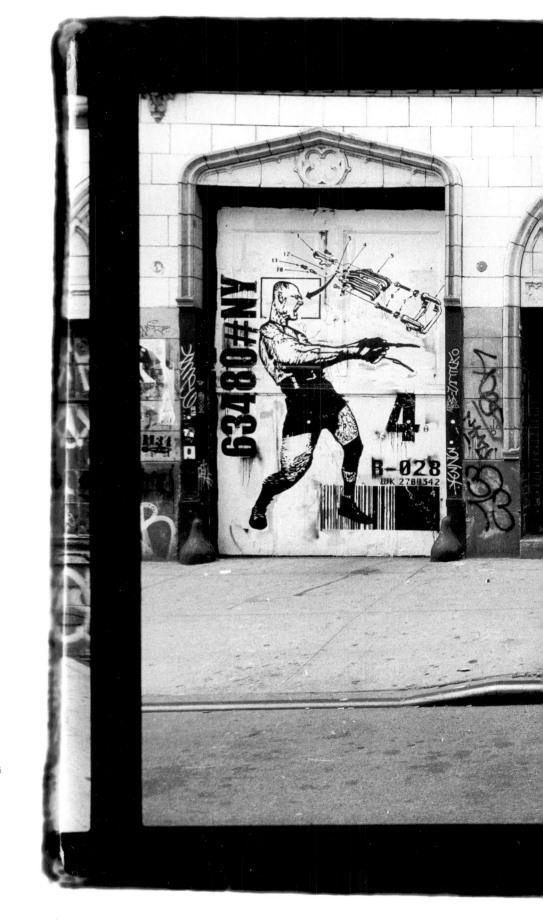

photography by Francesca Magnani

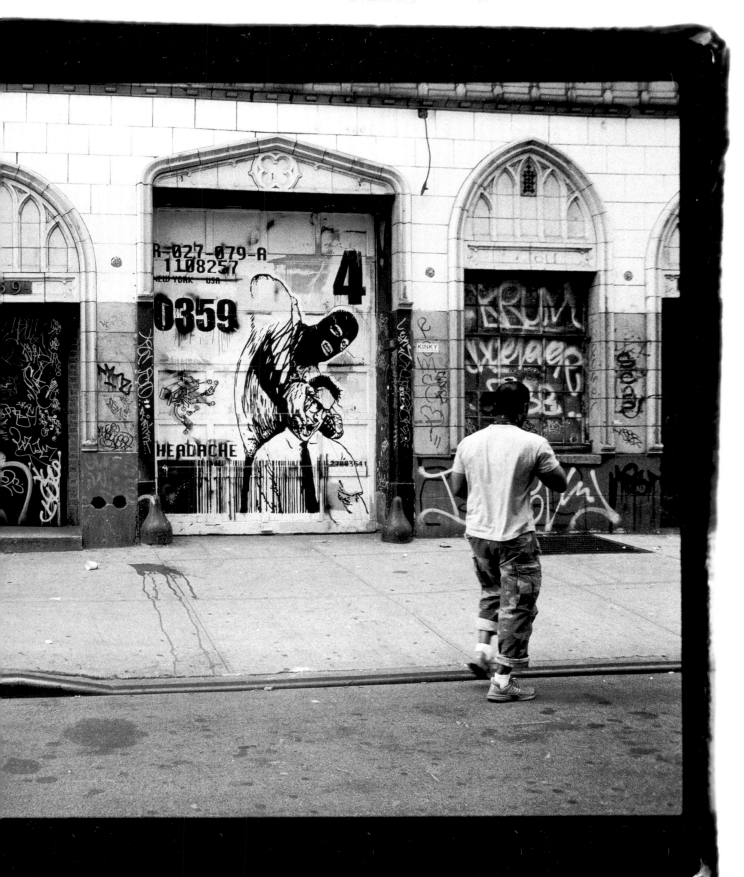

AXIS:

Art has been a personal catalyst for AXIS from the time he was a child, to when he won his emancipation at just 15 years old, to a wilding young graffiti artist, to the man who is represented here. Showing a keen understanding of the link between art and property destruction, AXIS' earliest artistic memory is "drawing a shark with big teeth in my uncle's house with a crayon the whole length of his hallway. I also remember drawing cartoon characters like Woody Woodpecker and Screwball Squirrel when I was young because they were violent. They had little mallets and I really liked that."

This early appreciation for art allowed for an easy transition into the art of grifting. "If we had to draw something for a book report kids always asked me to do theirs. I would ask for their lunch money in exchange. I was already hustling when I was a little kid. I remember there was this cute little chick in fourth grade. She got really good grades but couldn't draw so she needed me to do something for her book report. I did it for a weeks' lunch money."

The trouble didn't stop there as time spent skateboarding with friends led to an introduction to the seedy world of graffiti. "I met some older cats that were writing, there were more established. I started seeing what they were doing: more of the art side to it. I went from etching my name on things to actually doing lettering and characters. I officially started writing in '85. Graffiti took me out of high school. I was ditching all the time to go paint the yards. It opened my eyes to something. I knew I didn't want to do the whole school thing and I knew I didn't have to because what I wanted to do I could get on my own. I didn't need school to point me in any direction. I just wanted to be an artist."

"A lot of the stuff that I'm painting now are things that are going on in the world, combined with my heavy influence from cartoons and my sick sense of humor. For example, this round piece here of the demon swooping down on the little girl was influenced by all of these child abductions in Southern California. I felt compelled to do a piece about what was going on. The 9-11 painting is a documentation of an historical event that changed everybody's life. Back in the day, before there was a mass media, artists were responsible for documenting history. I feel it's my duty to put some of these things down on canvas. And then one day I might feel like drawing something totally retarded and goofy like a kid with Downs Syndrome on a tricycle."

www.stylepig.com

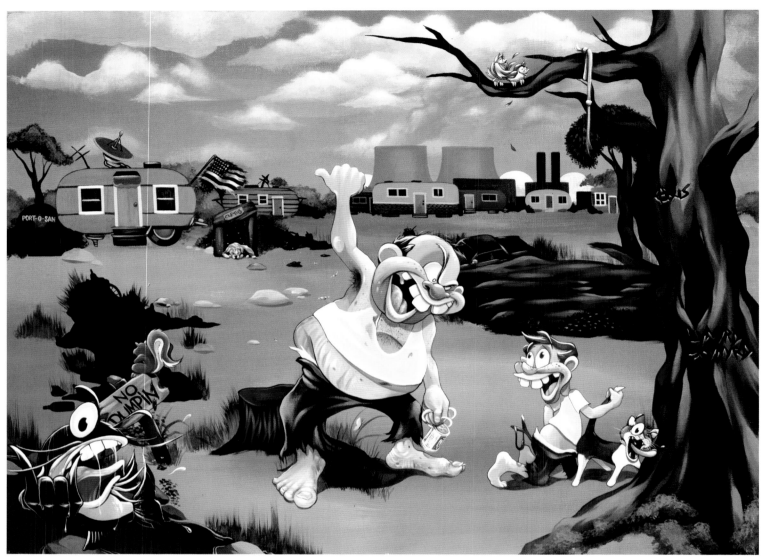

Git in That House Boy!
acrylic on canvas
24"x18"

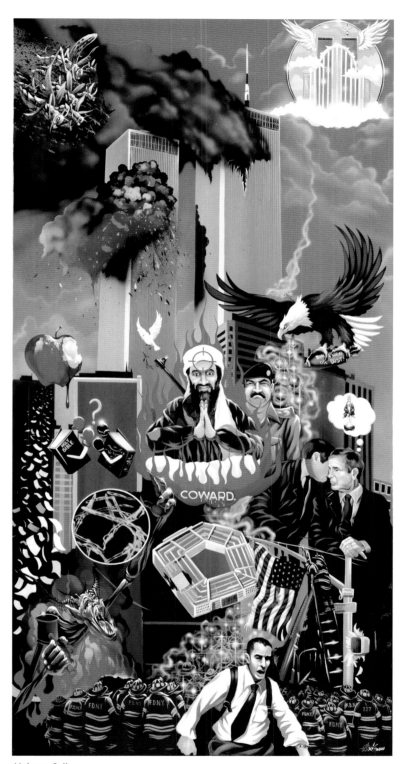

Wake up Call
blood and acrylic on canvas
48"x24"

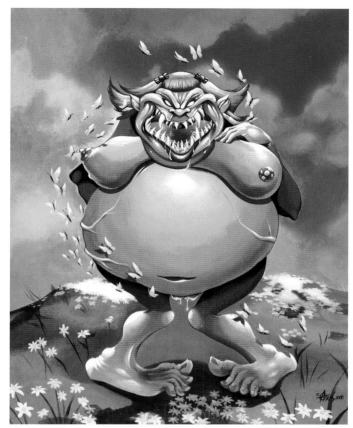

Butterfly Kisses For a Cute Little Fatty
acrylic on Bristol
11"x14"

Election Day
acrylic on canvas
16" round

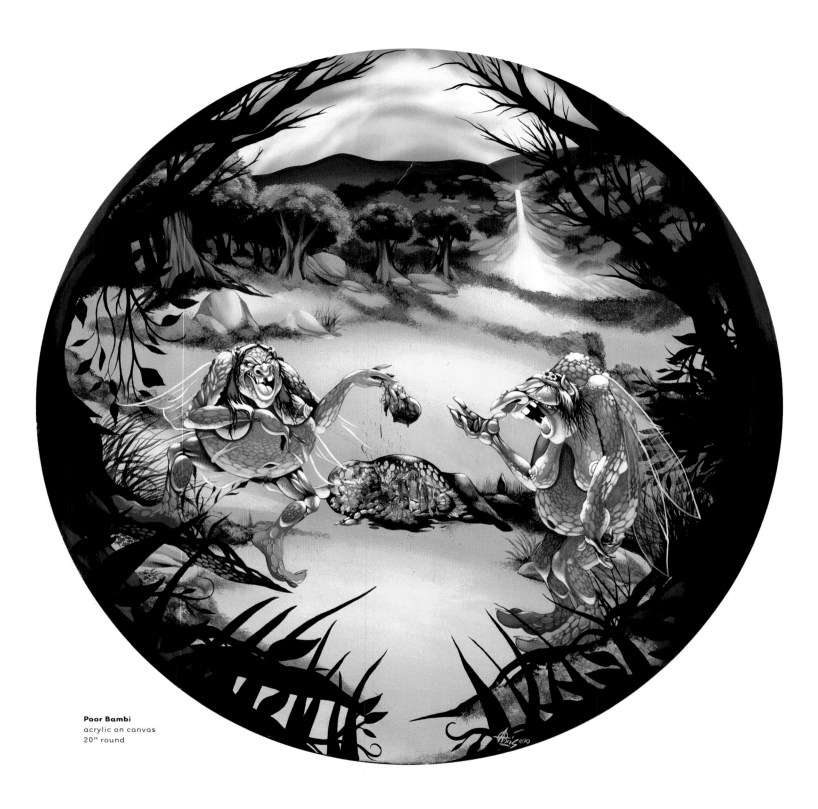

Poor Bambi
acrylic on canvas
20" round

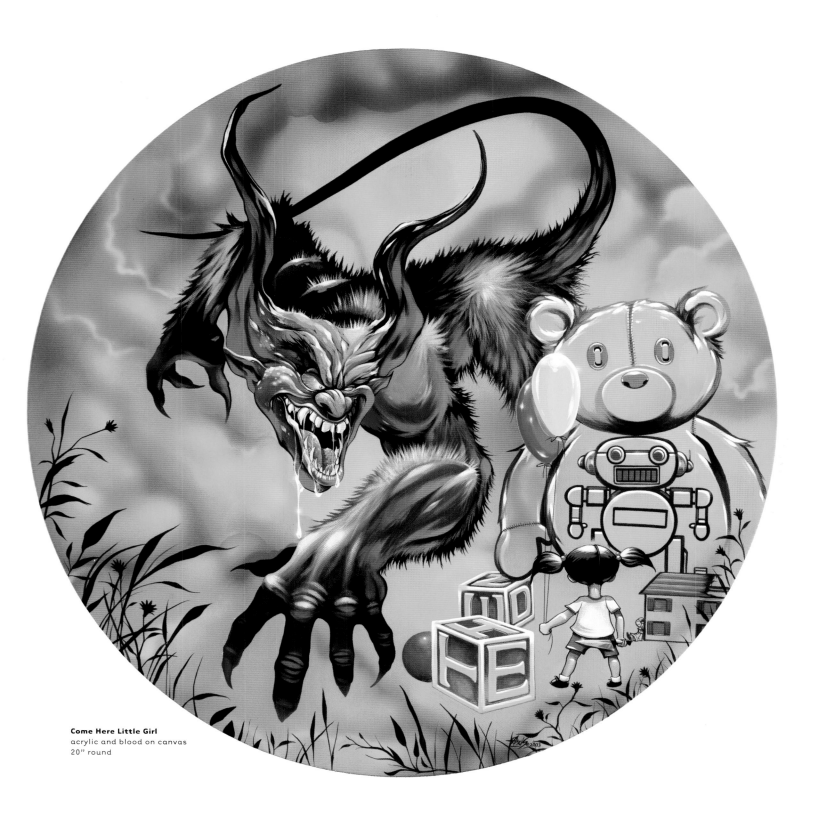

Come Here Little Girl
acrylic and blood on canvas
20" round

Estevan Oriol:

Estevan Oriol is an artist of many different talents, reflecting the numerous places he has been and the jobs he has done along the way. During the 1980's, Estevan was a bouncer at several Los Angeles hip-hop clubs and nightspots. Here he developed a relationship with his Soul Assassin brothers in Cypress Hill. Looking for a way to increase his knowledge of the entertainment industry, Estevan took a job as tour manager for House Of Pain in 1992. From here he first ventured into the clothing industry with House of Pain's Everlast with a line called "Not Guilty." This collaboration would hone his skills in clothing and eventually lead to Estevan's becoming the CEO of Joker.

In 1995 he discovered his natural gift for photography. Initially just taking flicks of the wild atmosphere of a touring rap group, he began photographing the people in the Los Angeles neighborhood he lived in. Estevan showed the ability to capture the raw essence of street life from a point of view only one with a true understanding of the streets could portray. Now one of the most sought after photographers in hip-hop, Estevan's work has been featured on album covers, advertisements, and dozens of magazines worldwide. He has also directed numerous music videos.

These photos of Estevan's are a series of portraits taken in Mexico. "My dad's side of the family is from Mexico, so I felt like I had to capture some of the culture of where half of me came from," he says of the photos, which are in color instead of his usual black and white medium. "I like to take pictures of people who you can kinda tell what they have been through just by looking at them…people expect to see me put out the black and white flicks so I just wanted to do something different."

www.estevanoriol.com

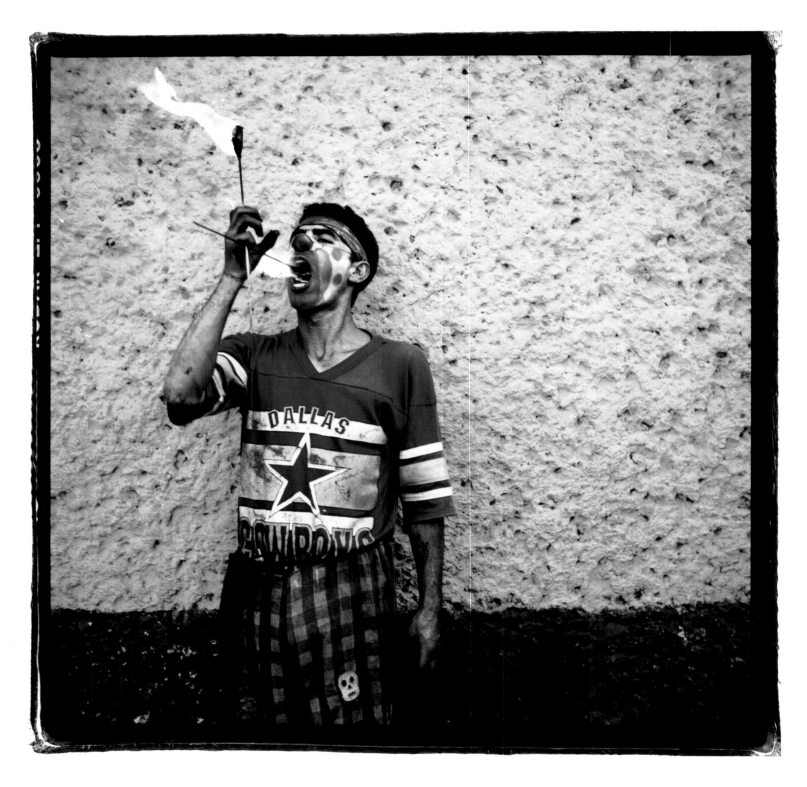

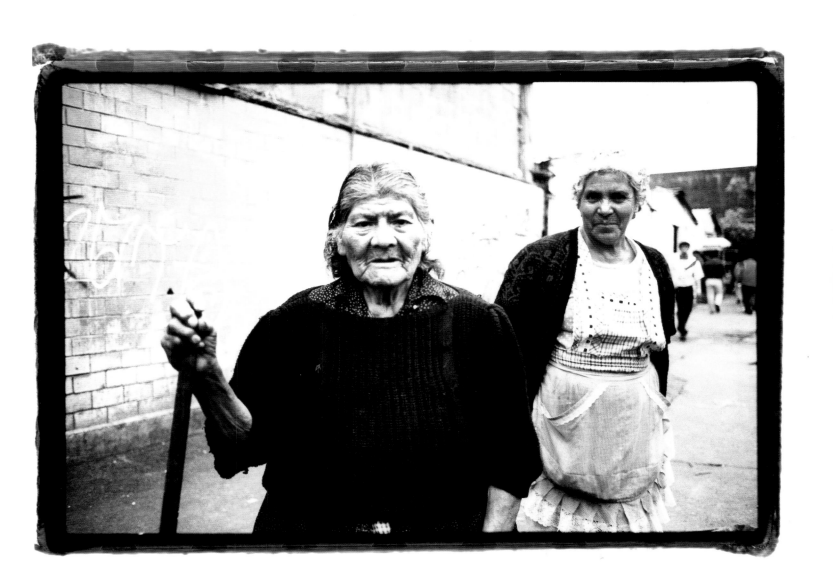

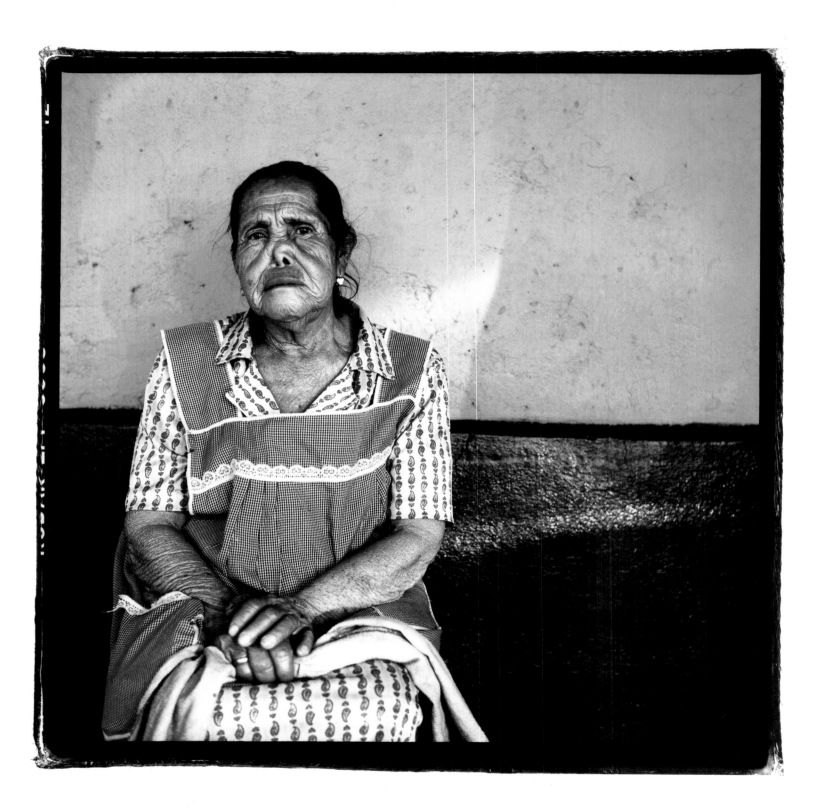

Mikkel Groennebaek:

A native of Copenhagen, Denmark, Mikkel Groennebaek graces these pages with a decidedly more heavy metal rethinking of a classic moment in rock 'n' roll. "I've always been a big fan of the Beatles movie Yellow Submarine, and how it was full of all of these colors and a crazy abstract story. When I was getting ready to do these pages I had been listening to a lot of 80's heavy metal music, so I chose to redraw the movie with the faces of Kiss. My favorite thing about the image is the way the colors and the shape of the letters and characters came out. I like the way it's all crazy with small details, bubbles, hidden letters, and colors."

With his partner Anton Juul, Mikkel produces graphic art and clothing designs for their brand, CastleCph. CastleCph is represented internationally through various gallery shows and in clothing stores in several major cities. Mikkel arrived at this point in his career through a steady diet of local artistic influences. "I've always been fond of drawing and painting. I didn't care much about school and homework, instead I spent most of my time drawing graffiti sketches and going out skateboarding. I started sketching and doodling in '85/'86, but I didn't take graff too seriously until 1994. That was when I did my first real pieces on walls, but before that I was more into skating."

Mikkel is also able to offer us some interesting insight into the strange customs that Europeans have for giving each other pets. "I had a Russian land turtle called Rasmus once. I got it as a kid but I didn't know it was going to outlive me. I gave it away to my girlfriend's dad because he has this work office filled with birds, fish, a cat, and now a turtle as well. He's a pretty weird guy, but not as weird as this American graffiti artist named Roger that I know. When he came to visit me in Copenhagen he seemed to really like Rasmus. I think he tried to have sex with it until he found out it was a male. Even then...."

www.castlecph.com

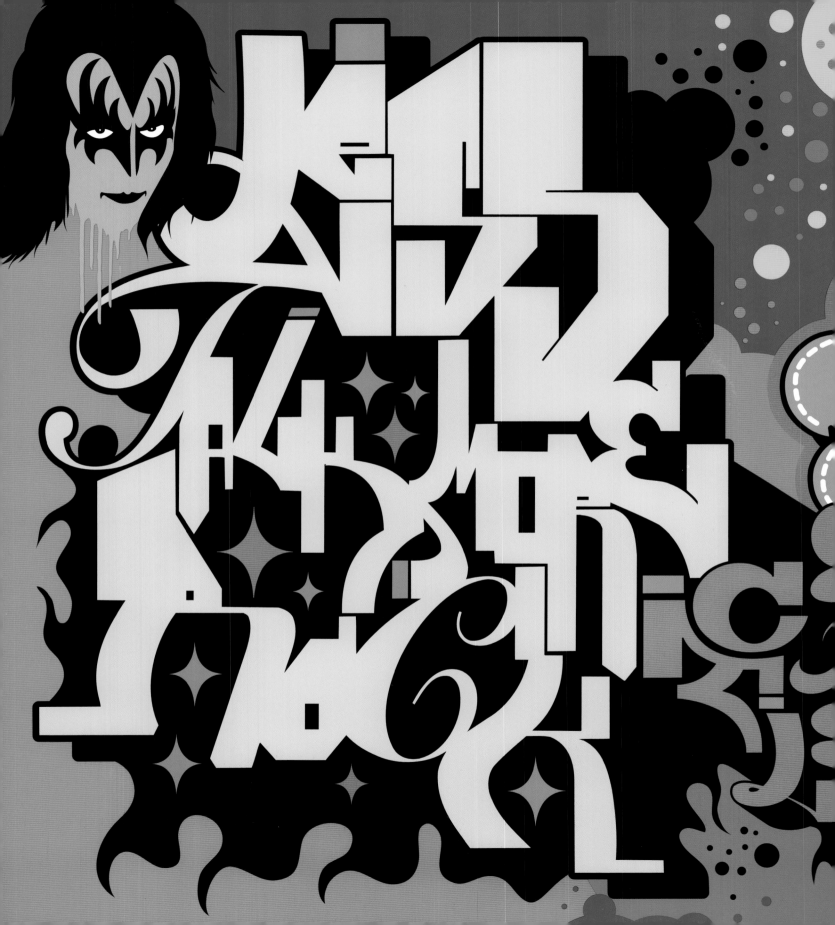

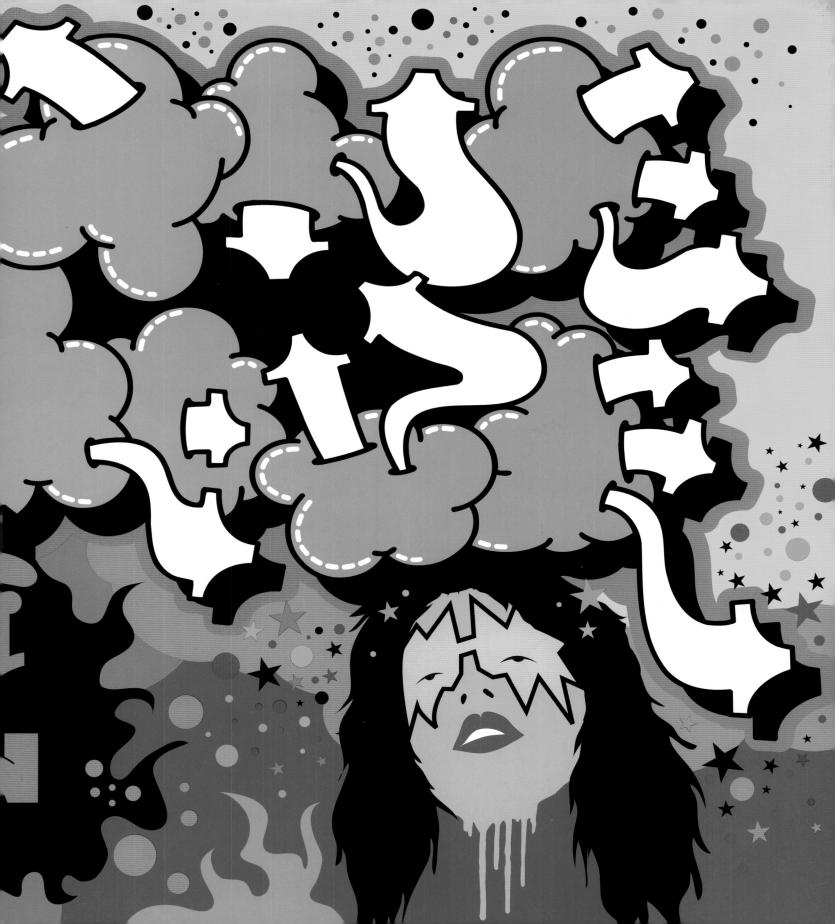

Clark And Hogan:

Located in Washington, DC, Clark and Hogan are the owners of MOCA, a grassroots alternative artspace devoted to supporting regional, national, and international contemporary art across a diverse range of mediums and disciplines. A force for positive energy in DC, the pair are constantly helping other artists and galleries. Clark and Hogan are also accomplished artists in their own right, as seen by the over 50 works Clark has in the National Gallery in Washington, DC.

Two of the images included on these pages are part of a series of subtle paintings dipicting sex from a female perspective. "More often than not paintings involving sexual images are done by men. It was a deliberate choice of imagery that the woman is in a more active role in one of the paintings reproduced. They're influenced by these Renaissance engravings from the 15th century of Italian artist Caracchi we found that were most likely produced for a private patron due to the explicit subject matter. Our favorite thing about them was hearing one woman tell us how the colors had her so seduced and fascinated that it was only after an hour of looking that she realized that the woman was sitting on the guy's dick. So we succeeded in our goal! People's reactions are always interesting — they were taken down from a show at a Catholic college gallery due to their possible offensiveness to the audience. Watching people take five minutes to realize active sex is involved in the picture and make a run for it out of the gallery is fantastic."

"A constant theme in our work is working with the past in the present. The fluorescent acrylic colors are now while the imagery comes from the 15th century so it combines to make a unique statement. Through the use of a projected image, the imagery looks screen-printed on the canvas but in reality it is hand painted, raising the issue of reproduction versus the original work of art."

The peanut images Clark contributed to these pages are part of a large series he started in the 80's that combine his interests in the graffiti pioneers of New York and the French international situationist art movement of the 1950's. They are a way of using pop art to make a statement that the general public can understand.

www.mocadc.org

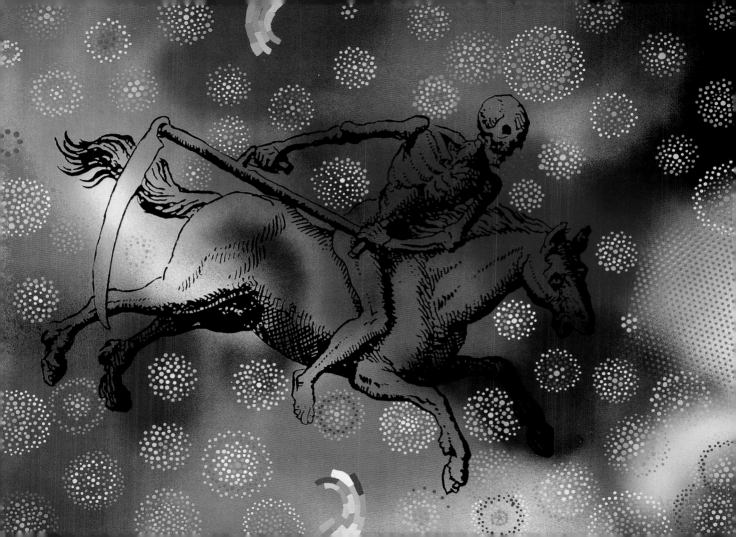

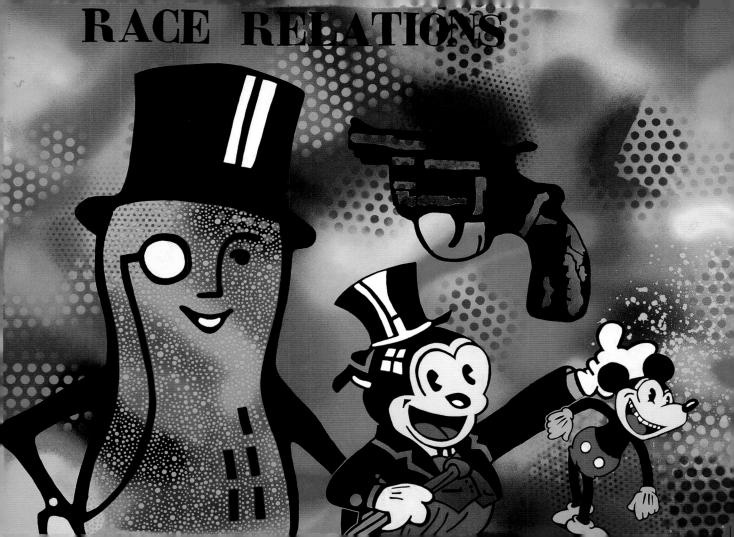

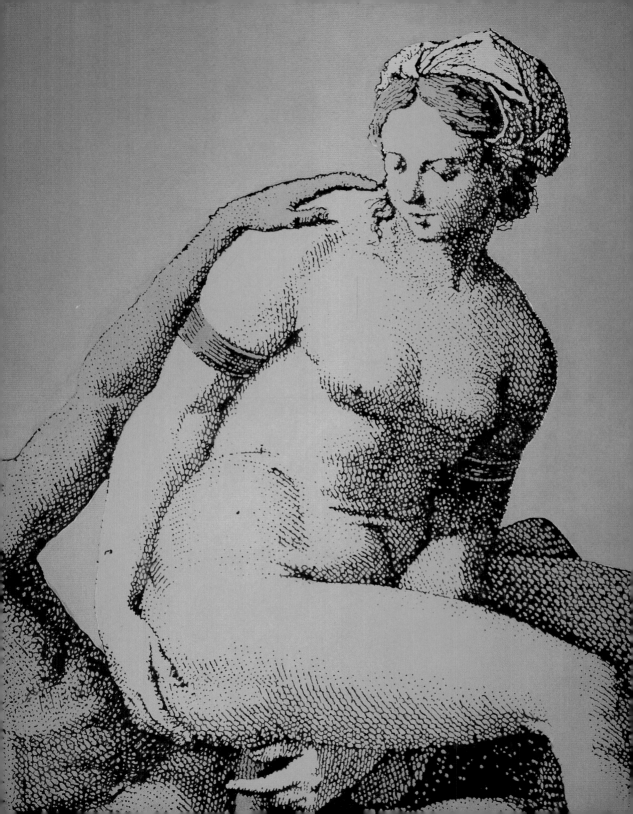

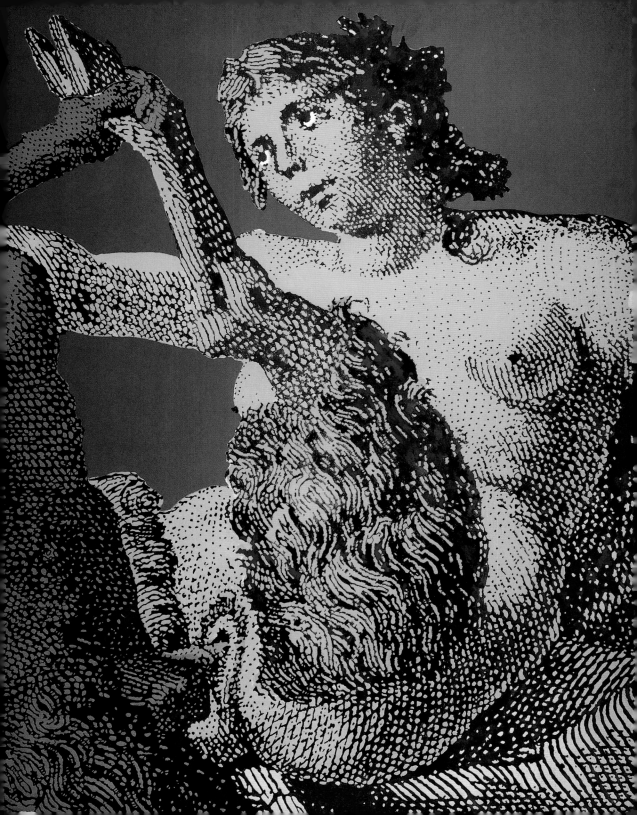

Ali Calis:

Ali Calis is a man of many skills. A graduate of Ohio University, he has degrees in graphic design and fine arts with a studio focus in painting. While attending college Ali also worked as a studio monitor in woodshop where he used the time to focus on his artisan skills, which play a major part in his style today. Although he didn't get to witness any gnarly accidents in the shop, he has come close to danger with his own projects.

"I did this performance installation involving a fullpipe and it was four quarterpipes that the two on the end were hinged together so that they could be erected by the way of a Ford van and a Jeep with tow cables. Once the top was in place I had to climb up and bolt the thing together. I had people supporting the sides with 2x6's whilst this endeavor took place. I was fearful of someone getting crushed."

Ali continues to meld his different talents into new creations, including using some non-traditional flat surfaces to paint on. "I've skateboarded since I was a kid, and I build skate ramps like half-pipes and other stuff. There came a point in my paintings where I wanted to incorporate the radiuses and transitions of the structures that I've always skated on, and try and build on top of them with a narrative. I wanted to tweak and twist the forms from the skateboarding world into the dialogue of my paintings."

"I want my design and painting to walk hand in hand, and I'm on my way towards that. I have different freelance graphic design jobs that I'm getting paid for, and I have my paintings out in shows, which doesn't pay yet. But I can put more of my art style into my design work and push both forward. People that are interested in having an illustrated design look when they approach me about creating an identity for their company see my paintings and they might go in a different direction based on something they see there. That's great then because they're going with a design that I can really get into because it's based on one of my paintings."

anjc25@hotmail.com

Anthony Yankovic III:

Anthony F. Yankovic III may have a long name, but he's direct and to the point. For example, when asked to reflect on why he creates art he replied, "Because it's fun. Is that stupid to say? No, it's not stupid. Everyone else is stupid. I can't attach a bullshit self-indulgent, freshman in art school, serious 'mommy and daddy didn't like me' meaning to the stuff I make. That's for retards. I can't tell you how many times I'll see a painting or a show that rules, but when I read the artist's statement, I immediately hate their guts and lose all respect for their existence. Why is it necessary to attach pretentious bullshit to your art? It's pathetic. My artist's statement would be, 'shut up.'"

Using mediums such as markers on pizza boxes, and with titles like "Drugs On Drugs," Yankovic is anything but pretentious. His energetic work is influenced by future-retro art on video game boxes and other pop culture standouts. "The one with the horse and the three members of ABBA (who suck by the way, but the album cover is tight) is similar to the 'messy paint on top of anything' style I've been into the last few years."

Yankovic is also eager to let off some steam about people he thinks should change their ways. "Anyone who makes a face when they see me drinking Budweiser or Busch, get bent. It's good beer, so stop being a baby. If it were from some queer microbrewery you would drink it. Anyone who's out of school, and living in Williamsburg and has mommy and daddy pay their rent. All eighth graders can get bent. People who say they want to buy one of my paintings, but preface it with 'I don't have a lot of money.' What the fuck? What do you want me to do? Give it to you? Jeez. M.C. Escher, you suck. RISD, MICA, and all other grad schools that didn't let me in, get double bent. People doing things like Critical Mass, vegan potlucks, dumpster diving, and all that bullshit 'I'm better than you because I care and don't shower' PC bullshit. You all need a nap and a beer."

www.junkdrawer.s5.com

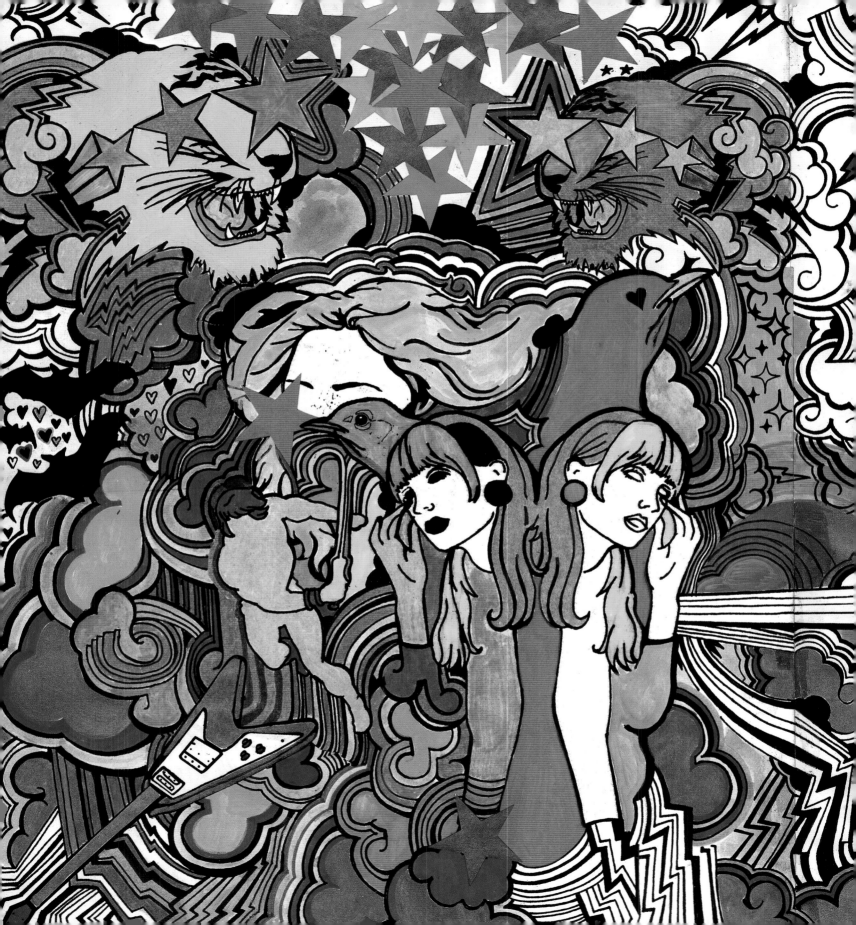

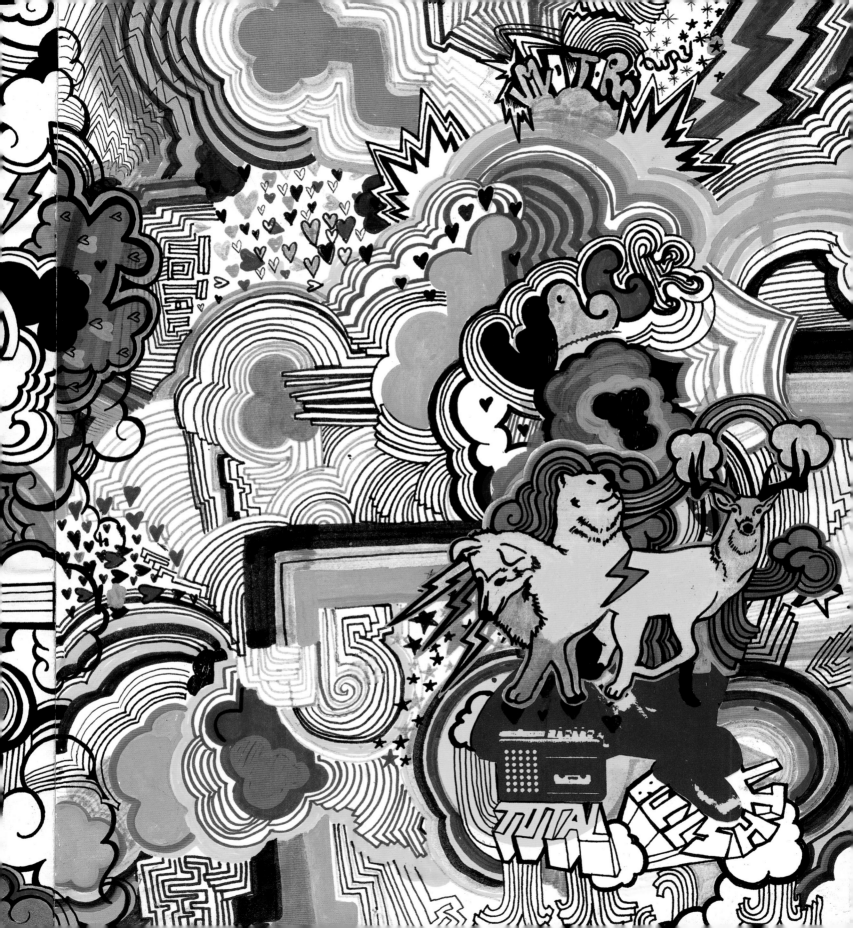

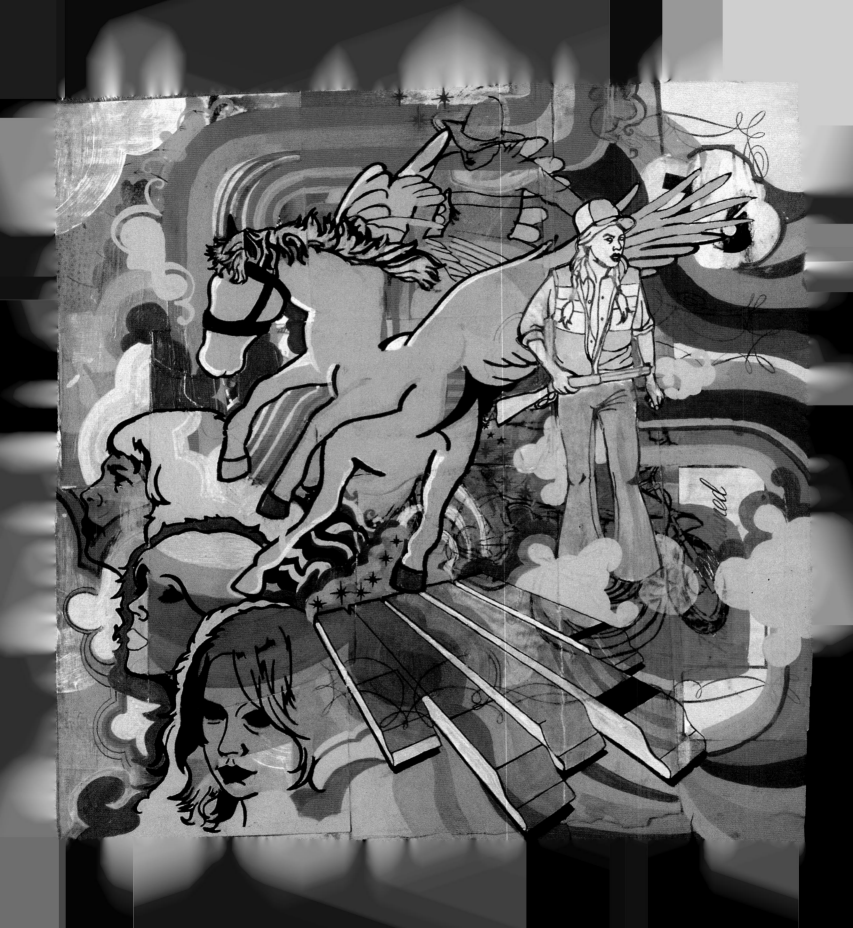

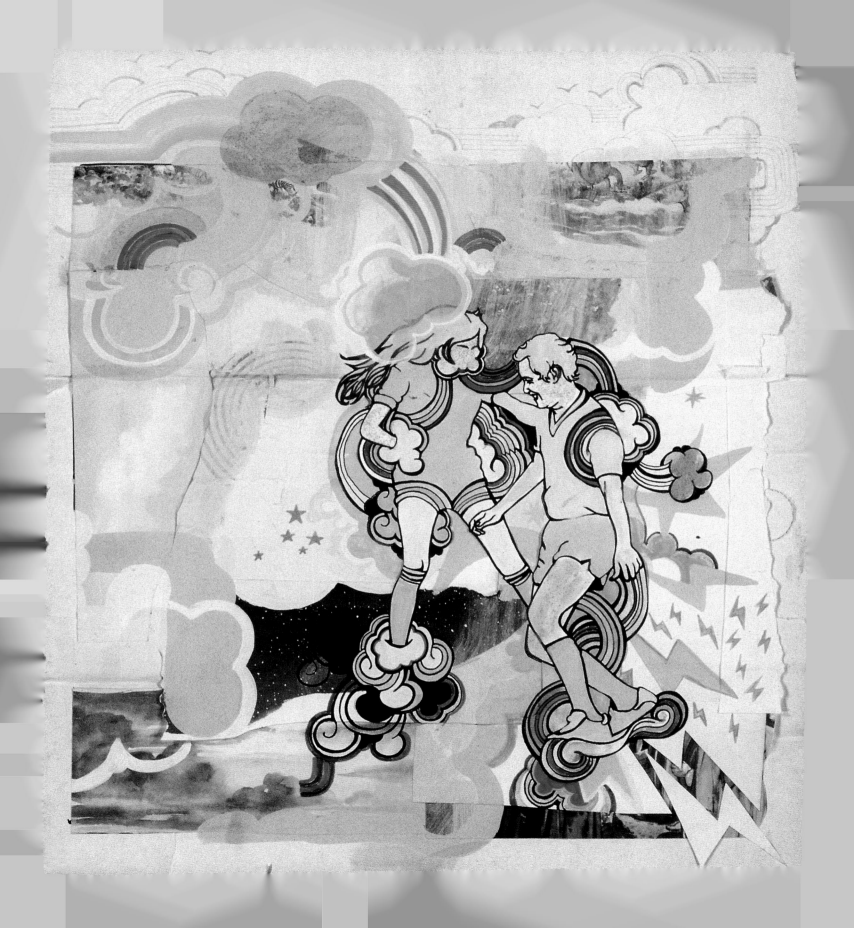

Adam Wallacavage:

Adam Wallacavage makes a good point when he explains that he's easy to find on the Internet because, to be honest, there're just aren't too many people in the world with the last name "Wallacavage." His approach to photography is very organic, often drawing on his surroundings for inspiration. "I photograph a lot of things for future ideas or inspiration or simply because I see something funny. I never thought of myself as a 'street' or 'documentary' photographer, but that's what I've been doing all this time for the most part. I shoot most of my photos without thinking. When I get film processed I find stuff I completely forgot about, I usually throw them into a pile and forget about them again."

The pictures presented here illustrate those piles of photos finally getting organized. "I used to work at a one hour lab and I always had thousands of small 4"x6" prints of my photos. Therefore, I never really got into printing my photos big. That's what the photos on these pages are, scans from 4"x6" prints. I like my photos together in groups all hanging out together. I want to start taking my work a little more seriously. I'm going to start picking my negatives up off the floor and start sticking them in plastic files and start printing them better."

"These pieces reflect the way I collect things. For the rest of the things that I do artistically, I also have a real passion for my house. I've been working for two years on my dining room. I'm not sure how to describe it, but I'm sure it's online somewhere. I'm into flamboyant interiors but it doesn't reflect in the way I look or dress, or the crappy car I drive, or the photos I show. I have strange taste and I thank God that I found my wife, Kathryn who puts up with me."

awallacavage@earthlink.net

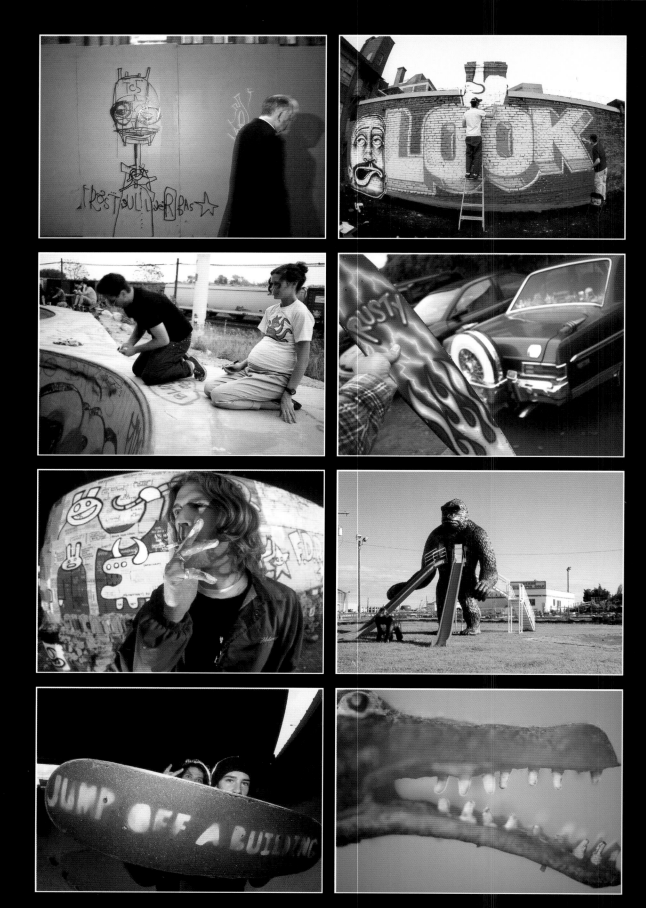

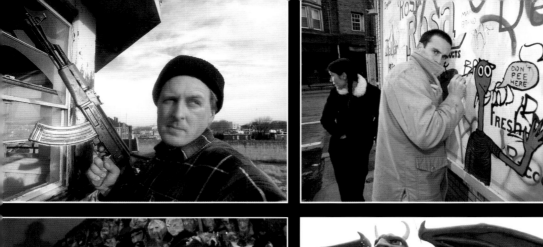

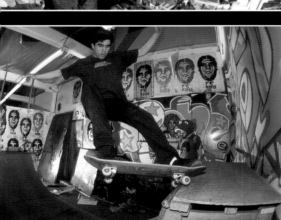

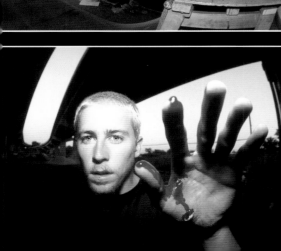

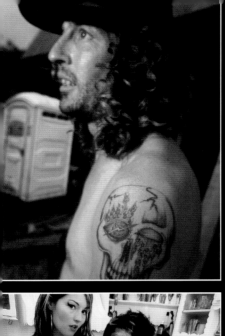

John Pound:

Inventive doesn't even begin to describe John Pound. In addition to painting over 400 images for the popular Garbage Pail Kids trading cards series, Pound has also created several other card series, had art featured in Mad and Juxtapoz magazines, and created the award winning "Random Comics" generator. John's ability to parody pop culture is only exceeded by his ability to transform the cute and cuddly into the frightening and grotesque.

Garbage Pail Kids was a full-on phenomenon, driving kids insane all over the US in the early 1980's as they looked to complete sets. What started out as a brutal parody of the Cabbage Patch Kids dolls was for many people their first introduction to artwork that challenged their perceptions. With names like "Boozin' Bruce" and "Ventilated Vennie" and pictures depicting electrocutions and massive amounts of bodily fluids, it's a wonder more of Pound's images weren't censored. In fact, only a few of his paintings were ever deemed too horrific for the series, including one of a pickled baby in a jar and another of a girl in a wheelchair rolling off a diving board.

Drawing heavy inspiration for his art from cartoonists and comic books, Pound set out to break new ground in the medium. "Some computer programs can create random text, and some programs can create random art. As a cartoonist, I wondered what would happen if you combined them to make random comic strips — would you get nonsense Sunday comics pages?" The resulting program from this experiment, a "Random Comics" generator, enabled Pound to produce some of the most innovative comics ever seen. The program allows for non-traditional page and panel layouts and the result is often surprisingly thought-provoking and beautiful. These Random Comics are further proof that computers can be used to create soulful art as long as the person programming them is willing to put their emotions into the project.

www.poundart.com

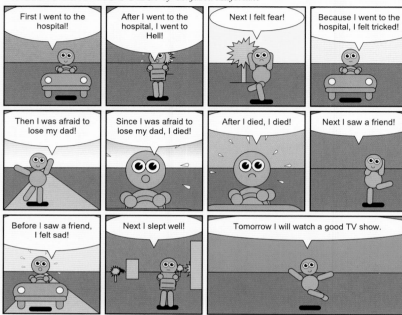

The image was created randomly by a PostScript computer program written by the artist. Each figure mutates from the previous one.

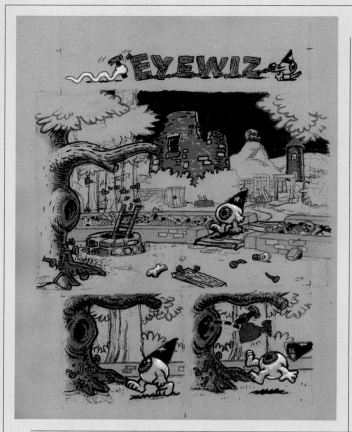
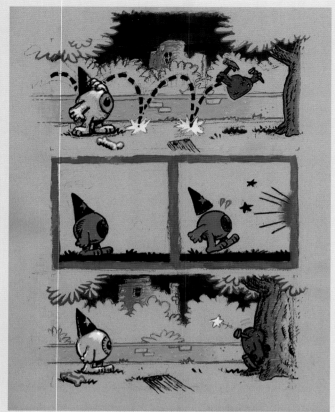
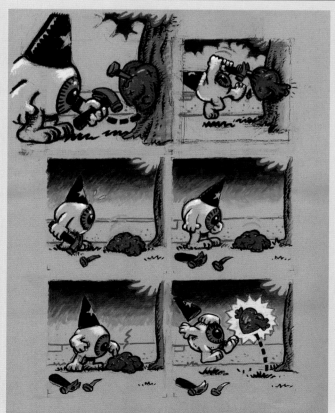
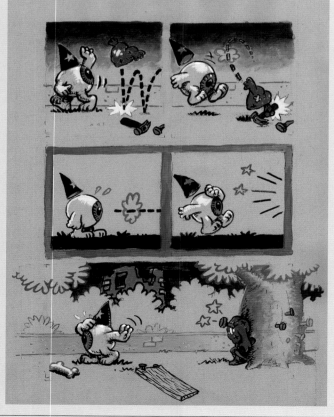

"EYEWIZ" A 4 page comic story. Acrylics on colored paper.

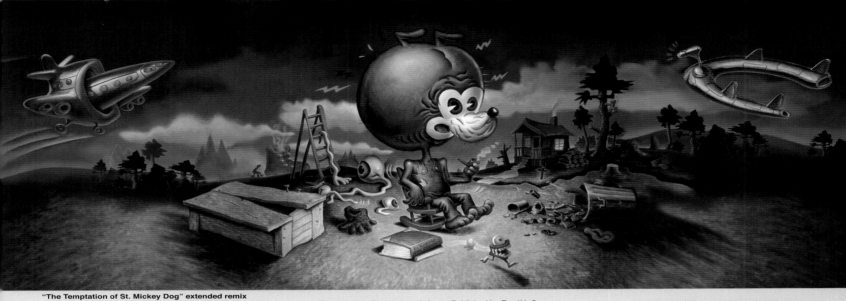

"The Temptation of St. Mickey Dog" extended remix
Source image was acrylics on paper on canvas. Image was recomposed in Photoshop to fit skateboard shape. Published by Fun4U, Germany.

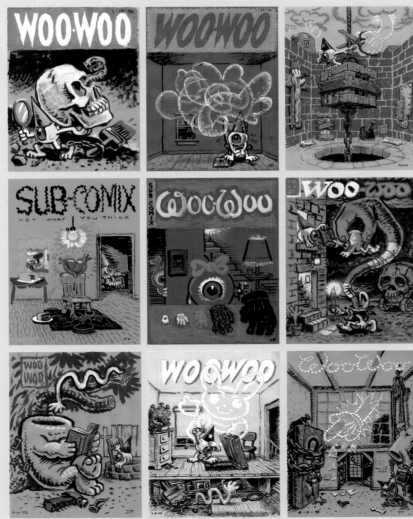

WOO WOO comic covers
Acrylics on colored paper.

more **WOO WOO** stuff
3D images created in Pixels 3D.

Richard Colman:

Richard Colman has always been something of an anomaly as an artist. As he extended from medium to medium, including graffiti and tattoo work, Rich's art became incredibly distinctive and somewhat troubling to look at. Filled with images of unshaven super-heroes homoeroticly groping each other, knife wielding zoo animals, shifty eyes, and the hooded figure of Death, you know Rich's work the second you see it. It gives you the sense that these works were created by something akin to a drunken wolverine with a paw full of markers – hilarious but also pretty fucking deranged.

"A lot of what I do is like innocence and decadence juxtaposed, which I find a lot of fun to work with. The decapitations are more of a comedy thing than a horror thing, while the homoerotic stuff uses sexuality to describe general day to day human relationships. Visually, I like the way that the sexual stuff works, especially with the superheroes. They offer another way to express personality and what issues may be lying underneath in somebody who wants to be a hero. With the images in this book, I turned in something that was looser and more colorful than a lot of the other work I do. Outside of that, the themes are the same as my other pieces. I like cartoony stuff, but I'd been doing a lot of really tight black and white stuff and I liked the idea of doing something that was expressive in a different way than the more controlled stuff."

Rich is also gaining a reputation for putting on quality gallery shows, something that is both a blessing and a cause for worry. "My favorite thing about showing in galleries is that it puts the fire under your ass and gives you something to work towards. My least favorite part about it is having to deal with the feelings that come up around a show, like expectations about how well things will go. The business end of it is very unattractive, unless everything fucking sells and you make tons of money. Then it's awesome."

richardtcolman@hotmail.com

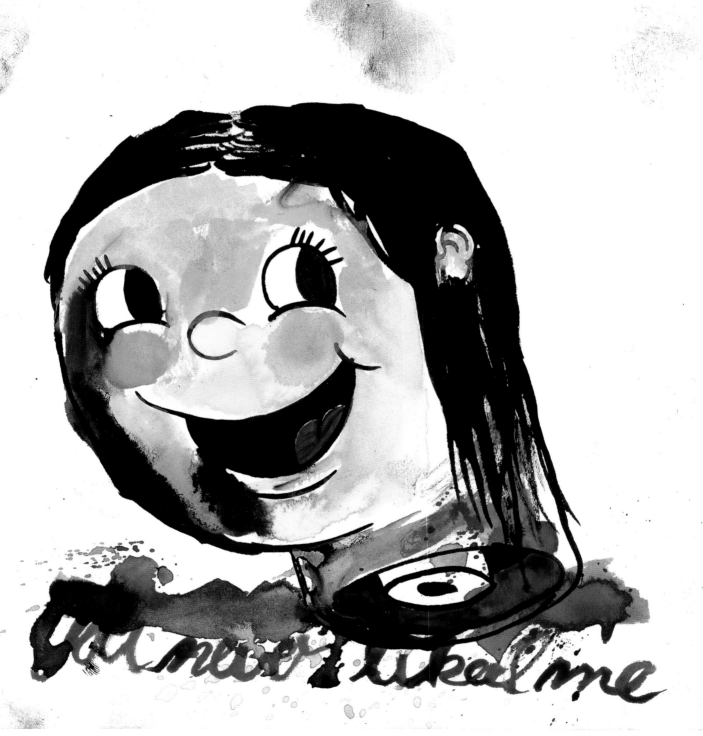

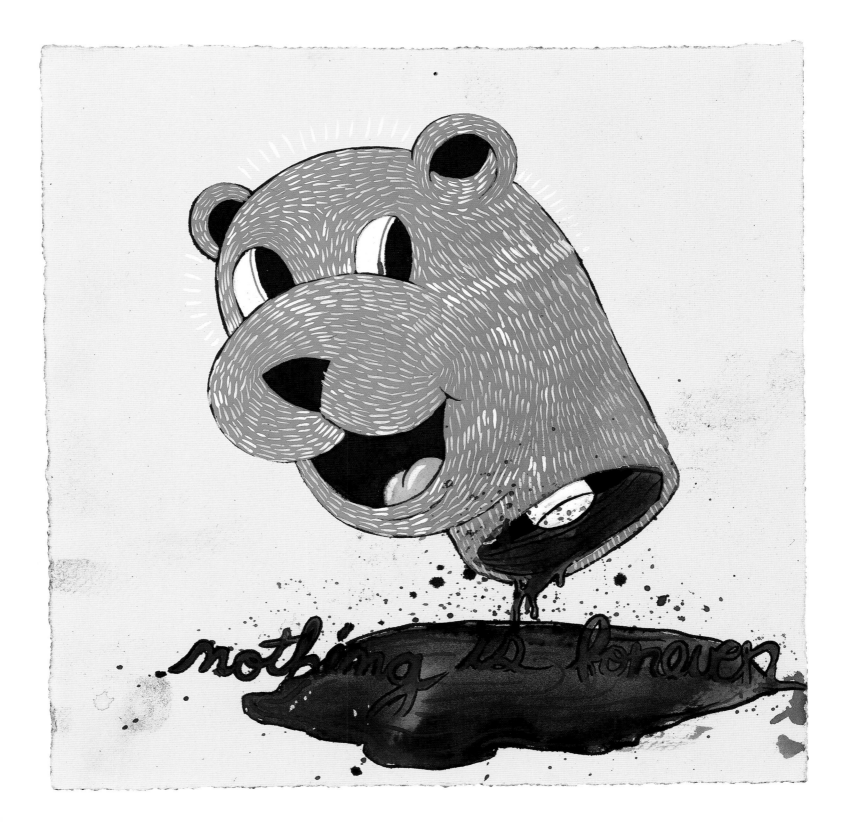

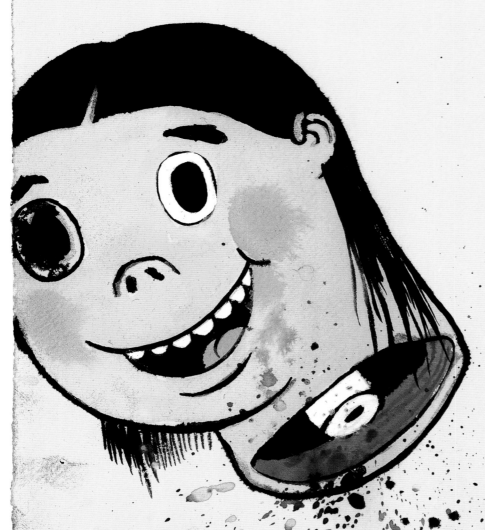

you were every thing to me

my grandmother's house

DALEK:

For many artists, inspiration comes from experiences they had when they were young children. For DALEK, one such event was nothing short of traumatic. "When I was in second grade, these workers were building a deck on the back of our house. There were lots of wooden stakes being used as markers with very sharp points. I saw the workers throwing lots of wood out of the back of their truck. Being a kid, I tried to imitate them. But I was a dumb kid and I threw one of the wooden stakes straight up in the air. It came down and planted its self right in my skull. It did a good job of sitting in there for a few seconds. It bled a lot and was a very messy scene. My mom was pretty stressed."

This painful experience could have something to do with the amount of decapitations and puncture wounds often present in DALEK's Space Monkey pieces. These creatures have become a calling card for the artist, and continue to evolve in scope. "The Space Monkeys are human representations for me. They are self-portraits in a lot of ways, and also portraits of humanity. They are floating in nothingness. I didn't want it to be a cartoon strip, like a Space Monkey in a house, then a Space Monkey in a car, so I avoided all of that. I didn't want to develop scenery like a house and trees. Once you put Space Monkeys in that kind of context it looses any kind of fine art quality to me."

Somewhere between head injuries and Space Monkeys, DALEK found time to become a respected graffiti artist and work extensively in the skateboard industry. As for his future with the Space Monkeys, nothing is certain. "That's kind of the beauty of it. I don't have a clue. They always transform rapidly from me drawing the same thing repeatedly. They switch up in undetermined ways. Where it goes depends on a lot of things, but as long as people are interested in seeing them I'll be able to pursue them, grow them out and work with them. Obviously, I would love to be 90 years old and cranking out some form of the Space Monkeys."

www.dalekart.com

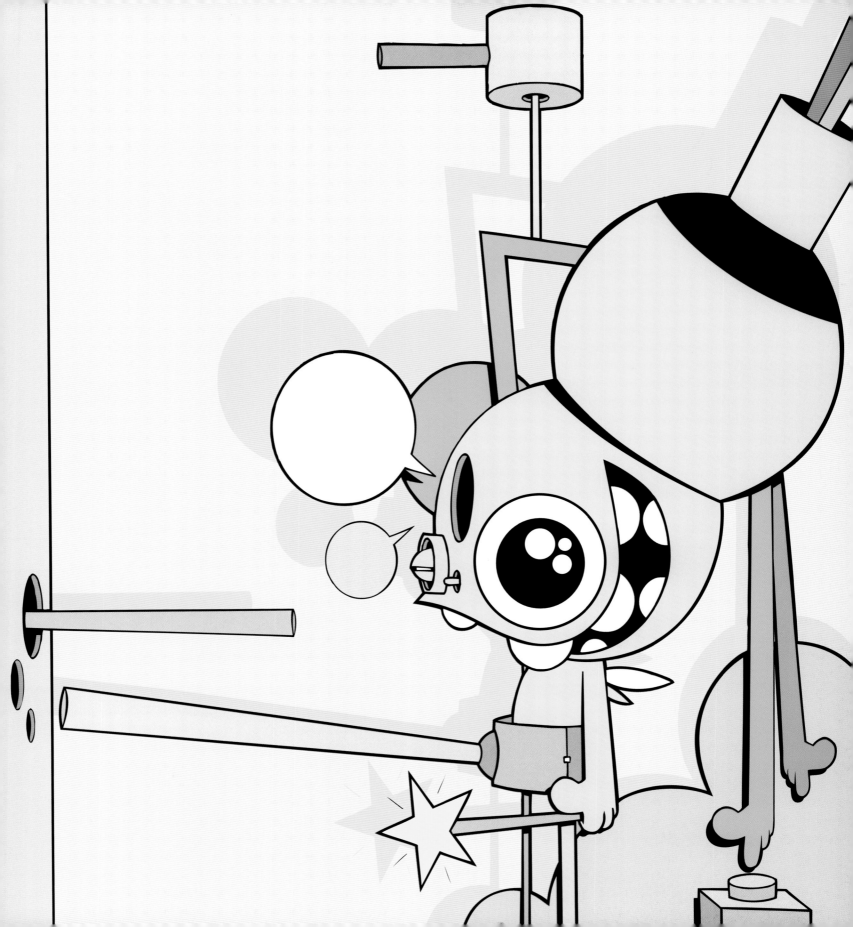

Cynthia Connolly:

When describing the amount of projects that Cynthia Connolly has been involved in during her career as a photographer you can't come up with enough adjectives to describe the massive volume of work she has produced. "I've been in a lot of art shows, and many times I've been the organizer of the shows. I did an auction a couple years ago in San Francisco called the Four-Hour Self-Serve Auction and Sale. I booked bands at dc space in Washington for five years and I've created a lot of projects within that job. For example, in 1988, I decided to book and record a whole week of bands and take a song from each band and make a compilation record. I organized and printed the book BANNED IN DC that year as well. I also did advertising and promotion for Dischord Records fulltime between '92 and '03 and before that I helped them out for the first ten years they were around by doing anything and everything. I've also taken my photos on tour for about four years like a band. I've set up a photo tour in Europe of my work by carrying it on a train... and setting up shows in five cities in Europe. I've published about 30,000 conceptual art postcards of my work, which I've also sold all over the world. I don't know... I'm sure I'm leaving a lot of things out and I wonder what that could be."

From DC, to LA, to Alabama, Cynthia has lived in plenty of places that have lent themselves to her work. She also finds travel to be an important part of her creative process. "China, Russia, Europe... I love Italy, Thailand, Indonesia, Singapore, Hawaii, and all over the US and Mexico. I think all these places have taught me the greatness of the food the world serves, and I think cooking different food makes you more creative. It makes you think about the simple things around you and what is in front of you. Places tell me more of what I like and dislike and how I'd like to 'express it' in my art."

cynthia@dischord.com

GREY:

It's no accident that GREY bears a certain resemblance to Dee Dee Ramone considering that the Ramones were a powerful early influence in this accomplished graffiti writers' artistic tendencies. "The earliest thing I can remember drawing is the Ramones based on the cover of their movie Rock 'n Roll High School. I rented it in 1984 and had a two-month late fee. I was 10."

An innovator in the graffiti world, GREY was the first writer aside from the Cholos to use the acid solution, "Etch", to get up. "I used the cream before the thinned-out "Etch Bath" was available. I tried to thin it out myself, but it didn't work. Thank God the Etch technology caught up to our needs and made shit that works in mops."

A well-traveled artist, GREY has been able to pull inspiration from all over Europe and America. On the other hand, he's not too pleased with those who are happy to borrow their inspirations from other people. "I don't like people that totally went to the style that I have been working on for a decade. They just went straight to it after they got sick of the last style they bit. And I can't stand the legal spraypainter. They make me mad because they are juicing the impact that vandals make. They are taking credit for our work. Fuck them. When I want to do legal art it sure as fuck isn't spraypaint and a wall."

contact_grey@yahoo.com

Grey ™
Grey ™ Design

SUIDIED
SUICI E

Grey ™

addicted

SUID

Grey ™ Design

no control
no control

trouble
trouble

Ben Woodward:

Ben Woodward is a founding member of Space 1026 in Philadelphia and in no way are his pieces on the following pages trying to support animal on animal violence. "I was into the idea of making a really awful job fun by making my coworkers laugh…like when trash collectors put a stuffed animal on the front of the truck to make the day go faster. Most of my work revolves around human nature and uncomfortable situations personified with animals so that race and sex aren't the issue."

This talent for amusing his coworkers wasn't the only thing Ben has learned during stints at stressful jobs. "The worst job I had was also one of the best. I used to work for Shepard Fairey in Providence, RI, back in the Alternet Graphics days. It was insane 'cause Shep taught me how to silkscreen real good and that you could live off your art and that you should never be a big headed art snob. But every once and a while, Shep would forget to take his insulin and he'd freak out and it would be the worst place on earth for like forty minutes. And I never want to see that Andre face again. Printing and cutting Andre's face for like twelve hours a day will make you want to go home and stick your head in the oven. But all that working on somebody else's art made me want to work hard as hell on my own stuff."

As for Ben's irrational fears, there's no telling where exactly they came from. "My biggest fear as an artist is that my arms will get cut off and I'll have to learn to paint with my feet or some shitty thing like that. And then everyone will only like my stuff out of pity 'cause I got no arms. They won't really like my art and they will be afraid to tell me that it sucks. I hate when people don't like my stuff and don't say it. Don't be a pussy, I won't cry. I don't like a lot of things."

www.space1026.com

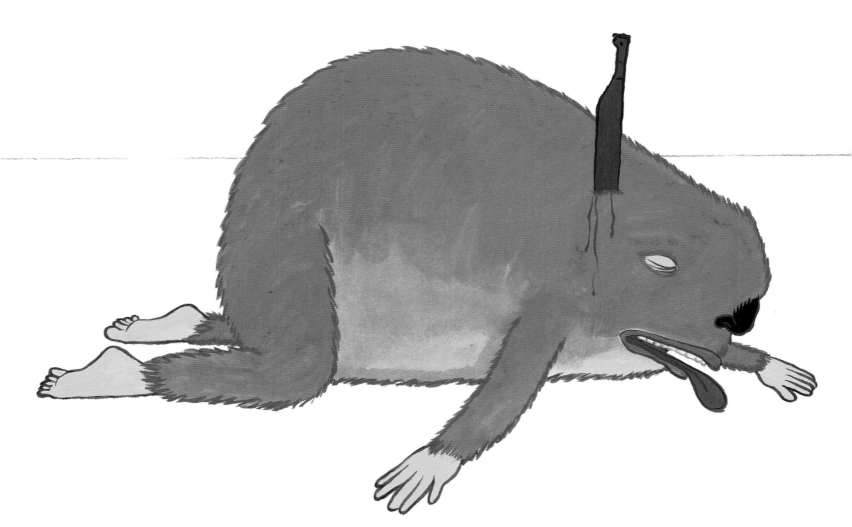

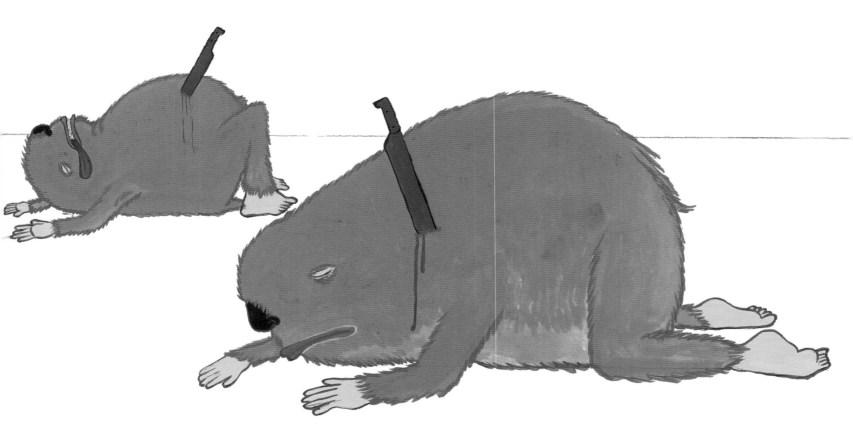

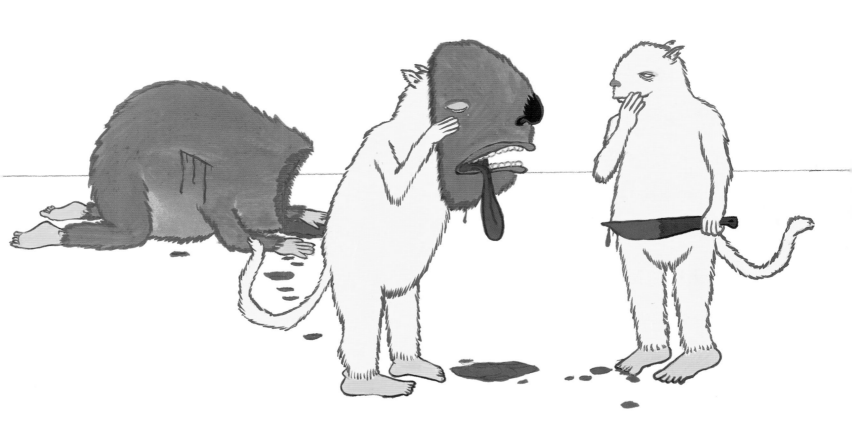

Mitch O'Connell:

With over 20 years experience drawing for a living, it would be nearly impossible not to have seen Mitch O'Connell's art in some way, shape, or form. Consider that his work has been commissioned for such diverse clients as McDonalds, Burger King, KFC, 7-11, Coca-Cola, Maxim, Spin, Playboy, Darkhorse Comics, Mad Magazine, Rolling Stone, Time, The New Yorker, Entertainment Weekly and dozens more.

This kind of success has presented an interesting set of problems for O'Connell. "I was lucky enough to have my art on the cover of Newsweek. I felt like the cock of the walk to hit that commercial high-bar and be on eight million magazines. Also that month I might have been doing CD covers, some advertising art, etc. I almost never turn down work (darn food and shelter!) so the stuff I do for my own amusement is squeezed in between paying jobs. I get to thinking as I plow through assignment after assignment, 'I wish I had the time to paint for myself and produce some "fine" art.' Wouldn't it be better for mankind if I spent my time creating "art for the ages" instead of a spot illo for "Juggs" magazine? When my wish is granted and I go a few weeks without an actual commercial job I'm happy to take that free time to do my own stuff, but after a while I'm wondering 'Why aren't people calling me? Don't they want to pay me anymore?' Sometimes when I'm making some money and the gallery art is turning out great I'll think in the back of my head that, hey, I'm the best thing going, and other weeks I'll be staring at a painting that I can't get right and a stack of unpaid bills and moan, 'Why isn't Juggs calling me?' A real full time job always seems just around the corner."

O'Connell has had multiple collections of his art published to rave reviews, as well as designing over 140 tattoo flash images. These images are displayed in parlors and are what patrons chose their tattoos from. These flash pieces are considered among the very best in the industry. O'Connell lives in Chicago with his wife Ilsabe and their children Leo and Kieran.

www.mitchoconnell.com

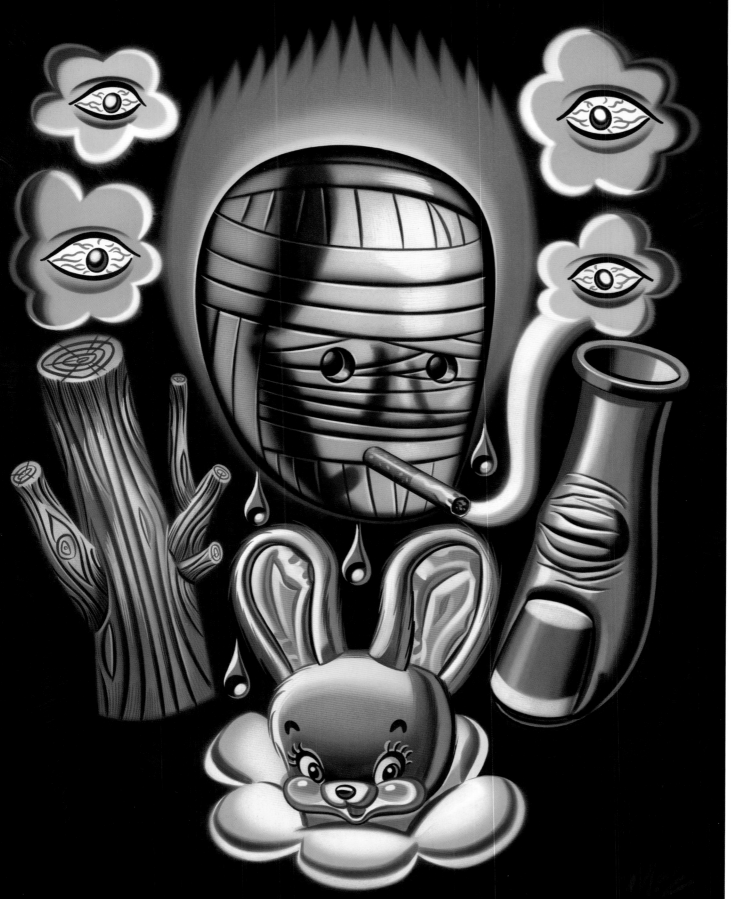

Thumbody Loves You, 11" x 14" 2002

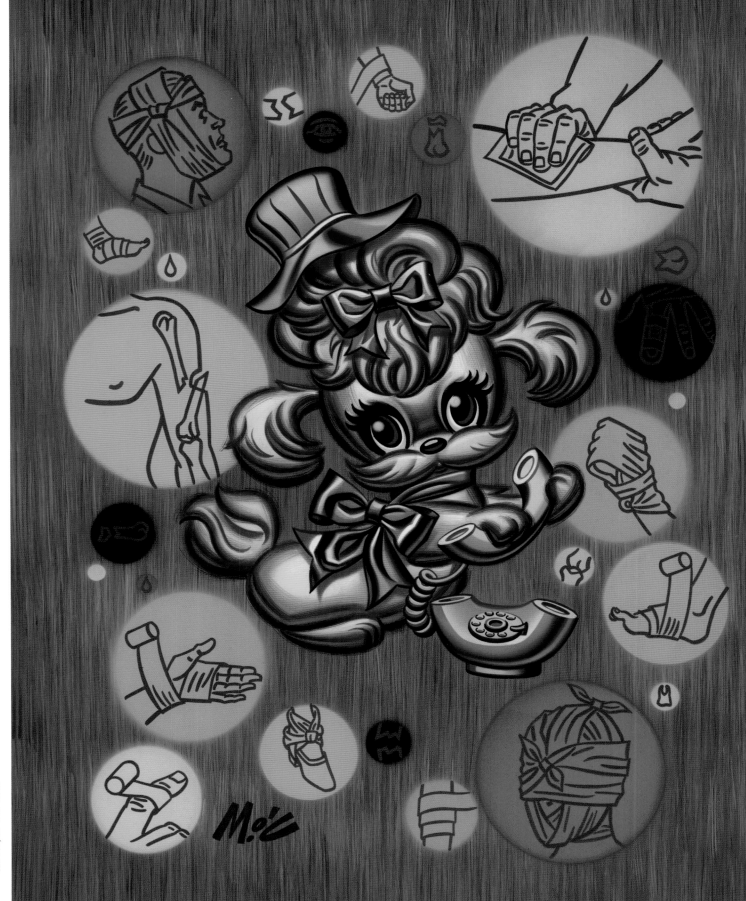

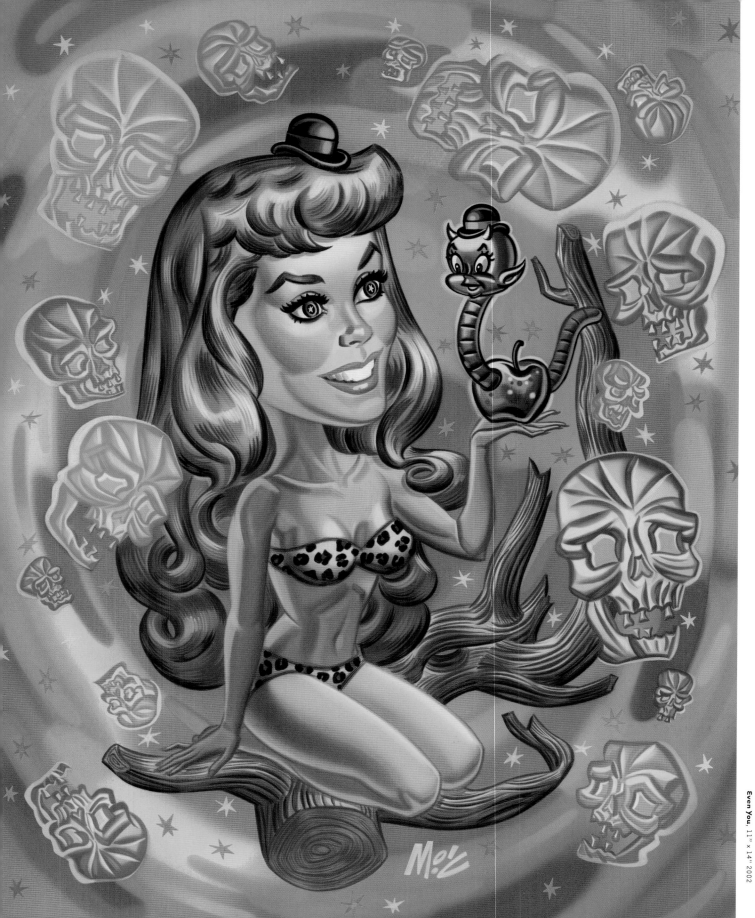

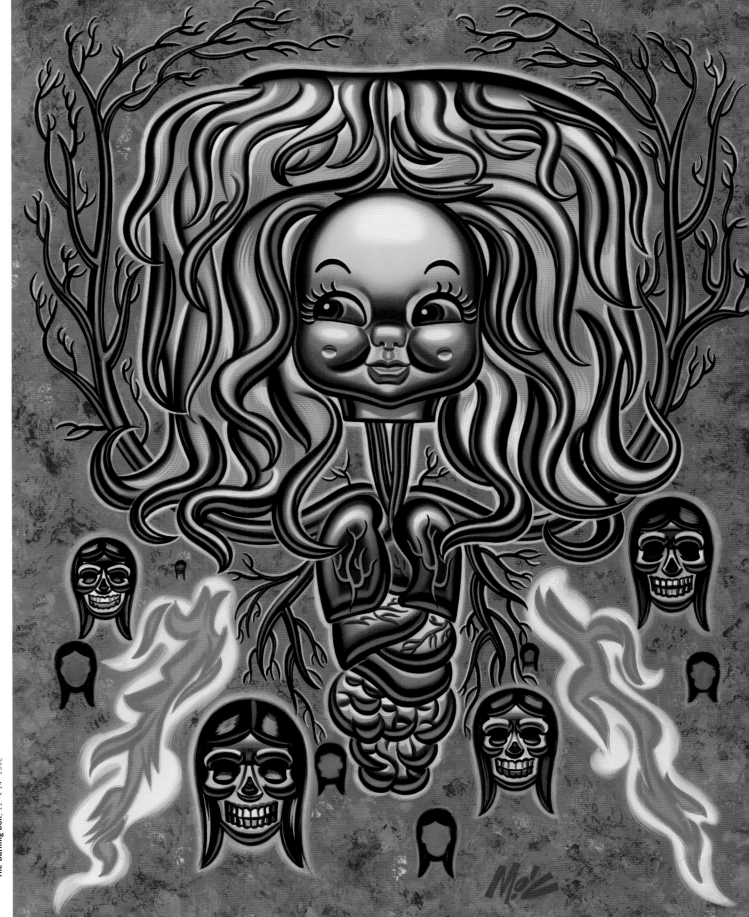

The Burning Doll, 11" x 14" 2002

KR:

Although KR grew up in a hotbed of graffiti activity, he cites one unsung hero as a major influence on his road to becoming an innovator in the field. "I grew up in Queens during the 80's when trains were still bombed. I didn't write back then, but my brother wrote and I knew a lot of writers. I used to ride the train to school; most graffiti was on trains or along train lines. Insides were killed with a lot of drippy tags in all different colors. Having drips in your tag was part of the style back then. I rode the B's and double R's to school as a freshman. This dude ROACHES TFV had insides on lock. He used to cop tags and characters all in ink. His tags were so drippy that they were often illegible, but that was his shit and you knew it. He was a big influence on me because he stood out from everybody else."

Moving 3,000 miles across the country created a good deal of isolation from other scenes for KR. This, as well as a desire for quality would be the catalysts that caused KR to create his on brand of ink, the suitably named Krink. "I moved to California in the early 90's. Shit was really different out there and street bombing was not as developed as it was in NYC. I wanted to bring drippy mop tag styles to the street. I tried a bunch of different stuff, but a lot of it was too sloppy or hard to control or homemade markers that didn't cap well and were messy. It took a while to figure out a good marker. Really, Krink came about kind of by accident. I had a style in mind; it was just a matter of finding the right shit. I came up in an era where you stole everything and you made it happen with nothing given to you. You took everything and you used different shit to work for you. It was easy to experiment because I never paid a dime for anything."

"When I finally came up with Krink, I held it down and only shared it with a few friends. We had the city on lock with mop tags. It became the standard in San Francisco. Living out in Cali, I never realized that what I had and was doing was really unique and effective. When I moved back to NYC in 98, I was a little older and it was/is really hot there. I started pushing my ink as a product, with a lot of help from my friends at Alife. Ever since then Krink is more widely available and I have had nothing but positive responses."

www.krink.com

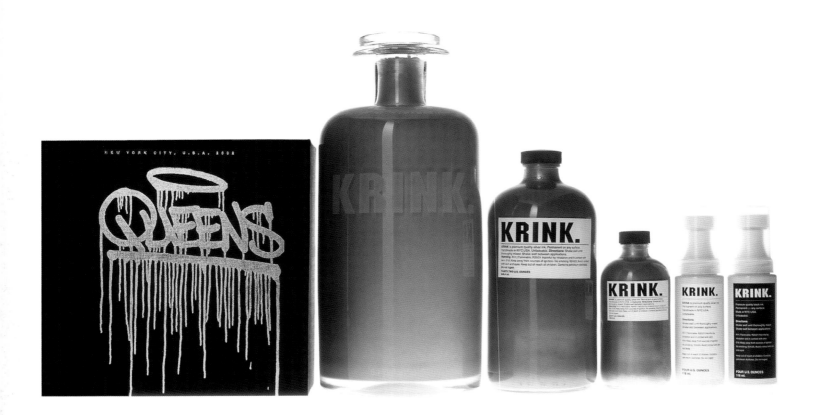

Queens box set. Collaboration with alife.
Handmade in England, foil stamp on clothbound board, routed
foam interior.
Edition of 100. Signed and numbered on back.
Box set A: Black mop, silver mop, 4 replacement tips.
Box set B: 8 ounce bottle of Krink, Silver mop, 4 replacement tips.

The Krink Magnum.
Handblown glass, sandblasted logo.
64 U.S. ounces. 2002.

32 & 8 ounce bottles.
4 ounce silver marker.
4 ounce black marker.

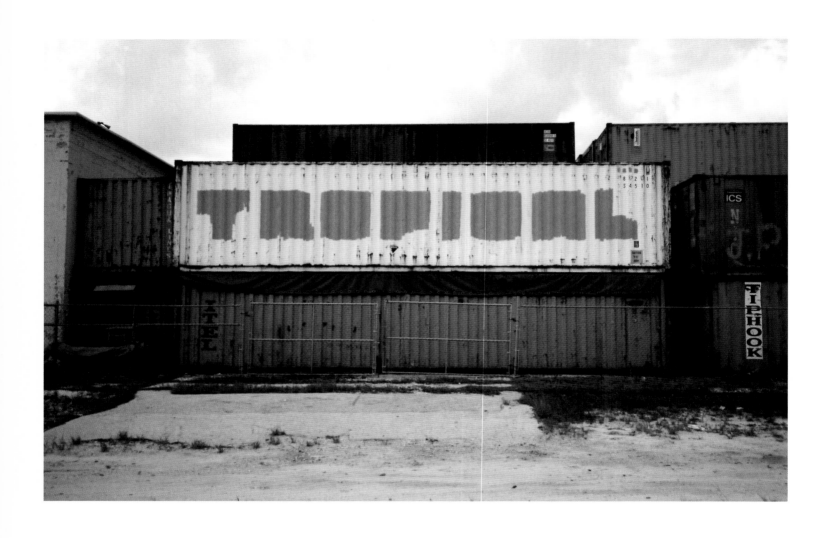

Tropical, color photograph, 30" x 40" 2002

Sunset, latex on wood, 36" x72" 2002

SABER:

In 1997, SABER proved that size does matter when he painted the world's largest graffiti piece along the Los Angeles River. Measuring 250'x55' and requiring 97 gallons of paint, the piece took him 35 trips — dodging cops, razor wire, and helicopters — over the course of a year to complete. This piece became SABER's most famous work, and now he has moved on to creating paintings that reflect time well spent in the graffiti world.

"A lot of my paintings are geared towards seeing reflections of emotions and instances, experiences and landscapes. I do paint graffiti on canvas every once and a while, but I feel that it belongs on a different surface because once you put a graffiti piece on canvas, it really isn't graffiti anymore." These ideas encapsulate the duality of SABER's artwork, striking a balance between painter and graffiti artist and creating a more expansive universe for his craft. SABER's work on these pages show that although graffiti is giving way to new ideas, it still remains an important influence.

For example, one of Saber's pieces on these pages is of the famous graffiti hot spot Bellmont. For Saber, this location has importance not just because of the graffiti on its walls but also because of the bigger idea that graffiti creates. "Doing a painting of Bellmont is a reflection of the places we've been and the places we go. Bellmont is a graffiti center to us as writers. The rest of the world doesn't have access to places like this and people don't know about them, but to us they're sacred. This painting is has a double meaning and a lot of contrast. Bellmont is this ugly horrible place to the rest of the world, but it also has some of the most beautiful amazing paintings anyone's ever seen happening down there. It's a constant process at Bellmont, a beautiful painting may disappear back into the environment when people recycle the wall, it allows the place to become a moving, ongoing piece of work. Bellmont is a working community that makes the place come alive."

"I did a lot of artwork before I got into graffiti, actually it's what made me interested in graffiti in the first place. I'm very serious about artwork and have been as long as I've known what artwork was. I think evolution is very important for graffiti artist, because most graffiti artists don't have the opportunity to move forward in their life on an artistic level because they are bound in traditions and set their ways. I see graffiti as a tool to further the progression of art on many different levels."

www.saberone.com

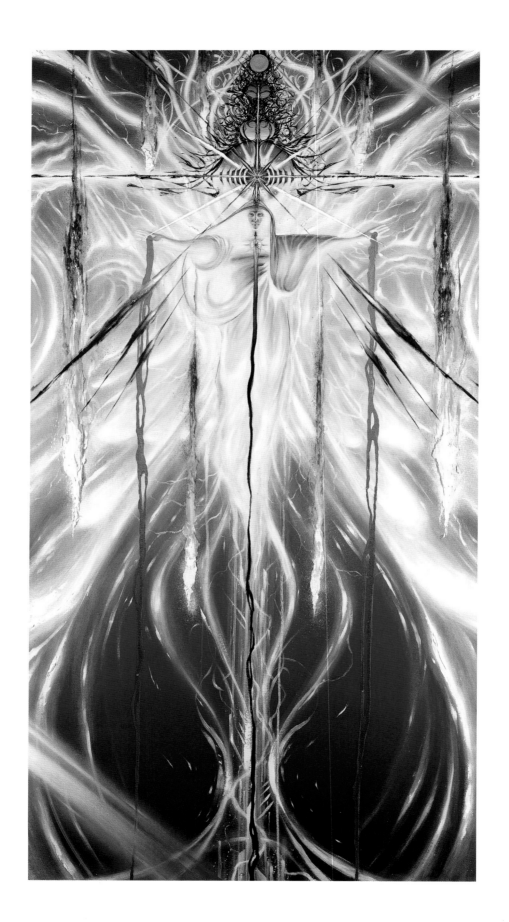

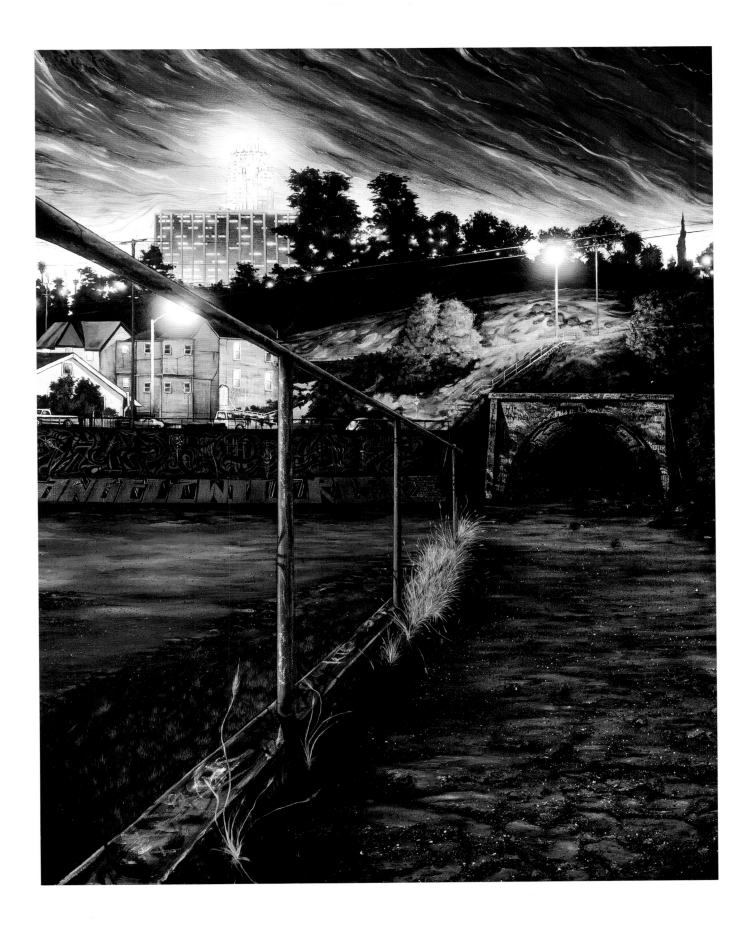

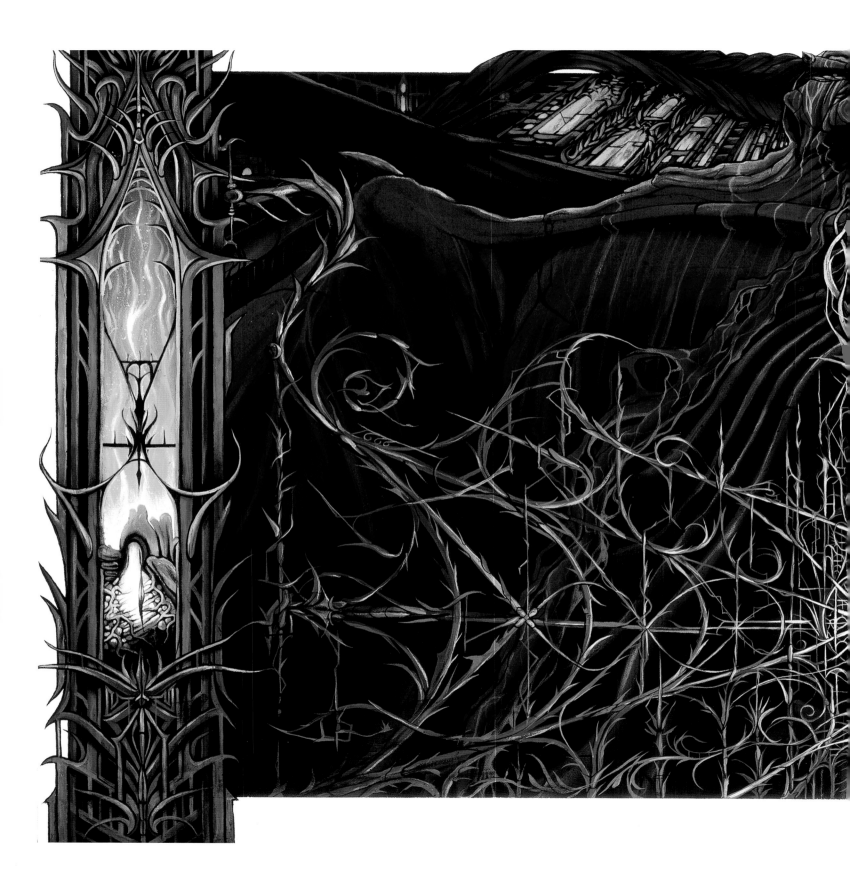

NƎWA:

He's the Caucasian you crave and his reworking of corporate billboards is some of the funniest shit you're ever going to see. He's NƎWA and he's proving to the world that you can be freaked out on drugs and not fall off any billboard scaffolding high above concrete and automobiles. It was actually graffiti that led to NƎWA's fascination with street art. "I used to ride the subways to New York and Philadelphia in the early 90's to buy drugs and beer with friends and I noticed this beautiful artwork called graffiti destroying every piece of property along the ride. Then once inside those major hubs of destruction, the graffiti was everywhere."

Reworking everything from the Trix Rabbit to the Nike "swoosh" into his billboards, NƎWA has the final say in what messages are reaching the average American consumer during their morning commute. "My art destroys private property and in most cases ruins the viewer's day. Nothing could be more rewarding than that other than the work of a serial killer." With installations promoting Jesus as a "Player Hater" and ones in support of domestic violence, you can see how popular NƎWA must be with Joe Citizen.

NƎWA's hobbies include, but are not limited too, shoplifting, doing drugs, trying to make it to work on time, and shoplifting on drugs. When asked about the awards that his work has won, NƎWA responds, "I have been awarded a matching set of silver bracelets in Philadelphia, New Jersey, and Kansas City. I'm also working on my first felony conviction for destruction of property and obscenity, so I should receive a free vacation at 'Club Fed.' I have also been placed atop the who's who list by local anti-graffiti forces." During the summers, NƎWA also teaches handicapped children how to swim at the local YMCA.

www.newamayhem.com

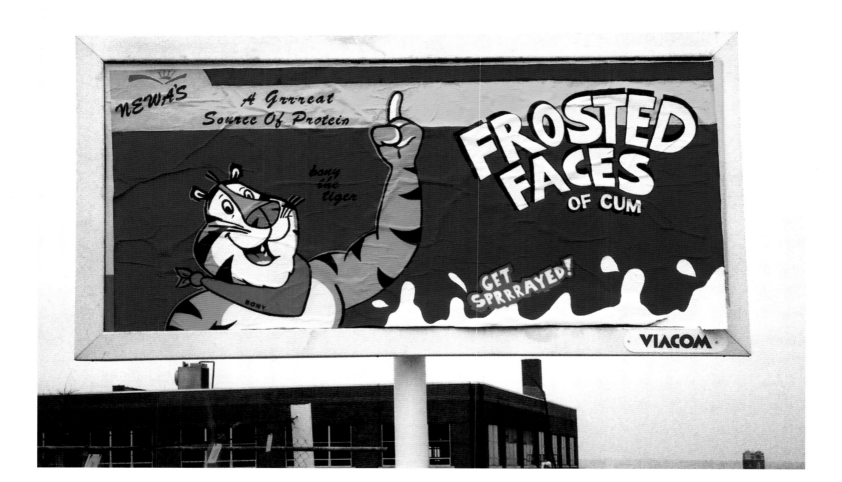

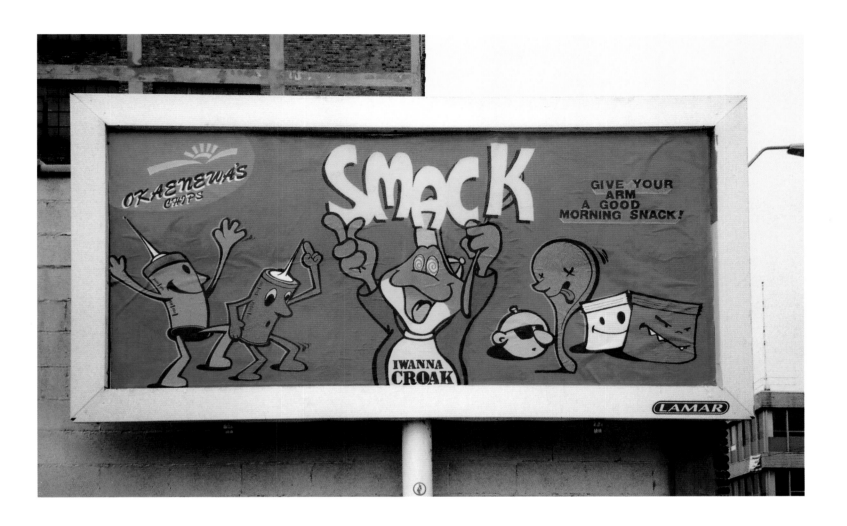

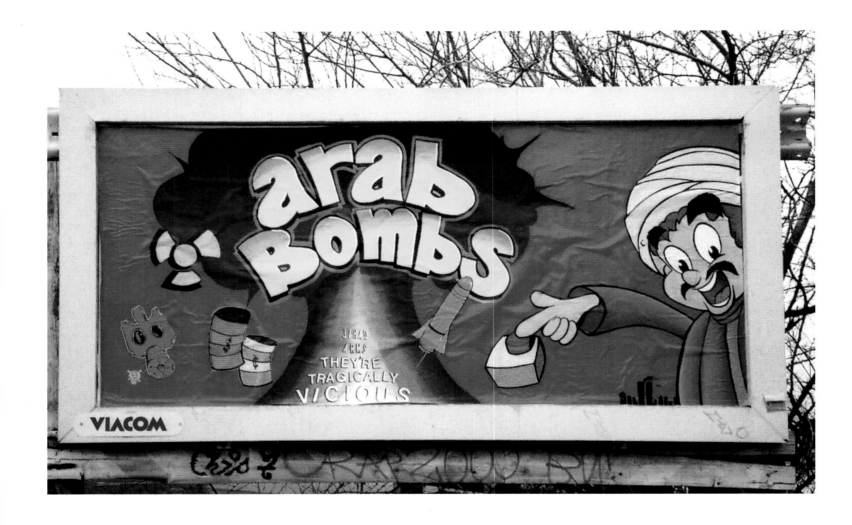

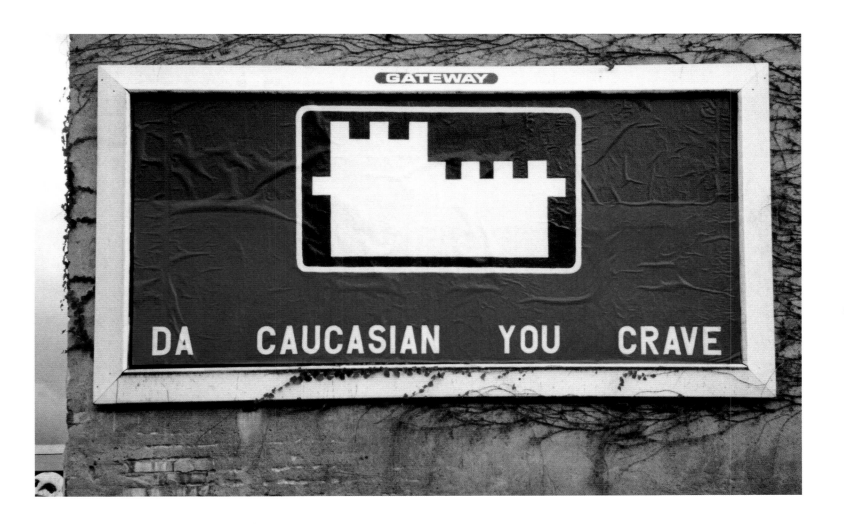

Chris Lindig:

Your life would kick ass if you were one of the guys that show up in Chris Lindig's artwork. You'd dress in a tracksuit, drive a Trans-Am, strap a sub-machine gun to your back, and stand on the backs of naked chicks. And that would all go down before your lunchtime hot tub date with two other naked chicks. Chris is a painter of a singular vision: his own. He claims to paint pictures of what he sees in his head everyday, which is pretty freaking scary when you think about it. "I like to think I portray a strange, true vision of colorful scenes of psychic visions that could happen." A graffiti artist who likes to keep that influence separate from his other art, Chris switched mediums for this book from wood to acrylic on construction paper. His hobbies include "bicycling, Trans-Ams, collecting old punk records, and naked chicks." He's also a skilled carpenter who builds furniture.

When asked to explain the evolution of his influences, Chris offers up a response that would have most doctors prescribing him Ritalin to control the attention deficit disorder. "When I was like 12, a friend of mine loaned me a stack of cassette tapes that had D.R.I., The Exploited, and S.O.D. on them. I was hooked on it right away, and I immediately threw my Ah-Ha and Culture Club tapes on the ground and stomped on them. Next, I got a skateboard and got booted from private school. Even though I don't own one, I think Trans-Ams are hot. Whenever I see one, I picture me and my dogs, and a hell of a lot of chicks wearing little or nothing, just mobbing around listening to Integrity loud as fuck. I was a bike messenger for a few years, which is how I got into bicycles. I think I got serious as an artist when I decided to put my visions down on paper with different colors. Furniture building is fun, but you have to be patient most of the time. I've made a bunch of different things like coffee tables, bookshelves, and custom projects like my punk rock entertainment center. It's tight because only punk records and a stereo are in it."

www.newimageart.com

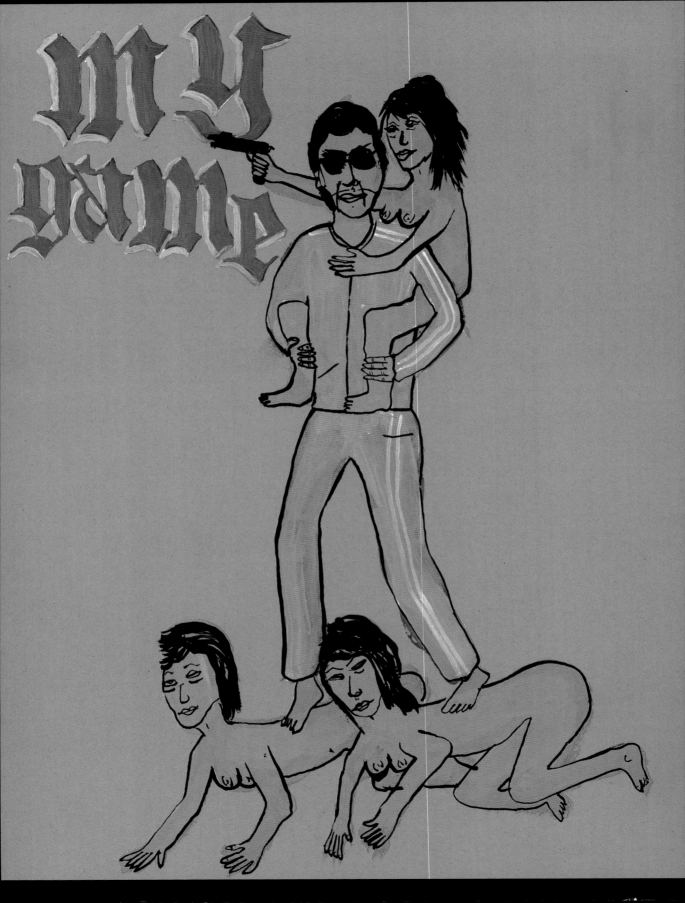

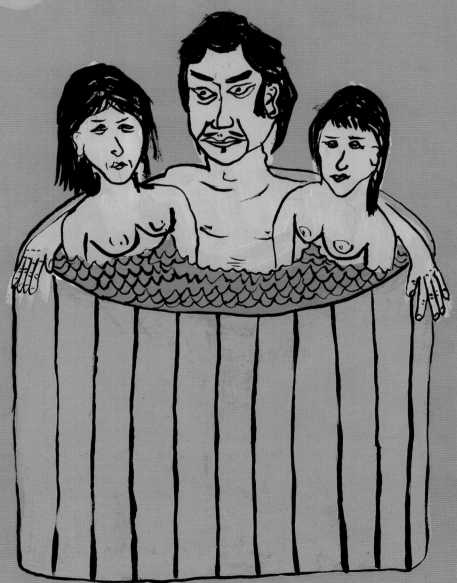

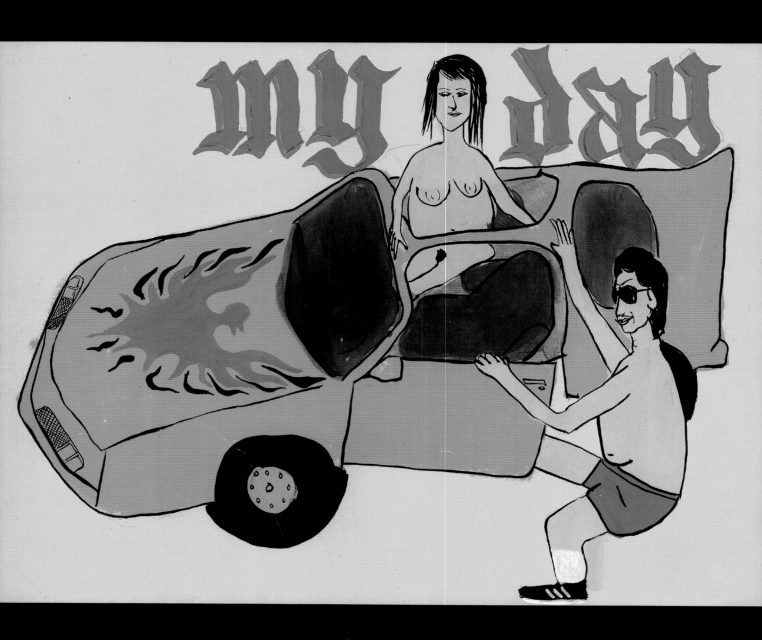

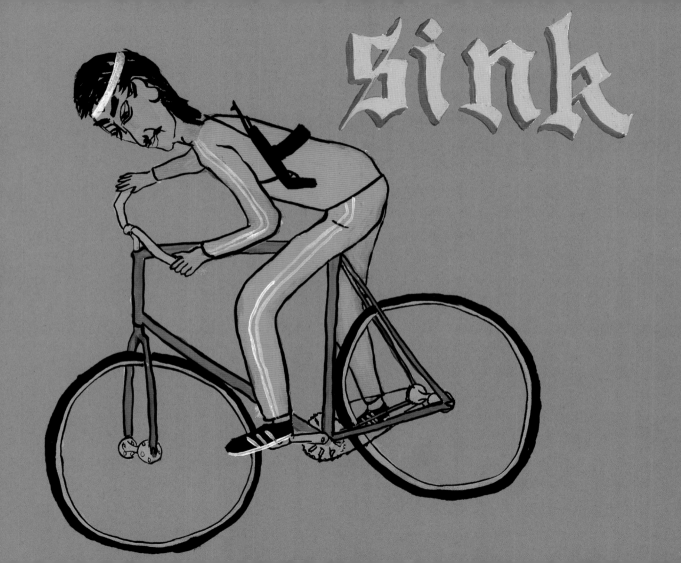

CYCLE:

Known for his skill and scope, CYCLE came up as a graffiti artist in Washington, DC, San Francisco, and New York City, his current hometown. He is one of the most educated artists on the scene, with a Bachelor of Fine Arts from George Washington University in Washington, DC, and a Masters in illustration from the Academy of Art in San Francisco. While earning these degrees, CYCLE infused himself in the local graffiti culture, an experience that combined with his studies to give him a well-rounded view of the art world.

"I wanted to prove myself legitimately as well as illegitimately. I can work within the system to accomplish things, but I can also work outside and around it. I went through the educational system to prove that I can work within those confines as an artist, but I've also been able to achieve things on my own by making things happen for myself. School taught me that art is about repetition, you need to just keep doing and doing. I think a lot of people do one or two things and they expect to have doors open for them, and it's not like that. I learned to believe in what I do and to keep working at it. The art world is like anything else; it's a hustle. Just because you have a degree doesn't mean you're destined for success. There are a lot of people without degrees that are really successful because they found a way to do it on their own. The education helps because it gave me a different point of view, but it's not the be-all-end-all. Either with or without the degree, neither way is perfect with out of a lot of hard work in between."

Now a full time designer, CYCLE incorporates graffiti into his fine art work. "It's an important thing for me to do. Graffiti was my first love and I see it a lot like the skateboarding and punk rock cultures. A band like the Clash came out of an underground scene, and kept doing their own thing and eventually the world made a path to their door. There was no point where they decided to crossover, they just believed in what they did and as they evolved as musicians and people they pulled in other influences. It's the same thing with my art. It started as graffiti, a kind of punk rock art that's underground and rebellious. That's where the energy for my artwork came from, and as I evolved as an artist and started pulling in other influences graffiti stayed with me because that's where the first spark came from. If I can't do it in the streets anymore, I'm just going to find new ways for it to evolve into my design or my canvas work. Graffiti is still the bastard child of the art world, but it carries a lot of energy with it that kids grab onto and use and that helps it to evolve. I still see it as an underground art form but it's leaking into design and fine art in different places."

chriscycle@hotmail.com

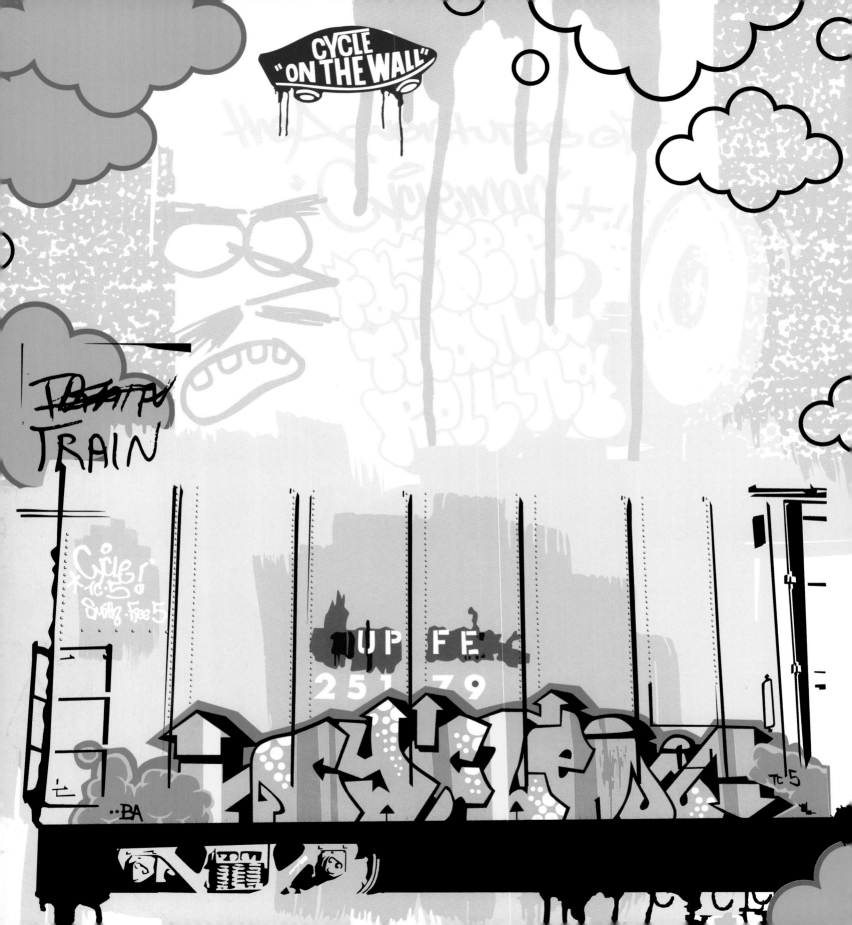

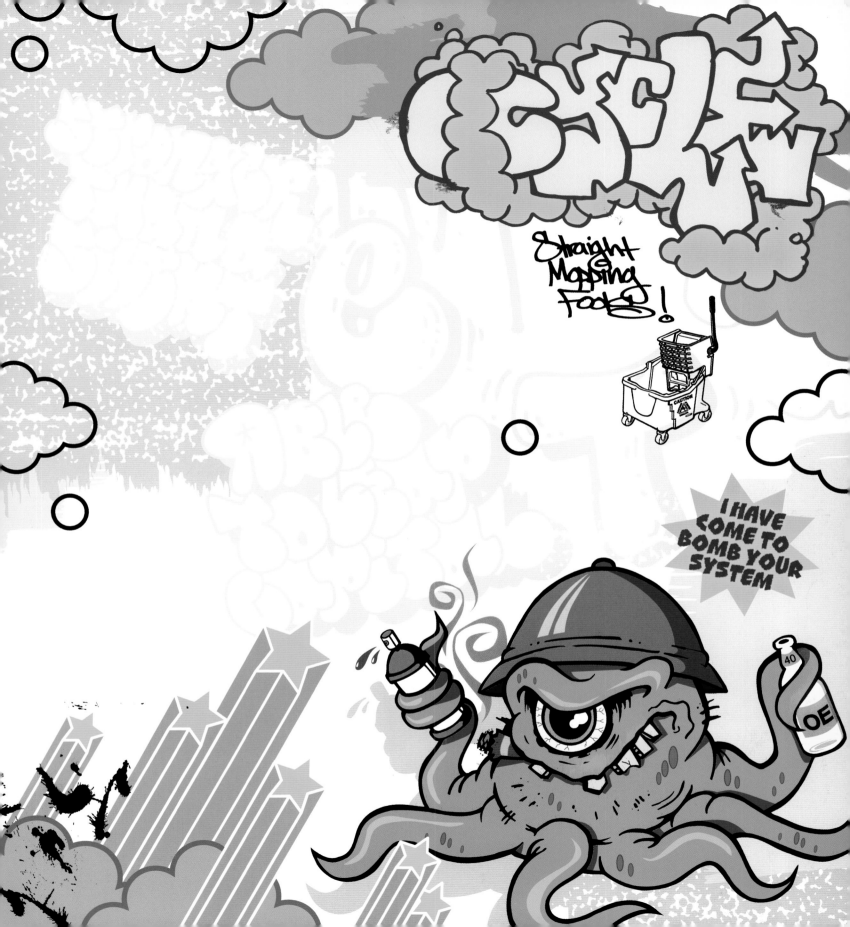

BIGFOOT:

You have to have lived in New Jersey at some point in your life to fully understand how an obsession with the band Kiss, graffiti and a mythical creature that lives in the woods can be funneled into one vision. Like a mad combination of driving to a hip-hop show, getting stoned in a van, listening to Love Gun, and talking to your buddy about that creature your dad saw eating a deer in the woods last summer — that is the kind of effect New Jersey has had on the art stylings of BIGFOOT. "I always felt different from everybody, like an outsider and I was always into nature and spirituality, like shamanism. I just wished I was some dude living in the forest and didn't have to fuck with society and aesthetically that's kind of what BIGFOOT is in relation to the human."

"I identify with a relentless fury and extreme characterization that embodies all that is Kiss. The alter egos the members of Kiss created possessed them, they became more than human.... real life comic book characters. This is something that inspired me to take on the BIGFOOT persona. My work is all about the characters I draw. I try to give them life and strive to give them as much personality as I can. I'm always aspiring to the four Kiss members' level of potency in terms of their characters."

So exactly how heavy metal was New Jersey in 1986? "There's so much to talk about. I skated with this guy in my hood, Marcus La Rock, and we'd ride in parking lots doing bonelesses with a boom box blasting Metallica, Whitesnake, and Iron Maiden. He was always drawing "Eddie" the Iron Maiden character, but his version was called "Kamikazi," and he only wore red, black, and white. He drew red kamikaze suns on everything and wore a painter hat with one on it. That's when metal was so pure, especially in Jersey with the chicks with big hair and skintight acid washed jeans. Wish I could go back in time...."

bigfootone@earthlink.net

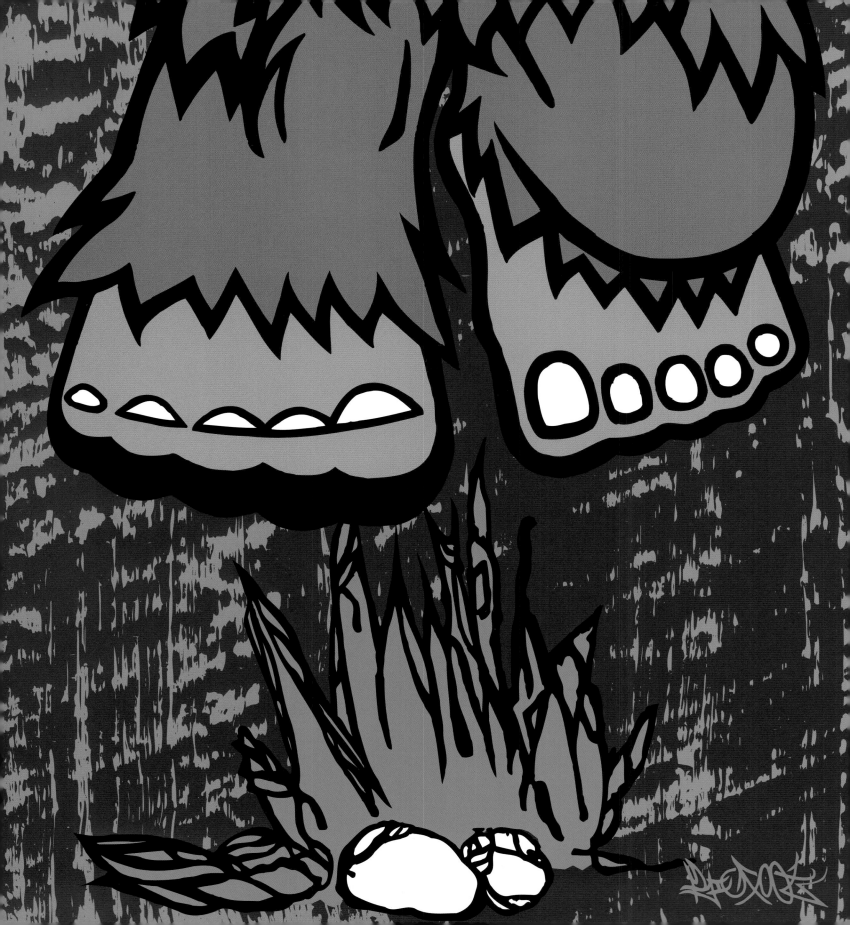

FREAK OF NATURE///

FREAK OF NATURE///

FREAK OF NATURE///

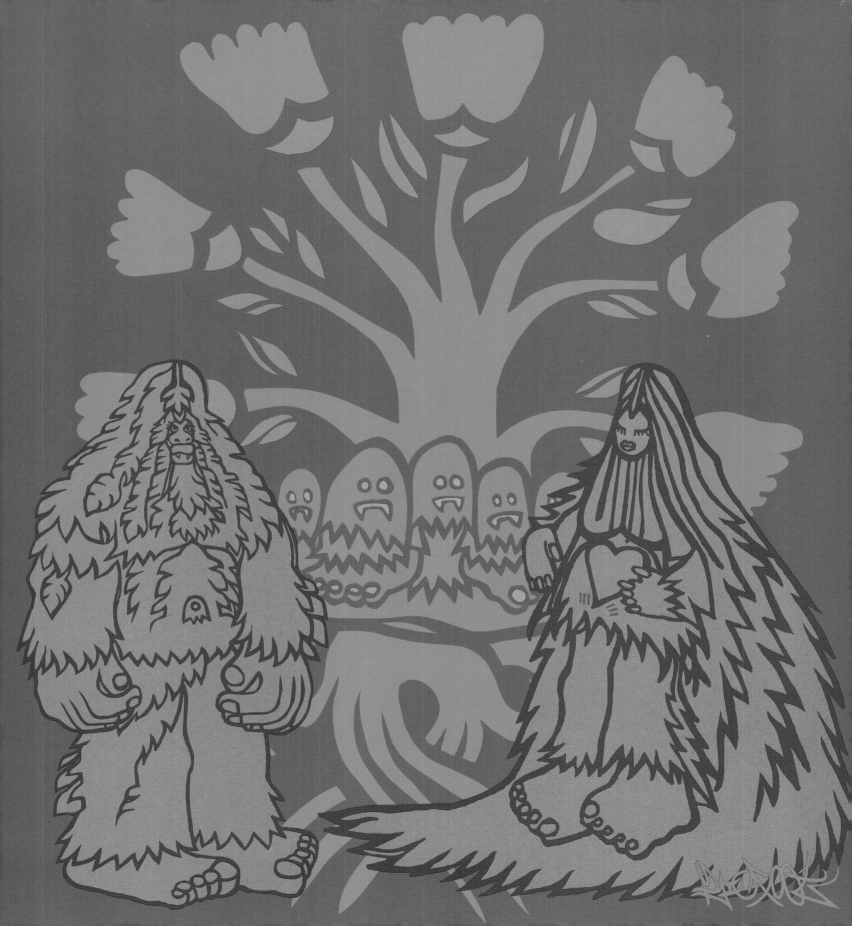

Carlos Batts:

"I approach shooting girls the same way I approach shooting a band, I try to come up with the best ideas and try to avoid it being about objectification. I try not to just concentrate on it being about the hole or the breast, how pink she is, or anything to do with it being in a sexual manner. I try to just get a good print and tell a good story. Granted if she's naked and in 7-inch heels it's obvious what I'm doing, but I try and approach it differently." So says Carlos Batts about his acclaimed ability to capture the female form in his photography, showcased in dozens of magazines and two collected volumes.

It's interesting then that given his success shooting naked women, he chose to not include any on these pages. "I didn't use my girls because I wanted people to see what I really do. The girls have dominated so much of my work that people don't even see or know about how I started out doing comic books and that I'm actually an illustrator and that I paint. I'm really proud of the fact that I'm recognized as a photographer, but at the same time I didn't want to do four more girls here so I get stuck with everybody thinking that's all that I do."

A man who also knows how to relax, Carlos has an interesting end of the week practice: "Dick-Out," or D.O. "D.O. is a philosophy about kicking it on Sunday, watching the game, hanging out with my lady and my dog. It's not about how I'm a nudist, it's just… when you're D. O., nobody's going to stop by. You don't accept calls when you're D.O., you're not trying to hear anybody. It's an ideology I'm trying to continue, it's like a cross between leisure and pimpology."

www.cbattsfly.net

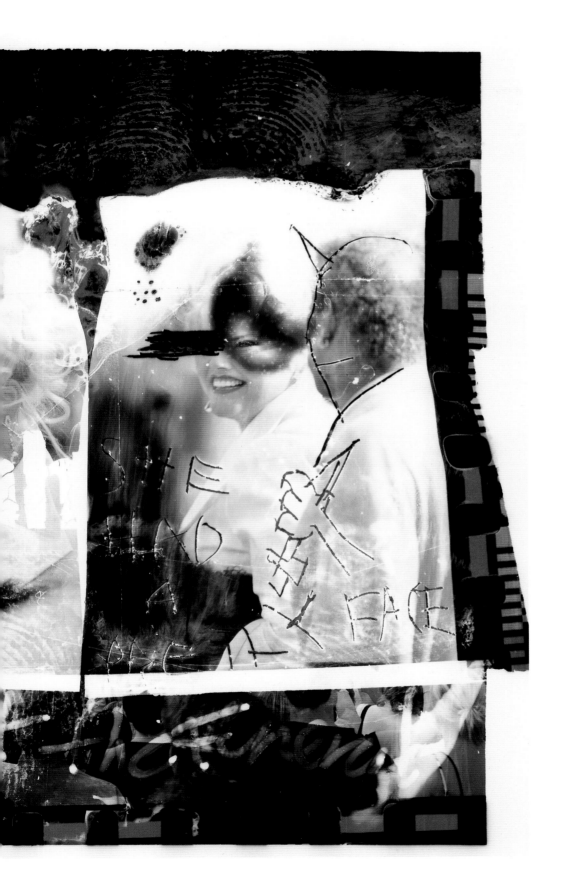

Chris Capuozzo:

For Chris Capuozzo, the line between underground art and the work of his design firm Funny Garbage is a thin one. For example, to him painting a graffiti mural requires the same kind of detailed forethought as a project for one of his clients such as Nike or Compaq. He sees similar artistic constraints in the way you would organize a comic book panel within its borders, and the way you have limited space to organize a website within the computer screen. This broad-minded thinking translates well into Capuozzo's contributions. "I wanted a way to bring together these things I love to see: letter forms, found art doodles, album cover art, comic book art, etc.... I wanted to make an open ended system allowing for a big variety of imagery. I think it makes for an interesting kind of narrative."

Considering his desires to draw so many different styles together into new art forms, it should come as no surprise when Capuozzo describes his dream project. "I would love to stage a play using an early Fantastic Four comic book as the story. All the actors would be 10 years old. Imagine a kid that age dressed up as the Human Torch, or Doctor Doom... that would be wild! You'd design sets for the negative zone...imagine the transformation of Ben Grim from human to being the Thing with a 10 year old. It would be beautiful."

For someone who has one of their sketchbooks on display at a biennial design show at the Cooper Hewitt design museum in New York, when you hear Capuozzo's rather trippy earliest artistic memory, you have to wonder exactly what's in said sketchbook. "When I was six, I was playing on a dirt hill and found myself hallucinating on the forms of the dirt. I was seeing caves and imagining cave people living and existing there. It seemed so real, all the little holes in the dirt, the pebbles, it was kind of spooky."

chris@funnygarbage.com

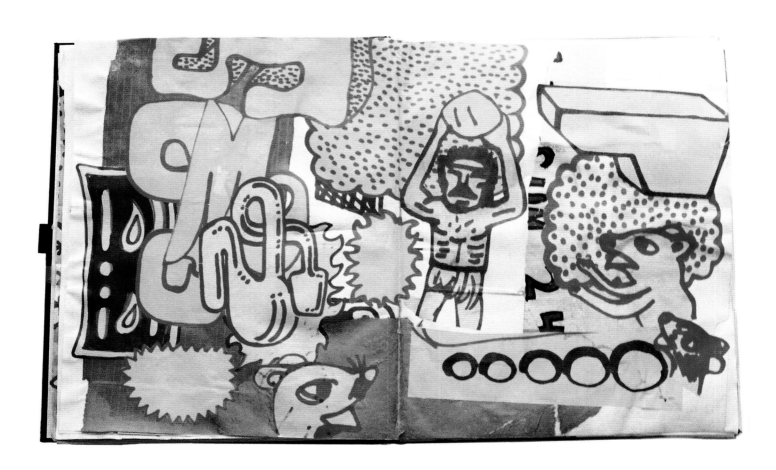

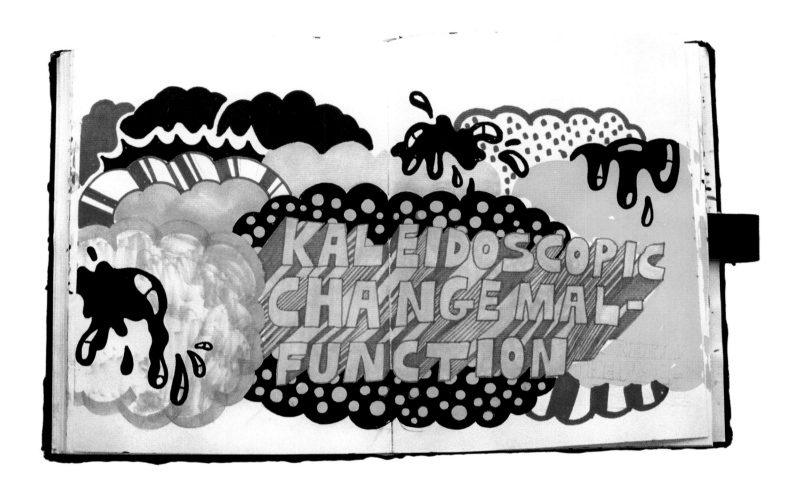

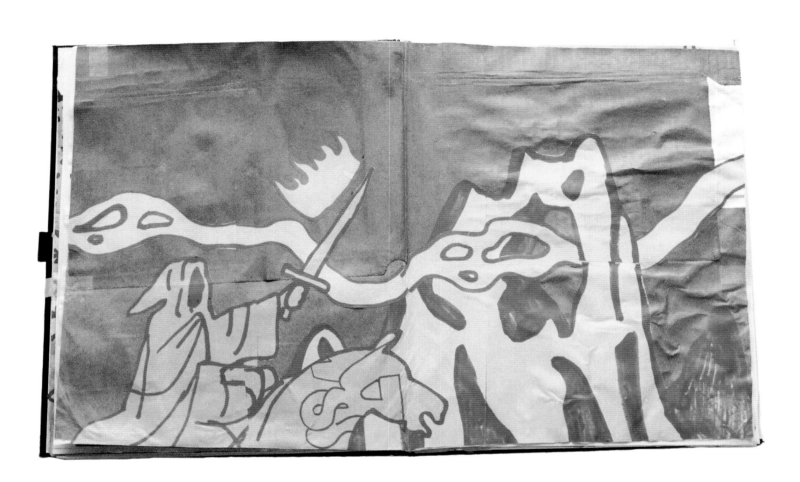

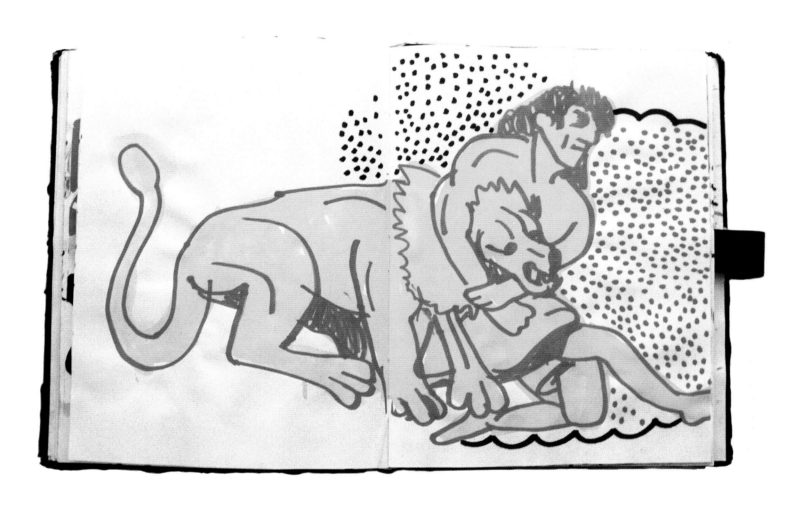

UPSO:

Where an artist lives is bound to have a serious impact on their work. For some, the local landscapes of Paris, New York, or Milan have been transformed into beautiful paintings and photographs. For others, a less desirable location has caused them to create art as a means of surviving; and to reach out for some culture in what is otherwise a wasteland. Take Toledo, Ohio for example. For UPSO, this barren northwest chunk of the state has forced him to become more creative. "I don't have anyone to interact with as far as art and design. It's all dead cities with no nightlife, surrounded by cornfields. It's an hour south of Detroit, so sometimes I go there for shows and stuff, but Detroit is scarier than Ohio. I do a lot of self-portraits, mostly because I don't have the most inspiring surroundings. I also find myself turning to the Internet because it's full of people that are interested in more than one type of art: graphic design, illustration, graffiti, and all the different styles within those art forms. I guess I actually get a lot of inspiration from being here in that it forces me to reach out and try new things."

Along with the bland environment of Ohio also comes bland people and even blander jobs. "All of the design jobs I've ever had have been dealing with clients who are like roofing contractors or building material companies. They want the most boring shit ever. There aren't even any creative solutions to the design problems they have because I'm working with logos that already exist, and you're just updating and plugging in new information. It's nice to have a job, but I need an outlet to do other stuff. It's like this guy I met recently who wanted me to work on his website. So he takes a look at my site and wrote me an e-mail all confused like, 'I reviewed your website but couldn't make any sense of it. Have you completed any websites for businesses? None of them are very fancy in terms of animation of artistic images.' Most of the people I interact with are terrified of any real ideas."

www.upso.org

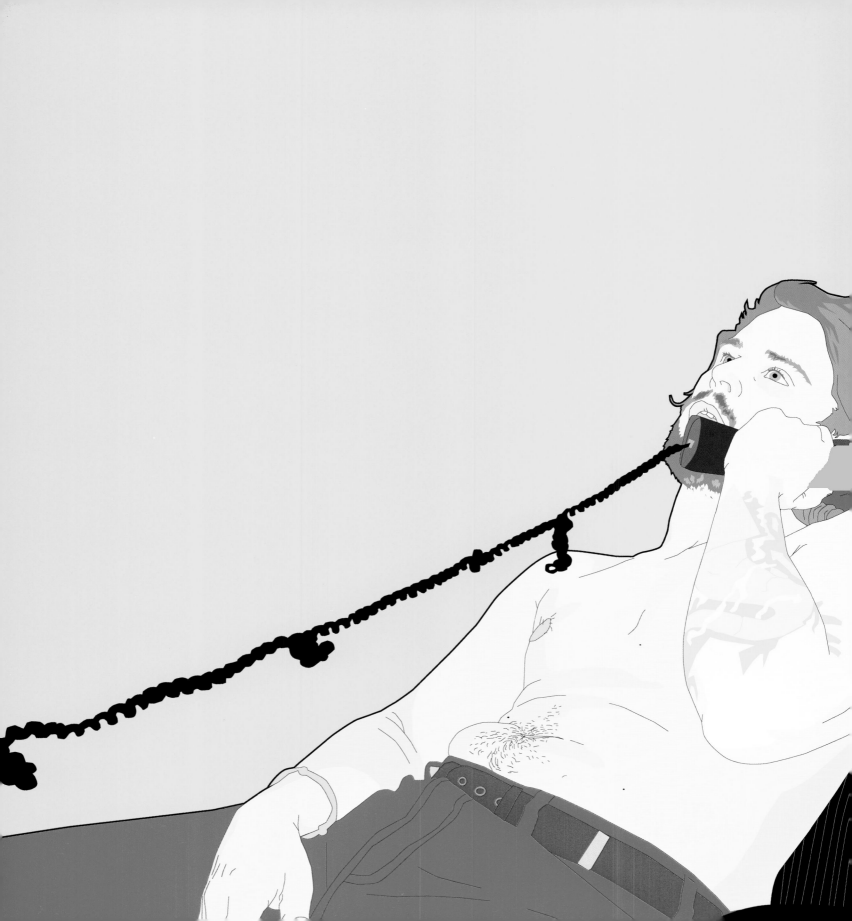

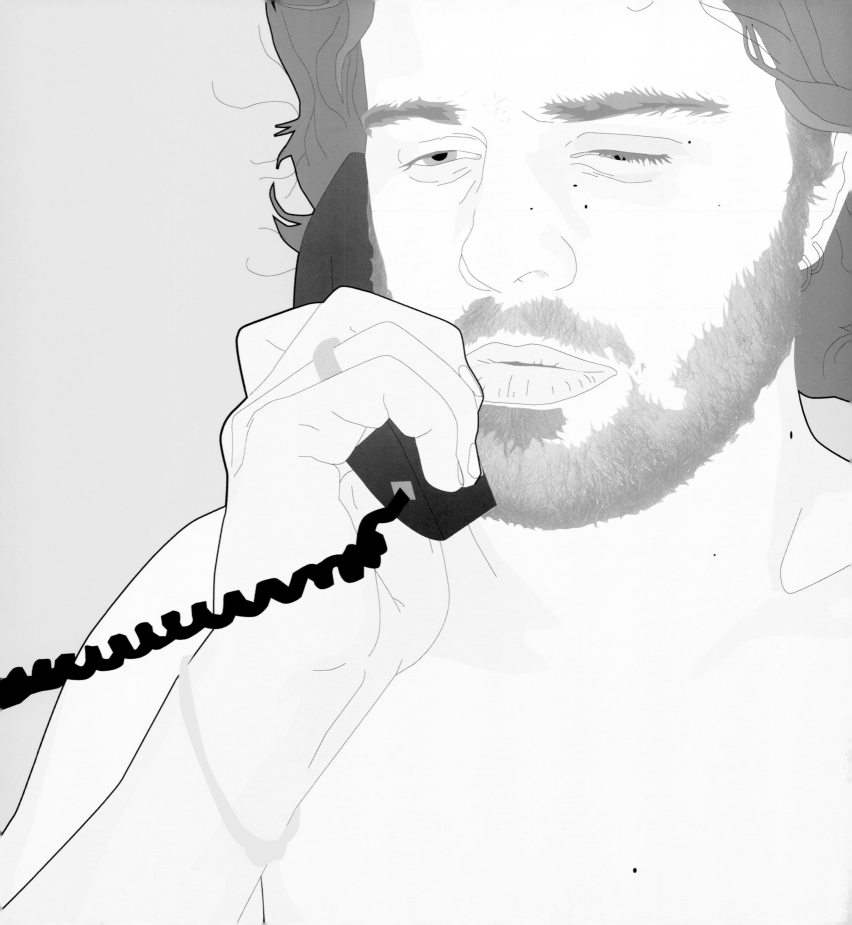

Joseph Whiteley:

Almost every artist has had to endure one hideous job or another to pay the bills while they concentrate on their art. For Joseph Whiteley, that job took on a surreal nature. "I'm the king of odd jobs, but there was this one that was really odd. I modeled naked for old ladies in a classy section of the Bronx. I was a life model for this class a friend of mine teaches and it's full of old rich white women. I had to sit there for three hours with this space heater.... I'm this really awkward skinny dude with tattoos, they were probably pretty bummed when they saw me. They were also pretty bad at art. What made it even stranger was that it was in this community center, in this elementary school type classroom, and there was all of this weird kids art and crafts up on the walls and all of these old chicks. It was a pretty weird situation."

This is a fitting story considering that Joseph's art concentrates primarily on the human figure, or at least a variation of it. "I'm trying to learn the figure in a classical way, get the academic side of it down. Then I want to take what I learn from that and put my own weird, tweaked-out twist on it. The grotesque is more appealing to me than the glossy, pretty look that you always see. At the same time without being too over the top with the shock value. I'm not going to paint a woman with like, eight tits and a dragon coming out of her pussy or something." With a strong background in both graffiti and traditional oil painting, Joseph focuses on combining the two to create images that are both contemporary and casual.

"I try to use everything I learn from life drawing and painting to create my own surreal, tweaked-out world from it. I'm sick of always seeing the standard, well-executed paintings of still life and portraits of young, pretty looking people. I'm more interested in exploring the awkward and grotesque, what lies beneath the fake, glossy surface that we use to hide what's really going on with ourselves."

bigmerltsc@hotmail.com

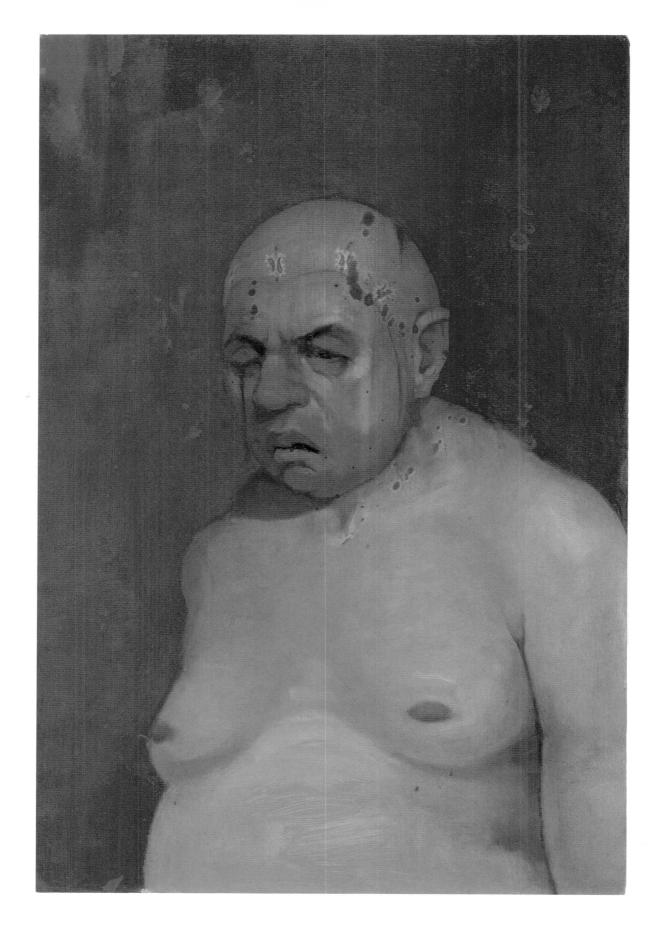

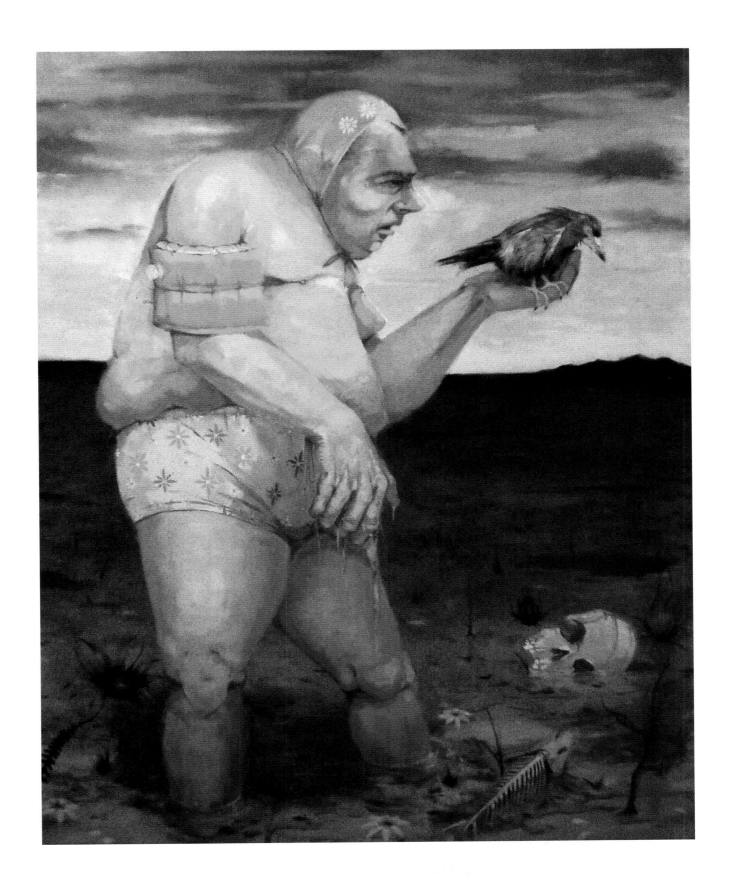

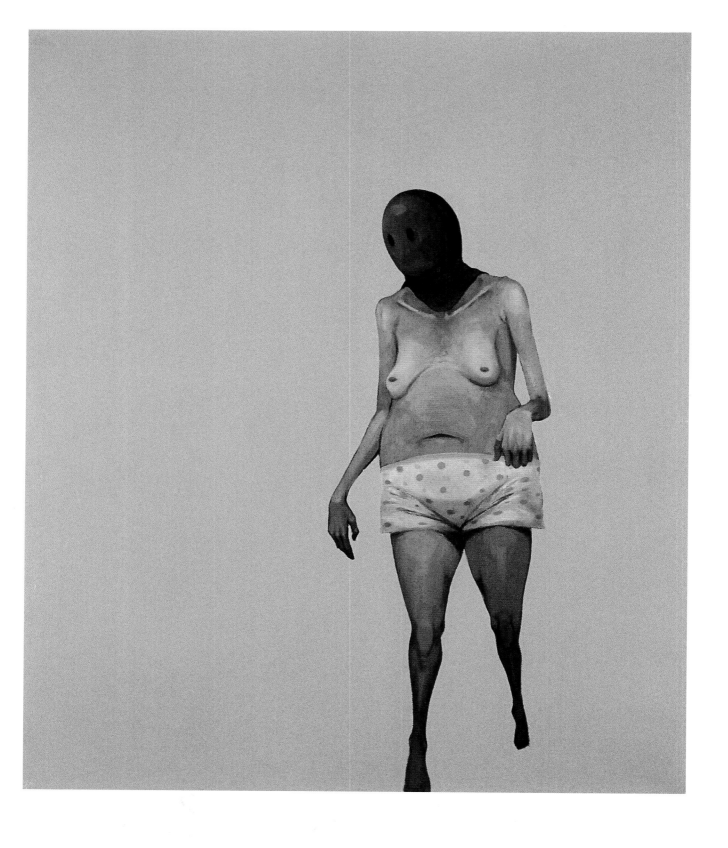

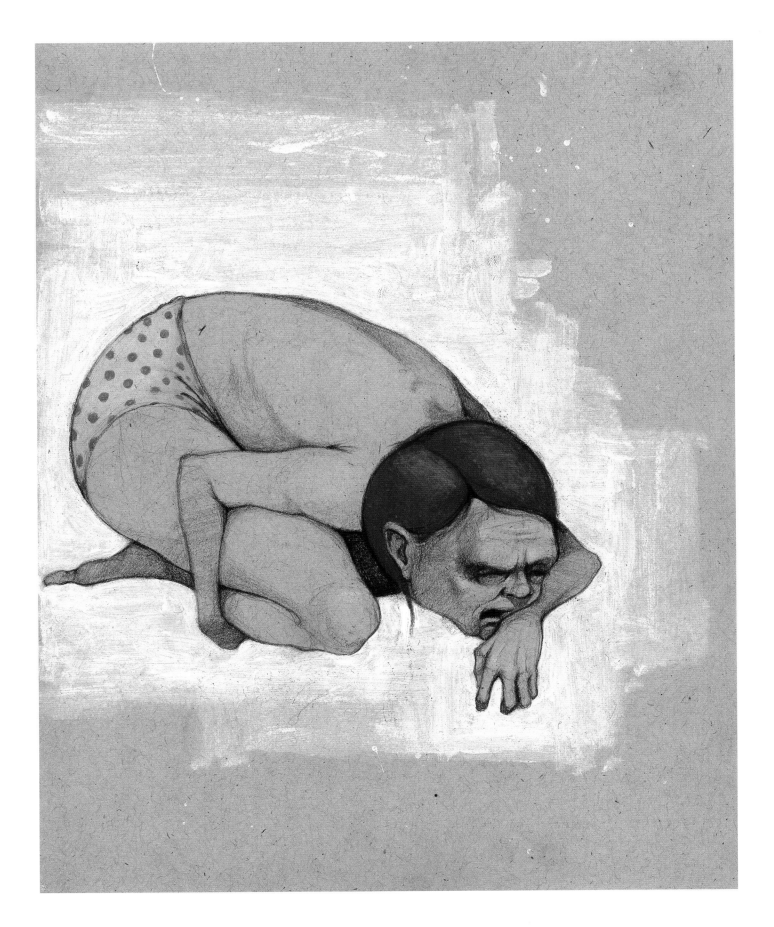

Jim Houser:

As a teenager Jim Houser began scribbling poetry and drawings in his journals. Driven by impulse and inspired by words, those scribbles grew into crisp, colorful paintings with text. The idea to log his creations in journals was something that Jim had been practicing even before his teen years. "When I was really little my dad would bring me home sketchbooks. He insisted that instead of drawing on loose pieces of paper that I draw in these books because he thought that some day I'd want to look back at my art. And he was right because I still have all of them to this day. A lot of the stuff I do now references what I was doing back then at age 9 or 10. I'll look through the books and take ideas out and see the way I was looking at things back then."

Jim's use of words in his paintings is a staple of his work, but it has also given some reason to compare him to a certain other type of artist who also use words in their creations. "I don't think of myself as a street artist. People who do stuff on the street have really particular ideas of who is a street artist and who isn't, and I don't look at things that way. There's stuff that I've done on the street, but that's not my whole deal. There are people whose art is on the street and that's part of how cool it is because you're like, 'wow, look at this awesome thing that's not going to be here for very long.' The only part of my art that I feel shadows that is the fact that I've become more like an installation artist than just a painter. What I do in galleries, where I try and make this little world and at the end of the month when the show is over, everything gets buffed. Just like it would on the street. It only lives in photographs or in people's memory. I get lumped in with street artists because there are people who are older than us don't understand the full scope of what they're seeing and it's a good way for them to categorize everything they see that's at all similar. Look at someone ZEPHYR or FUTURA that were doing stuff on the street and then look at how Basquiat was looked at as being a graffiti artist as well. They knew each other and had similarities in their art, but were different kinds of artists."

www.newimageart.com

170

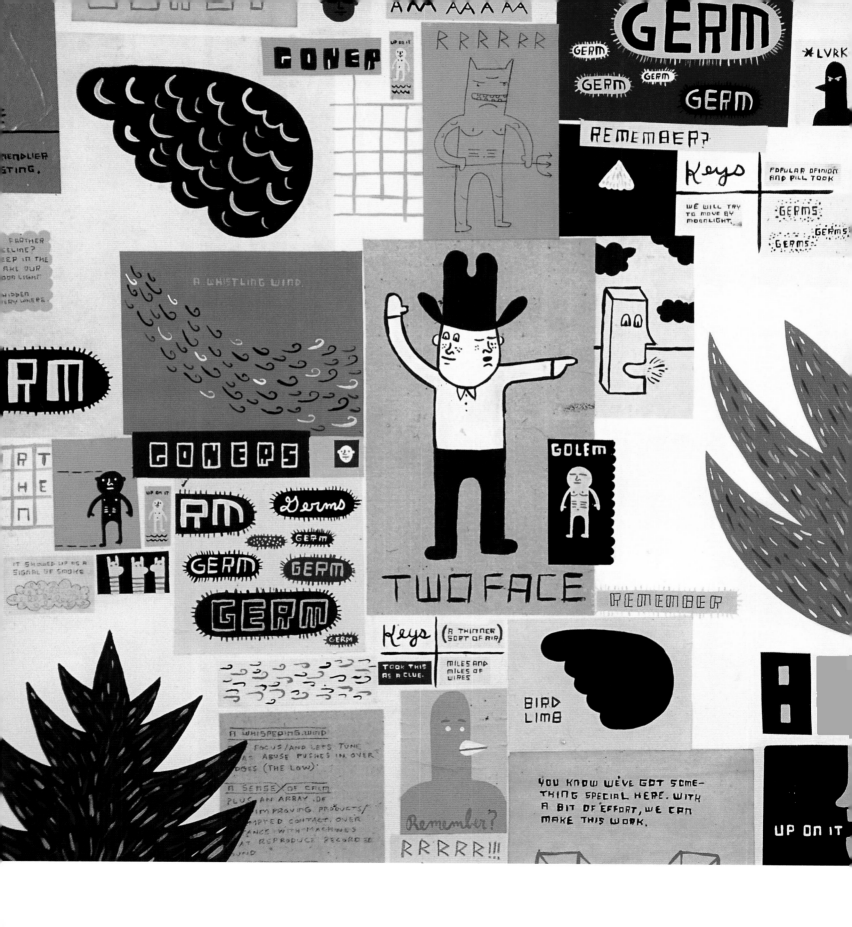

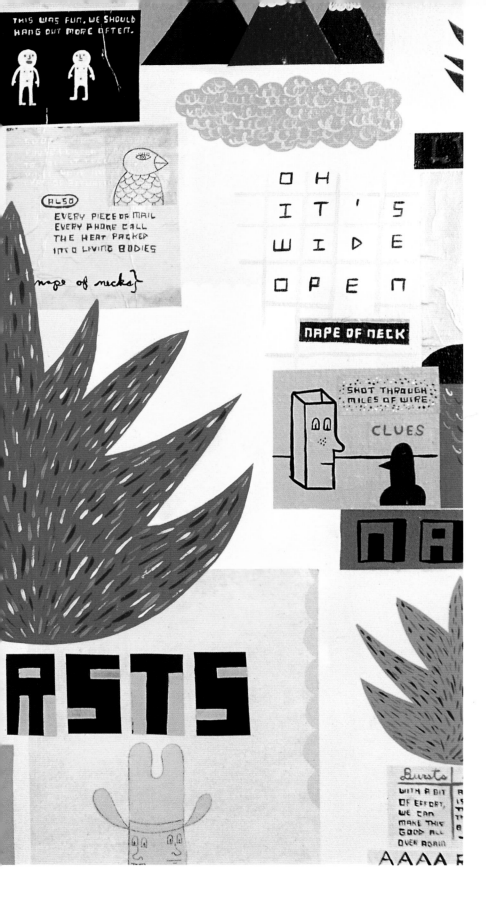
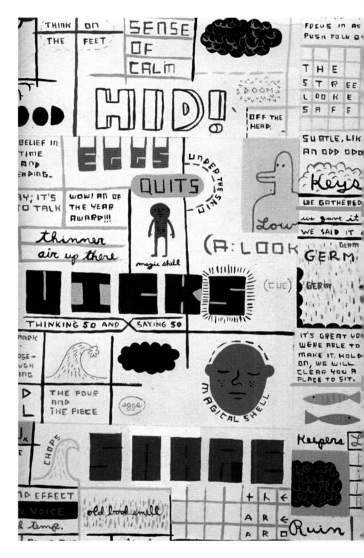

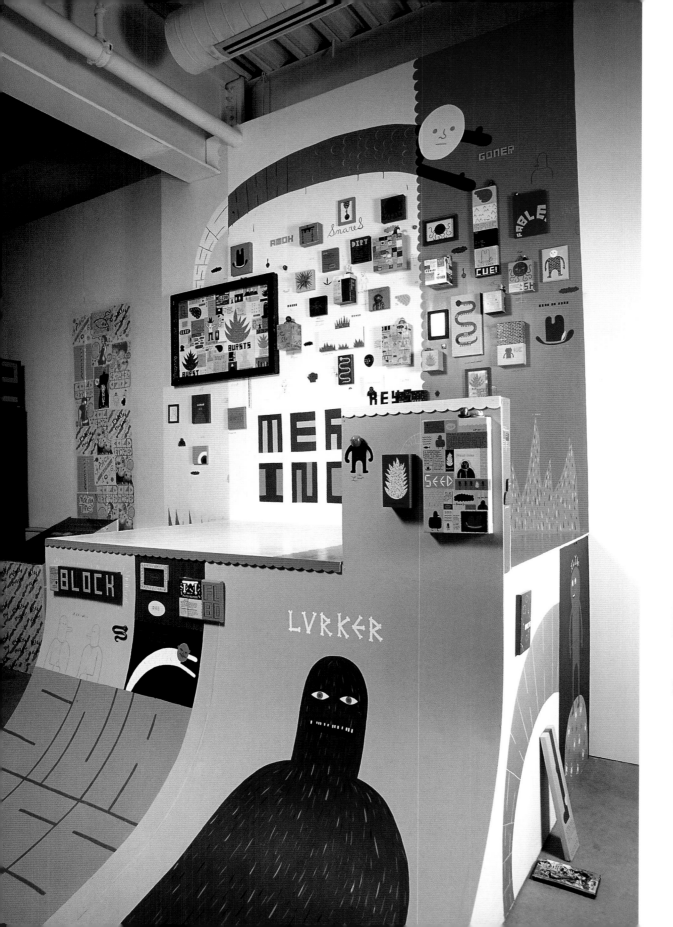

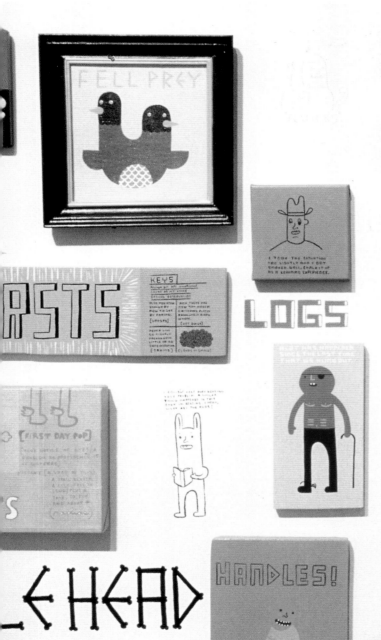

REVOLT:

REVOLT started his career as an artist writing his name on the sides of New York City subway trains in the late 70's. At the time he was partnered up with such graffiti legends as BILROC (RTW President), NE/MINONE, RASTA, QUIK, and ZEPHYR. A few years later, while attending art school in Baltimore, REVOLT played a huge part in kicking off the city's graffiti scene. Still an active graffiti writer today, REVOLT has become a legend himself and sports the alter ego "The Evil Dr. Revolt." "Evil is everywhere, and I try to be everywhere I can. I try to be all I can be, everywhere I can be. It took many years of studying and on the job training in the trenches of graffitidom to become who I am. The trenches were dirty, smelly and filthy."

"Graffiti got me into lettering, which I had never really been all that interested in. The classic limited aerosol pallet we used of black and white, silver and red, Jungle Green, Icy Grape and Cascade Green would test our creative ingenuity. The raw primitivism that's associated with graffiti has been stylistically co-opted by a lot of people. Especially since it's been accepted by all of these art schools as an important movement of the latter half of the 20th Century. How it influences my work? I live and breathe it. I don't consider myself an originator. That's a label that people have applied to me. I'm honored to be included in such a nefarious crowd and hope we can keep graffiti on the rise to the actual height it can aspire to."

REVOLT has developed a style that mixes graffiti and comic book-style illustration. "I was always into comic art, so it seemed like a natural extension of that. People come to me with an idea they want rendered and I try and find that happy medium. Comic art was a big influence. I grew up watching Batman and Superman on TV, reading all the old comic books, especially the Marvel Age when Marvel created Spider-Man, the X-Men, the Hulk, and the Fantastic Four. There was also the good horror stuff like Creepy, Erie, and Vampirella. And of course the EC comics and Mad magazine. Comics still play a role in what I do today. I'm working on a couple of comic projects right now where I'm doing illustrations, coloring, inking, and some logos. I'm still into the flavor of comics, like graff, the characters, the mythology, and the iconography."

revolt@nytrash.com

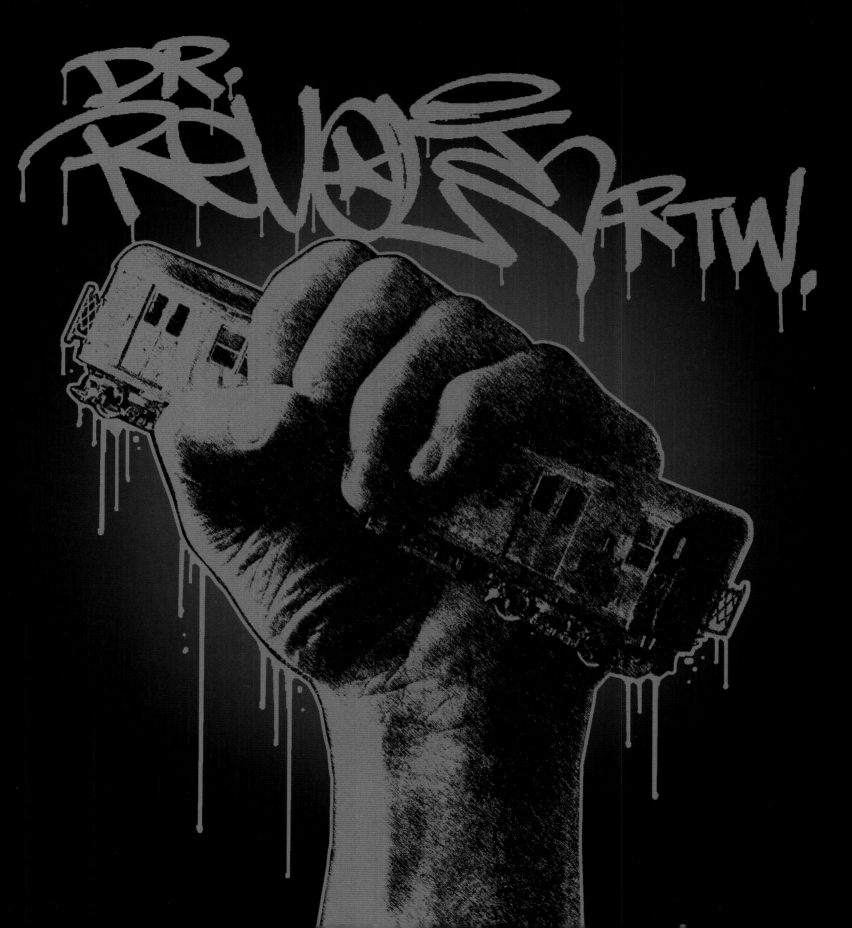

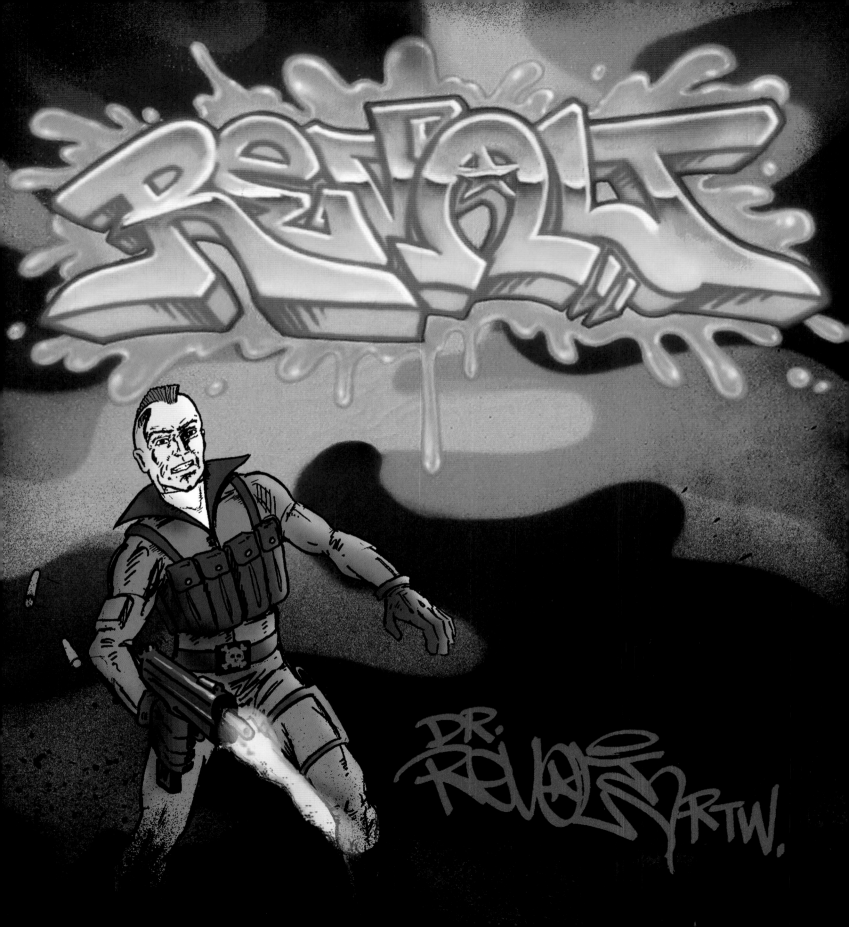

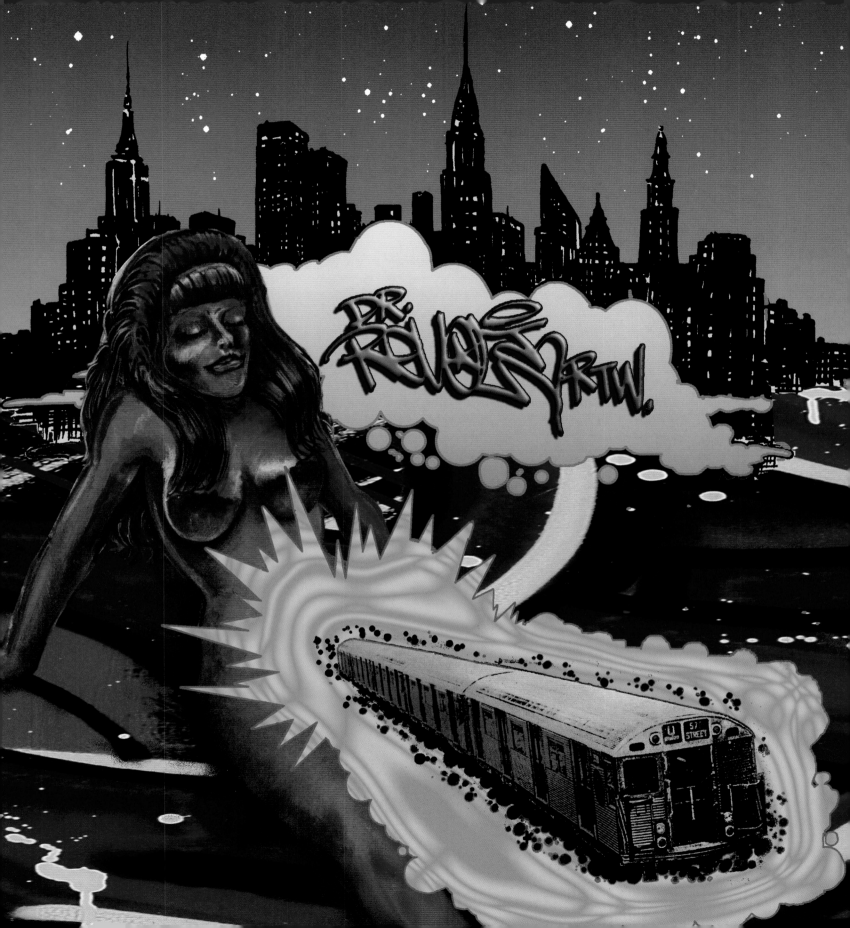

Ben Loiz:

You might not have expected to see flowers in this next section, but Ben Loiz is doing his best to remind us to stop and take the time to appreciate different things. "I started making flower arrangements a few years ago as a way to get inspired by something that was not a part of my everyday motivation. Much of my earlier work was very visually connected with design or graffiti…things that I was doing everyday. I wanted to challenge myself in creating something that wasn't an obvious inspiration. Knowing that elements of my everyday life/work would automatically show up, making these pieces different than other flower paintings."

Even with such a strong focus on technology in design, Ben does his best to keep things organic. "Computers play a big part in my art, but they are not my sole medium. I like to always experiment with different mediums, whether it is with paint, photo, chalk, pencil, fabric, computers, video, etc. I feel that my style is more in my ideas and the way that I go about thinking and laying out each piece. I try to not do too much work that looks the same, is created the same way or has a recurring image that people can pin me down to. Once I have accomplished an idea I like to move onto the next thing."

Ben runs the Typevsm studio with his wife Reneé. Together they create client and personal work for print and motion, as well as exhibition.

www.typevsm.com

Graphic Havoc:

The five members of Graphic Havoc avisualagency™ work within the overlap of art and design. Their interests lie in the exploration of the collaborative process and its effects on commercial design and fine art. Each member pursues their individual creative goals and then brings that experience to bear on the collaborative projects within the framework of the company. In the case of commercial design projects, the collaborative effort also includes clients and other outside entities. Three members are showcasing art on these pages.

Derek Lerner is a New York based artist, art director, and graphic designer. He started Graphic Havoc avisualagency™, with his partner Randall Lane in 1994. He subsequently received formal training at the Atlanta College of Art, where he earned a B.F.A. in drawing, printmaking, and computer art in 1996. The diversity of Lerner's work can be found on album covers, t-shirts, websites, television, and films as well as in galleries.

David Merten was born in the Dirty South and is amazingly handsome. Here he presents a mixed media work-study for a painting in a series titled A Pyrrhic Victory. Wearing his southern heritage on his sleeve, the series shows representations of a developing relationship between a horse and a 1972 Ford truck.

Co-founder of Graphic Havoc, Randall Lane's work comes from autobiographical sources as well as art history and cultural metaphors. "My father was in the army while I was growing up. We moved frequently, all over the U.S. and in Germany. Given the autobiographical nature of some of my work, all of these experiences traveling have played a role in the artwork I make today."

www.ghava.com

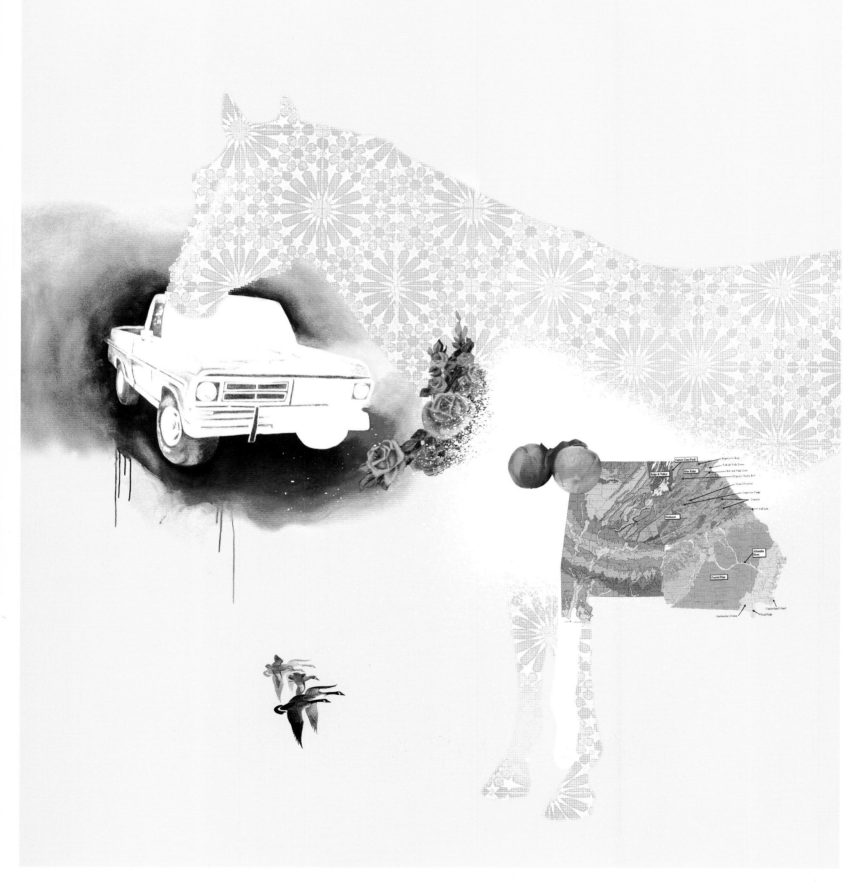

Rebecca Westcott:

An article in a newspaper once suggested that Rebecca Westcott was the loving daughter of painters van Gogh and Alice Neel. While this may be true, her art has been affected on a deeper level by simply being her mother's daughter. "My mother is an artist and that had a huge influence on me. By the time I could speak I was telling people I was going to be an artist. I had a lot of support from both of my parents. If you look at my stuff you can tell right away that I'm a woman.... it has a feminine touch to it, but with my mom it was never about being a female artist. I can't even remember having a conversation with her about that. The focus was always on just having a really strong work ethic as a person and an artist. That was the most important thing she put across to me. She showed me how to go on working as an artist and having all these other things in your life going on and juggling all these things together."

"Traveling also has a huge influence on me. I go to the local markets wherever I am to look at the hand-painted signs. I take a lot of pictures of what's going on and it works its way back into my paintings. I'm also looking at what the culture has to offer food-wise because I love to cook. For me, cooking and painting is all tied together. They're both something that my mother and I used to do together and to this day they both continue to make up part of who I am."

A graduate of the Rhode Island School of Design and a member of Philadelphia's Space 1026 collective, Rebecca often finds her portraits in interesting company. "I get lumped with the whole 'street art' thing even though I have really nothing to do with it. I don't know if it's because of my work or because of my age, but I like it because those people influence me more than 'fine artists.' Street artists have this spontaneity and they create art that doesn't take months and months to produce. I like the quickness and simplicity of it."

www.newimageart.com

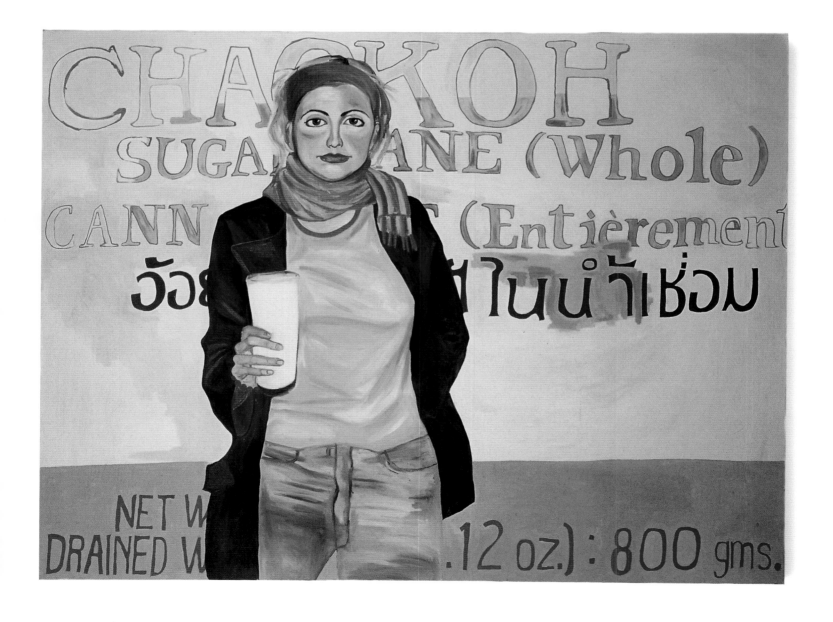

Rebecca B. Westcott

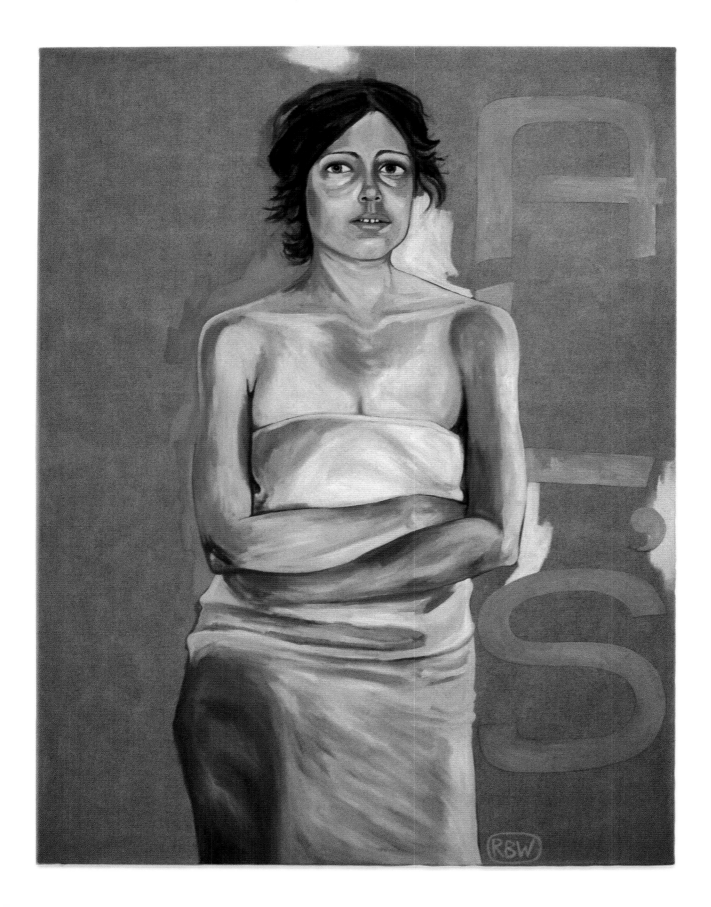

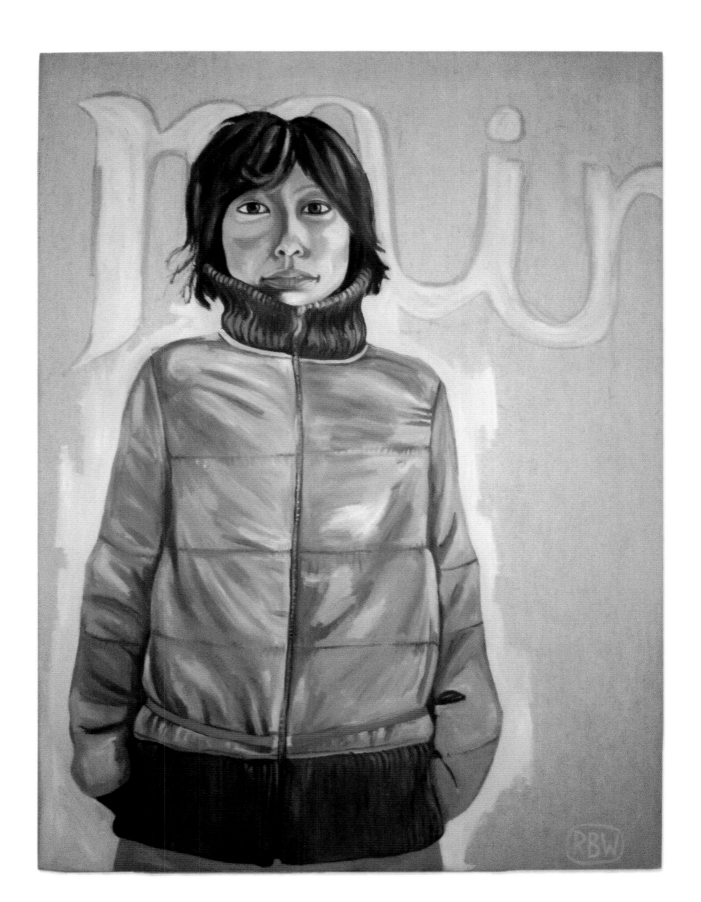

GIANT:

In his fourth year of architecture school at the University of New Mexico, GIANT left college to pursue his passion for art. He was quickly inducted into the world of graffiti by his mentors DOC and AGREE, and became enamored of its culture of lawlessness and freedom. A growing reputation in the graffiti scene for having a strong technique and unique style led GIANT to design jobs in the skateboard industry as a full-time designer for Think. From there he found new levels of success and fame as a tattoo artist.

With so many changes in his situation, GIANT can distill it all down to the five most pivotal moments in his life. "My trip to San Diego, the first time I experienced California — skateboarding, punk rock, girls in bikinis, the beach, hot rods, all that shit. Moving to San Francisco in 1993. Losing my virginity. Moving to England and leaving things behind, dissolving things. Tattooing myself when I was 26 and deciding that I was going to do this to other people. That set into motion a big turn in my life as an artist."

Leaving school didn't hinder GIANT's abilities at all. "I've been drawing since I was little and I taught myself for the most part. I think I knew how to paint and draw fairly well before I went to college, so I don't know if the formal part of it helped much." It's a good thing that GIANT found success with art considering the alternatives. "I worked the midnight to 8 A.M. shift at a porn store for a few months. I'm sure you can imagine the kind of people that shop at a porn store at 4 A.M. on a Tuesday. It's not good."

www.graffiti.org/giant

Andrew Jeffrey Wright:

While several of the artists here speak extensively about how events in their childhood affected their art careers, Andrew Jeffrey Wright contributed a piece from when he was actually a child. Andrew Jeffrey Wright proudly presents this authentic piece of his earliest efforts with graffiti circa 1980. "I was in 6th grade and graffiti had just made its way to the Philly suburbs. I was friends with a kid who had an older cousin that lived in the city and did graffiti. I remember going out with him and my friend John and writing on the back wall of a carpet store, and then this guy took us over to the baseball field and showed us the dugouts he had pieced. I was never very good at graffiti and I think my sketch shows that. I figured the sketch was a nice artifact that other people might enjoy seeing."

Keeping the youthful energy flowing, Wright's other contribution is an updated form of potty humor in the guise of stuffed animals... well, pooping. "I wanted to do a section on different animals dooking, but I really didn't want to go around for months snapping pictures of dogs and cats, so I figured I'd just do it with stuffed animals. Then for dook I was going to use mud, but then I remembered the old Baby Ruth in the pool scene from Caddy Shack, and so I was like 'candy!' I used Tootsie Rolls and Milky Ways for these photos. Or maybe it was just Tootsie Rolls."

While the world may never know how many Tootsie Rolls it takes to make realistic looking animal dung, it can be sure of the awards Wright has won for an animation he made with Clare E. Rojas called "The Manipulators," and the fact that he manages to get by on just $7,000 a year. When asked exactly how he can survive on so little money, Wright simply says, "By living in Philadelphia."

ajwspace1026@yahoo.com

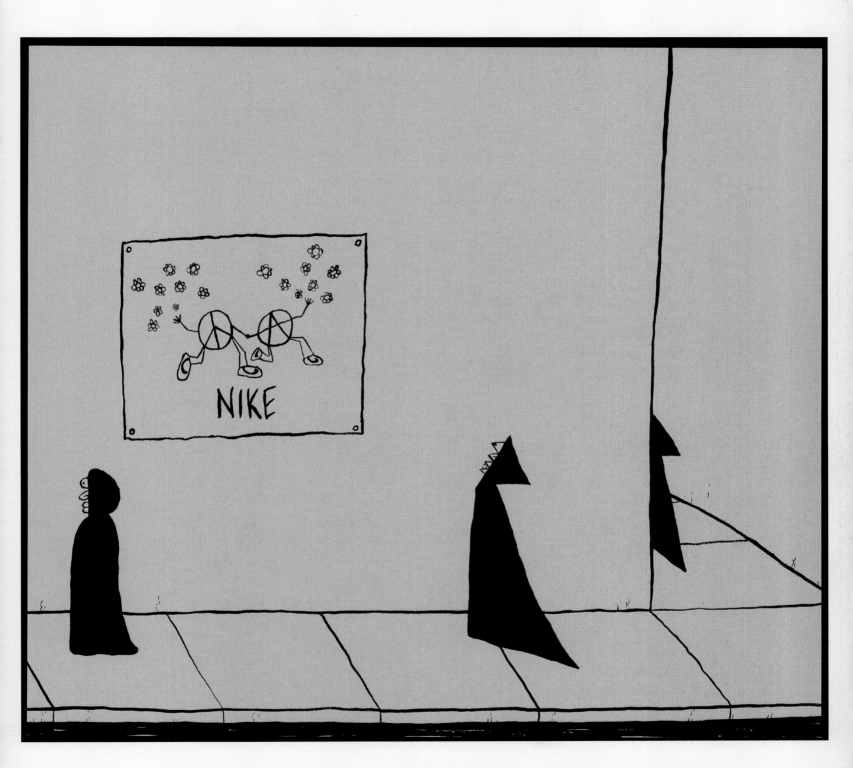

Sam Flores:

The question of "Where did you grow up?" elicits an immediate response from Sam Flores. "I grew up in Albuquerque, New Mexico... lotta cholos, hairspray, and drunk Indians that swing chains at you." If such visceral imagery comes to Sam's mind so quickly when asked about his upbringing, one must assume that it had a pretty strong influence on his art. "I grew up with my mom, we were mad poor living in a shitty-ass neighborhood. When I was hungry I would borrow bread from the neighbors, and when I was bored my moms would give me paper and pencils. I started drawing when I could walk. I would usually have to draw on brown boxes. When I was a young lad I remember winning this art contest in 5th grade, where the winner got his art painted up on a billboard. That was the first time I saw my shit high up booming on a huge sign above the freeway. It was tight."

These images from Sam represent an evolution in his art that includes more work on computers. At one point it seemed like this change would never come to pass. "Growing up, I was hating on computers. I used to do all my lettering and logos by hand. Shit would take me all day to do one clean word. So I finally said fuck it, and got me a Mac. It makes things a lot easier, but I try not to rely on it to do all my work. I still believe in actually being able to create something with just your mind, hand and a pen... no button pushing. But as I got into doing clothing designs, I started to really have fun with some of the different mediums. Two of these pieces were created with Illustrator, while the other two are acrylic paintings of photos I took in Singapore. I wanted to put some figures into those situations, and kind of create a relationship between the people and their surroundings and environments."

www.samflores.com

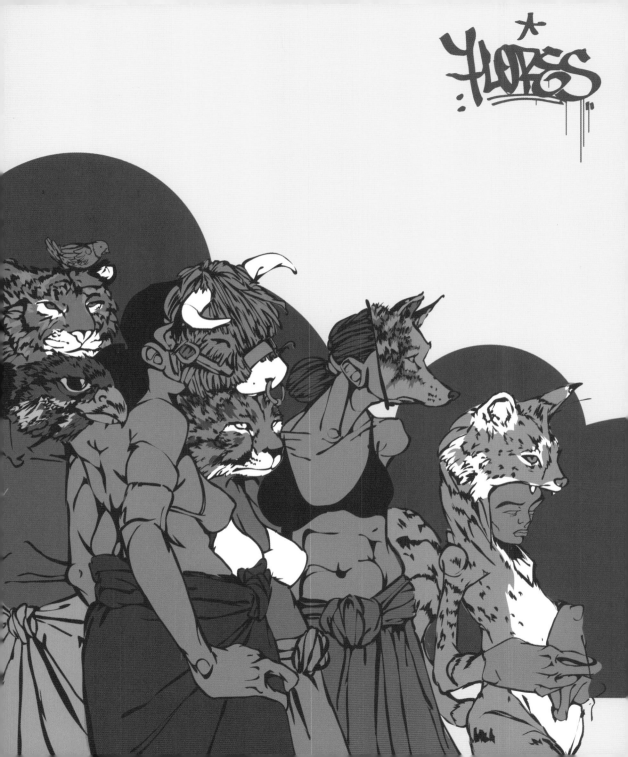

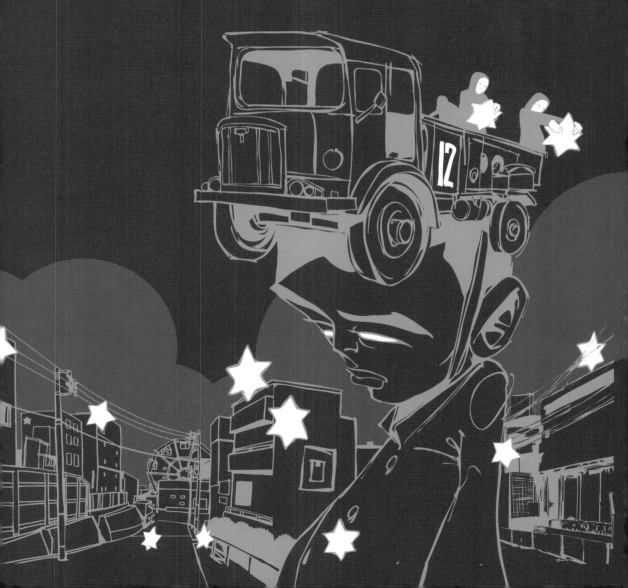

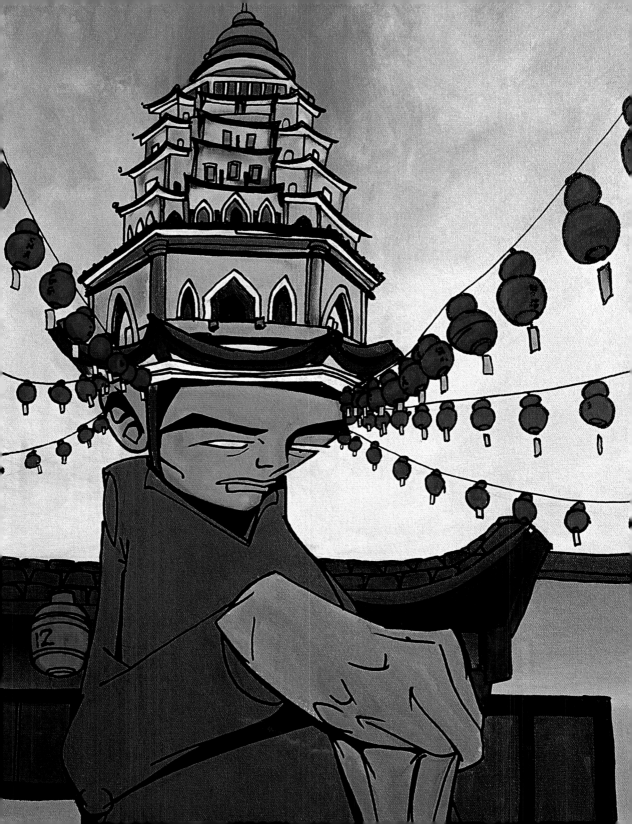

Shane Jessup:

While obviously skilled as an artist, Shane Jessup seems to lack some basic skills when it comes to researching references for his work. "One of the pieces here is a big self-portrait with religious connotations, but for no real reason. It was actually supposed to be a portrait of Jesus, but I couldn't find reference material I was happy with." Having overcome not being able to find images of arguably the most recognizable religious figure in the world, Shane went on to create more art for his section in this book. "There is a series of paintings called Things To Hurt People With. One is of a hand grenade, another is of a hammer, one is of brass knuckles, and the other is a heart. They were painted on scraps of Ikea furniture and then framed. I try to keep some kind of humor in my work, whether people will get it or not."

As a child, Shane discovered graffiti when his family moved from a small town in Texas to California. The form had an incredible impact on him and continues to be a day-to-day influence. "Graffiti has influenced everything in my life, especially my work as a clothing designer and graphic artist. And in turn, design has influenced my graffiti. You can take a lot of design elements into graffiti. My work in design helped me to concentrate on aspects of graffiti like color theory, use of negative space, basic layout, and other fancy sounding things like that."

Shane decided to forgo art school and chose a decidedly more do-it-yourself path towards learning design. "I moved out of my parents house on my 18th birthday and had to support myself. I delivered pizzas and did random jobs and I couldn't afford to go to college. I tried a few classes at a Community College but it just wasn't my thing. I saved my money, bought a computer and decided to teach myself. I felt like the technical aspects of the design world were changing so often that what I was going to learn in school would be outdated almost immediately. While I was working at a skate shop, I would go in early and try to design graffiti t-shirts on their computer and that's when I knew that I could continue my education without school. It wasn't completely on my own, though. Getting a design job at the skateboard company I work for now was invaluable in my learning. I worked with other people who were self-taught and it really opened my eyes to see the different ways people would go about doing the same thing. Basically, I was just learning what I could, where I could and things took off from there."

www.timeistooshort.com

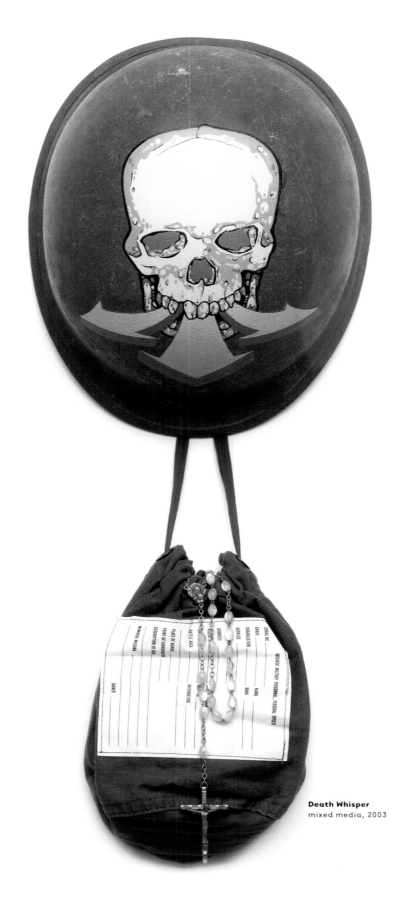

Death Whisper
mixed media, 2003

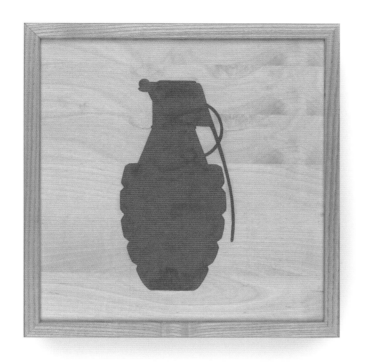
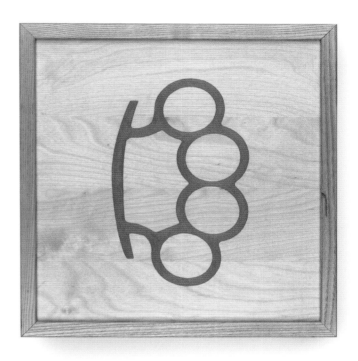

Things to Hurt People With
acrylic on Ikea, 33" x 34", 2002

Seven Sins
acrylic on canvas, 36" x 48", 2003

Design Course #1 & #2 – digital

Anton Lopez:

It can be difficult to tell fact from fiction when discussing Anton Lopez's interests other than art. While it is true that he was born in the Philippines and now lives in New York, it's hard to be sure if he's telling the truth about his hobby of making over-sized replicas of vintage monocles out of balsa wood and mother of pearl inlays. By the time he's explaining how he won a Tony Award for "Best Modern Dance" for his choreographic re-interpretation of the Will Smith and Gene Hackman movie, Enemy of the State, you're not quite sure what's up or down with this guy. What you can be sure of is how vast amounts of international travel as a youngster molded his art style. "I took a few trips to Asia and Europe when I was younger. Visiting new places had a real impact on my work. Europe with their economic and elegant design like hotel towel embroideries, plane tickets, airports and highways was a real influence. In Asia, I felt connected to the colors and patterns. The speed and movement of cities like Hong Kong and Manila definitely left an impression."

Travel aside, these days Anton finds most of his creativity fueled by what's going on right outside his front door. "I think that my work sometimes ends up being minimal because living in New York City sometimes leaves me feeling like I've been visually molested. My reaction to that is to try and make paintings with less visual noise. I've been painting with this in mind for a while now, and though I find it difficult, it's rewarding to finish a piece that I feel has just the right amount of information."

"These pieces were painted during a period where I was experiencing a lot of turbulence in my life. I wanted to find a way to build some form of protection. I painted icons such as spears, masks, and patterns from Asian screens and African shields. I also used imagery from animals exercising basic survival instincts, like a bird that was in the middle of a defensive dive into water. A book I bought about Tahiti inspired another painting. That piece is my escape hatch, a place to retreat in case the defense fails."

typhoonseason@hotmail.com

Jamie Reid:

Jamie Reid's artistic style was the visual foundation and soul of the entire punk movement in England during the late 1970's. This is absolutely no small contribution to the world when you consider the legions of bands, magazines, books, clothing, and young people that continue to be influenced by punk's protest of pop culture. From anarchy flags subverting the Union Jack, to the sharp use of safety pins and torn ransom note lettering, Jamie's art was truly the stuff legends are made of. From 1976–1980, Jamie worked full-time with the Sex Pistols producing artwork and visual materials for a number of singles, album covers, and the Pistol's feature film "The Great Rock 'n' Roll Swindle."

Introduced at Croydon Art College to Sex Pistols benefactor Malcolm McLaren, Jamie was a natural choice to artistically interpret the band's image, but for Jamie the punk movement went much further than that. When reflecting on those early days of the movement, he says, "It was the democracy of it all that mattered. I've always believed in the punk attitude and how that spread into other places. It was making things out of nothing, which we're doing now more and more." And his work does continue on. Its effects can be seen shaking the system from the French workers who wrote "No Future" on their barricades during a general strike in Paris, to the "God Save The Queen Flags" flown by Australian Republicans in their quest to have the Queen of England removed as their head of state.

When you look at his almost surreal family background, it's no wonder Jamie went on to create art with such a propensity for influencing social behavior. Reid's grandfather died gun-running for the Chinese during the Boxer rebellion, his great-uncle was the head of the Druid Order and one of the first Labour parliamentary candidates, and his brother was the press officer for the Committee of 100 and one of the 'spies for peace.' His work can be seen everyday on the streets of cities all over the world, and in numerous books and exhibitions.

www.jamiereid.uk.net

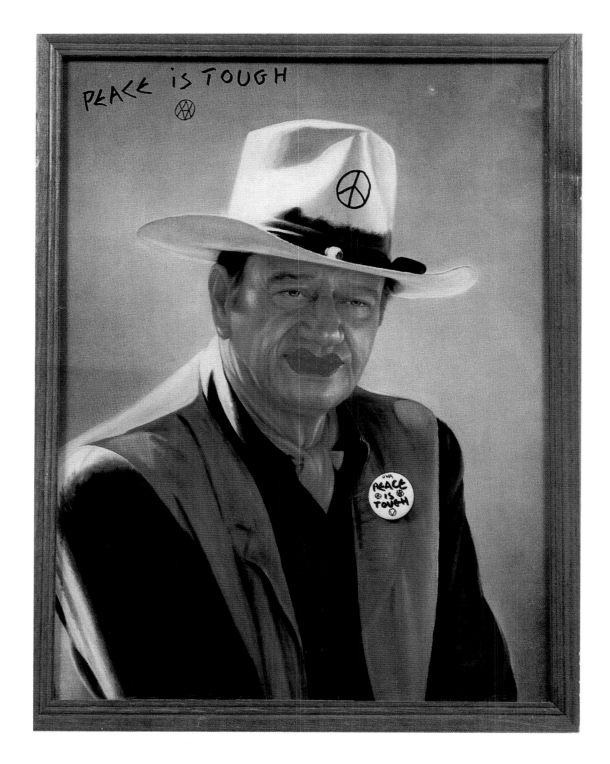

JOHN WAYNE.
Peace is Tough.
done 1992 JAN 16.
outbreak of 1ST GULFWAR. & so on & so on.

Exhibition & installations at Jump Ship Rat. Liverpool 2002.
Panoramic photo - Will Curwen

Canvas - four elements on the lawn.
1998-9.
photo :- Maria Hughes.

Tepee. — Installation
JUMP SHIP RAT LIVERPOOL 2002.
photo Jamie Reid

Stargate II. – 1999.

used for C.D. sleeve – 'Afro – Celt. Vol III.

& Poster 'further in Time'.

Interiors

Strongroom Recording Studios.

STUDIO 1 & STUDIO 3.

1990 - 2000.

Fifteen year project & still going

Anthony Ausgang:

Born in Trinidad and Tobago to Welsh and Dutch parents, raised in Texas and residing in Hollywood, Anthony Ausgang is like an artist's version of the United Nations. "I've been to most countries in Europe and a few places in Indonesia. In Bali I saw a huge tree trunk that had been carved into a dancing figure and I was amazed that such a great work of art didn't have a signature. It made me realize that when I'm dead, the only thing I'm gonna leave behind that no one else can will be my paintings." Drawing from a perplexing set of influences ranging from Saturday morning cartoons to Greek antiquities, Ausgang is opinionated but informed. He lists a 14th century painting in the Hermitage Museum of a Dutch village by an unknown artist as his favorite work, but he also appreciates a fast Rat Rod built in a garage in the desert.

"A painting has to be a complete illusion, like a window that you can stick your head into and look all around... not just the image that's painted. The creation of a painting is about making a believable 'universe' in which all things make sense, even if the world depicted makes no sense by our world's standards."

A successful artist who appears in several magazines and exhibitions each year, Ausgang also boasts an impressive list of commercial clients including Tower Records, MTV, Sony Music, and Mr. David Lee Roth. He was the proud recipient of a blue ribbon for a drawing of a hamster he did in 6th grade.

www.ausgangart.com

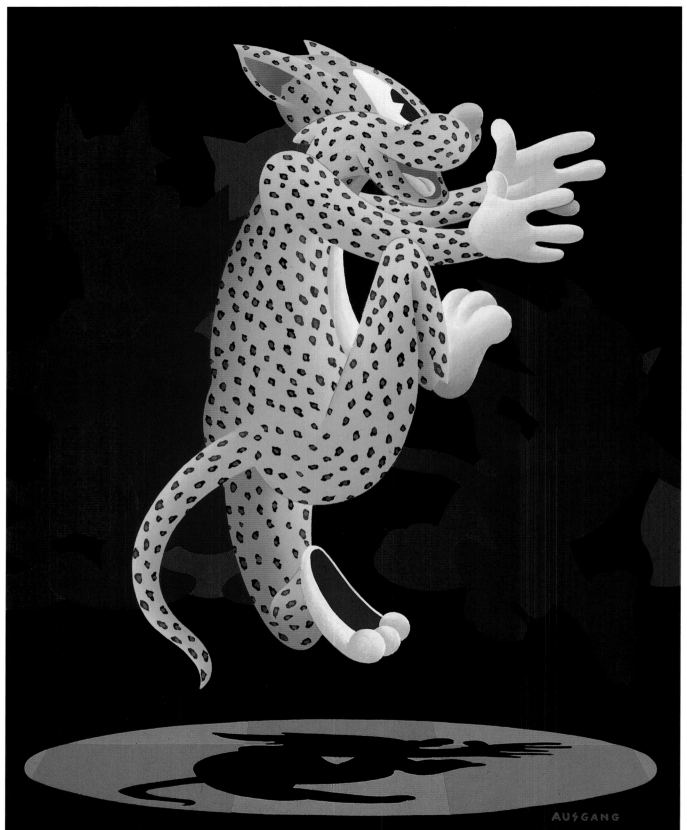

The Raver
acrylic on canvas
2003

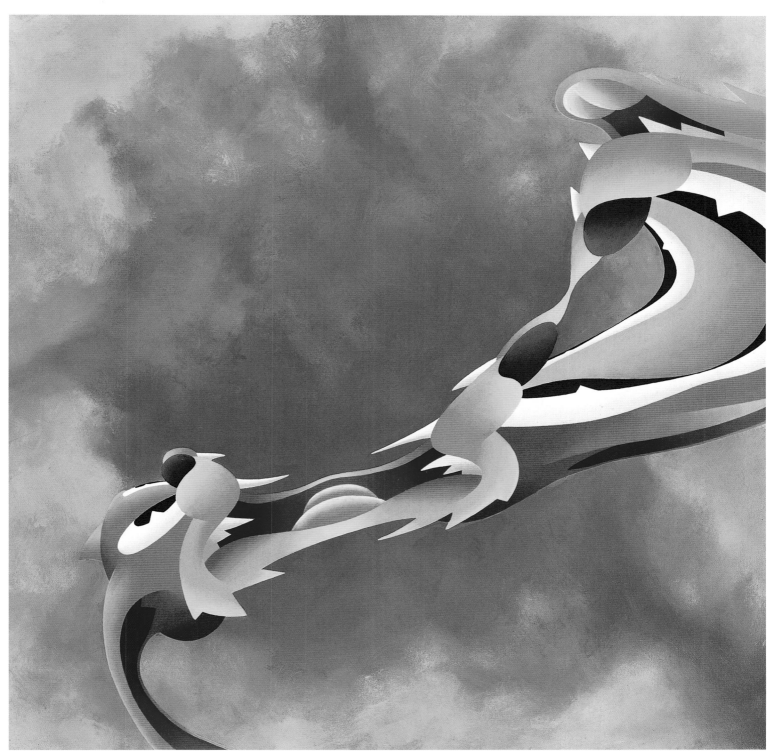

Splitting The Catom
acrylic on canvas
2002

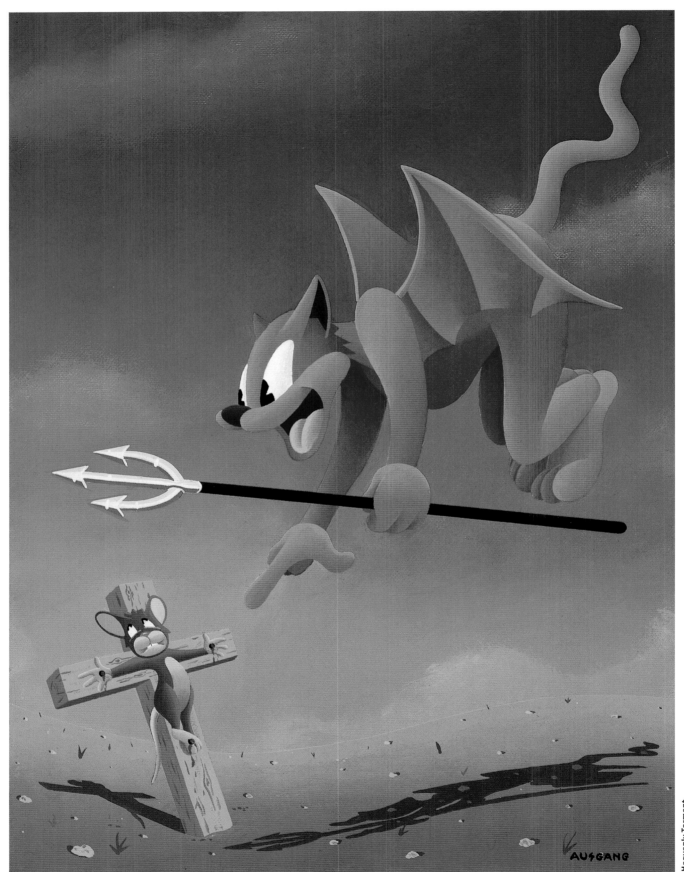

Heavenly Torment
acrylic on canvas
2003

Dave Schubert:

"I like the photos in this book because they're all just honest portraits of people." Dave is a photographer 24 hours a day. He's like a magnet for unbelievable situations, the impact of which can't be missed in his work. "Going out to take photos is like going out on a field trip. I just get out there and hang with people and see what's happening. I always have my camera with me in case something comes up.... I don't really set out with a planned assignment when I take pictures. I'm lucky to live in San Francisco, where there are a lot of talented people. I have a lot of talented friends, and they're inspiring me all of the time. I just walk down the street and get to see a lot of crazy things."

Introduced to his craft at a young age, Dave developed a strong work ethic and a do-it-yourself attitude towards photography. "I grew up overseas and I used to go traveling with my parents. I had a Polaroid and I'd make photo books out of the pictures. Then in 7th grade, my friend Kevin showed me how to make prints in his darkroom. This was around the time that I started taking pictures of my friends skateboarding. Skateboarding was a major influence on my photography then because I was always shooting what I was doing, and all I was doing then was skating. It was through skate magazines that I got my first professional work. I was doing advertisements for my friends in the industry that needed them."

"I still do my own prints. I like to make my work part of a process. This way all the mistakes are mine, not somebody else's. When you make something with your hands, there's always going to be something that's not perfect. That's the good part. It's more personal that way if I make the mistake and not some machine doing the print."

www.newimageart.com

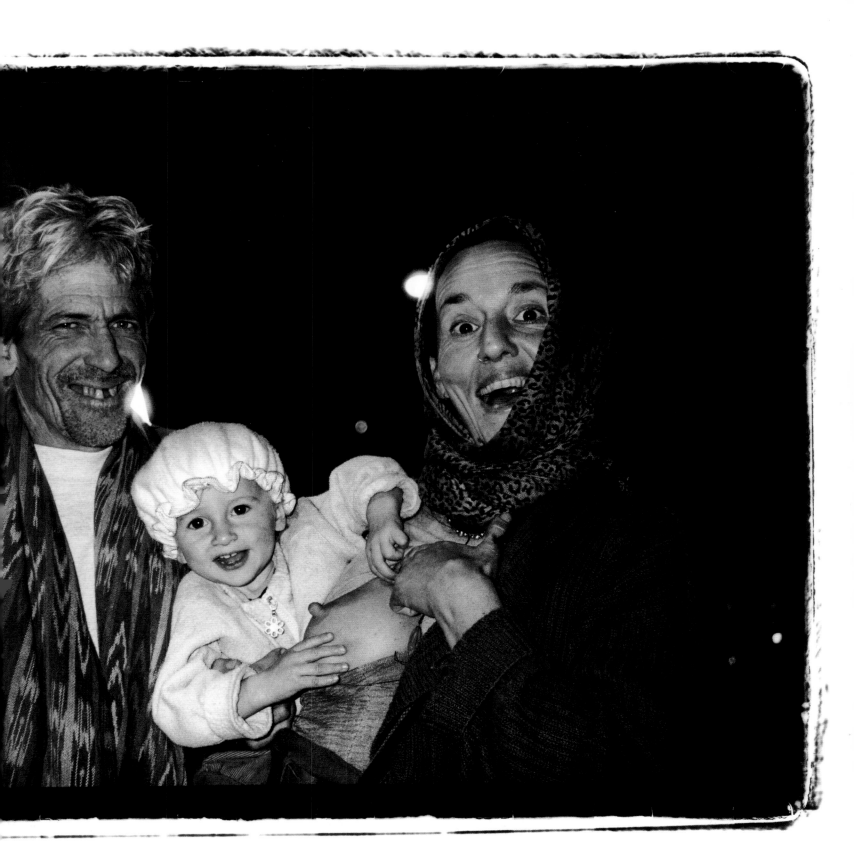

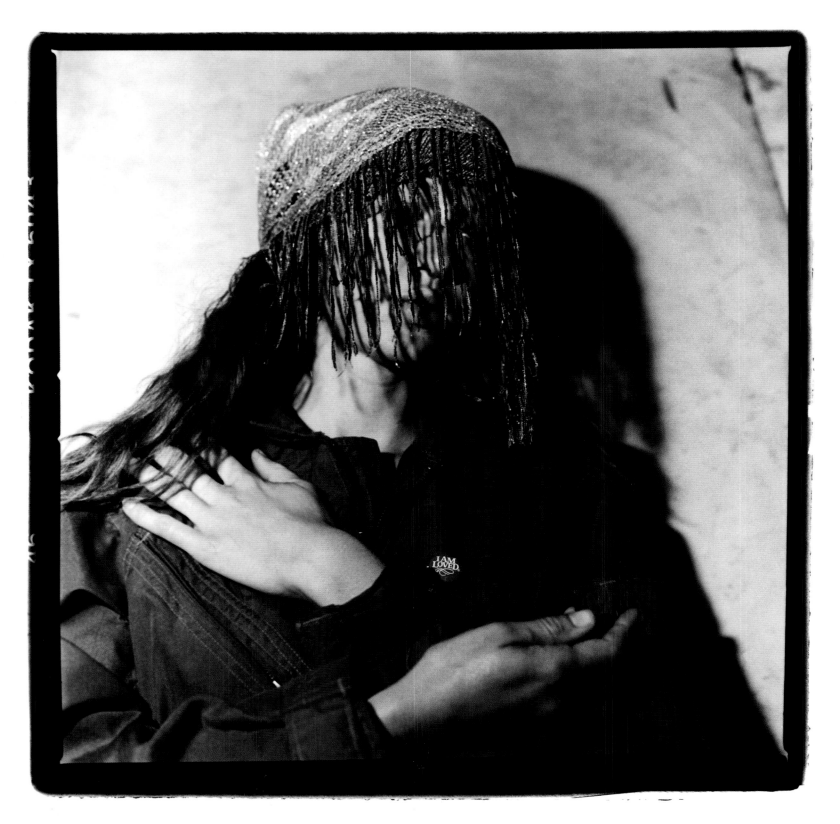

EKLIPS:

Influenced as a child by the graffiti that was showing on the West Los Angeles freeways, EKLIPS started writing graffiti in 1986 before acting as a founding member of influential crews, AWR and MSK. EKLIPS was immediately moved to start practicing this new form of art by sketching at home. Then as luck would have it, his family moved to a hot zone of graffiti activity. "A year after that first glimpse of graffiti, I moved two blocks away from Motor Yard, which was a big yard in West LA that's really famous with a lot of history. I started going down there and talking to people and taking photos and doing little pieces. Then in '88 I got together with a couple dudes in my high school that also wrote and we decided that we needed a crew. After a month or so we came up with the name, 'ARR — All Rights Reserved,' but I wasn't really feeling the two R's. My brother, CYDE, came up with the idea of changing it to 'AWR — All Writes Reserved' and that was it, we started pushing AWR as hard as we could. We wouldn't even write our names, just the crew. As we met new people, it expanded from West LA to the Valley, then down to Orange County and then San Francisco and Minnesota, etc."

For EKLIPS, his family's move closer to the Motor Yard wasn't the only time in his life that a change in location triggered an increased appreciation for art. "I was raised all over the world. I went to boarding school in Europe for two and a half years when I was a kid. I've seen a lot of European styles of art as well as a lot of American styles. All of my life I've been surrounded by all different kinds of art and that's been an influence along with specific things like fine paintings, different kinds of lettering on billboards, logos, and advertisements. I'm like a letter fanatic."

These contributions from EKLIPS represent his continuing obsession with letters and his collective art review, the Seventh Letter. "The seventh letter is 'G.' To me it has a lot of meaning. It's a letter that has surrounded my life. Everything I've been involved in, some way or another 'G' has been a part of it: graffiti, graphic design, God, the seven original members of my crew. I put together a group of graphics from people who have contributed to the Seventh Letter that I've worked with and put them through the computer. It's an expression of graffiti in an illustrative format."

"Graffiti has ruled my life. It's given me a lot of life and taken away a lot of my life. No regrets though. I'm blessed to have been surrounded by such amazing artists that are taking the style that myself and some of the older heads laid down and taking it to the next level. That kind of keeps me in existence even though I don't paint so much any more. I'm still painting through them."

casey@theseventhletter.com

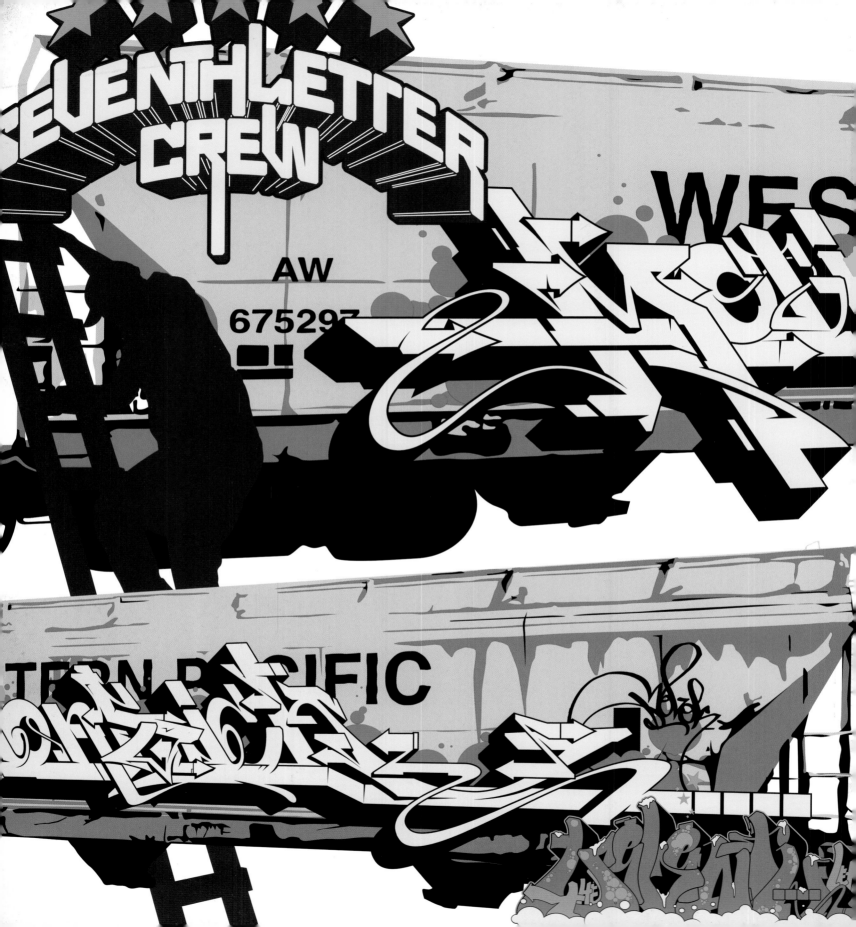

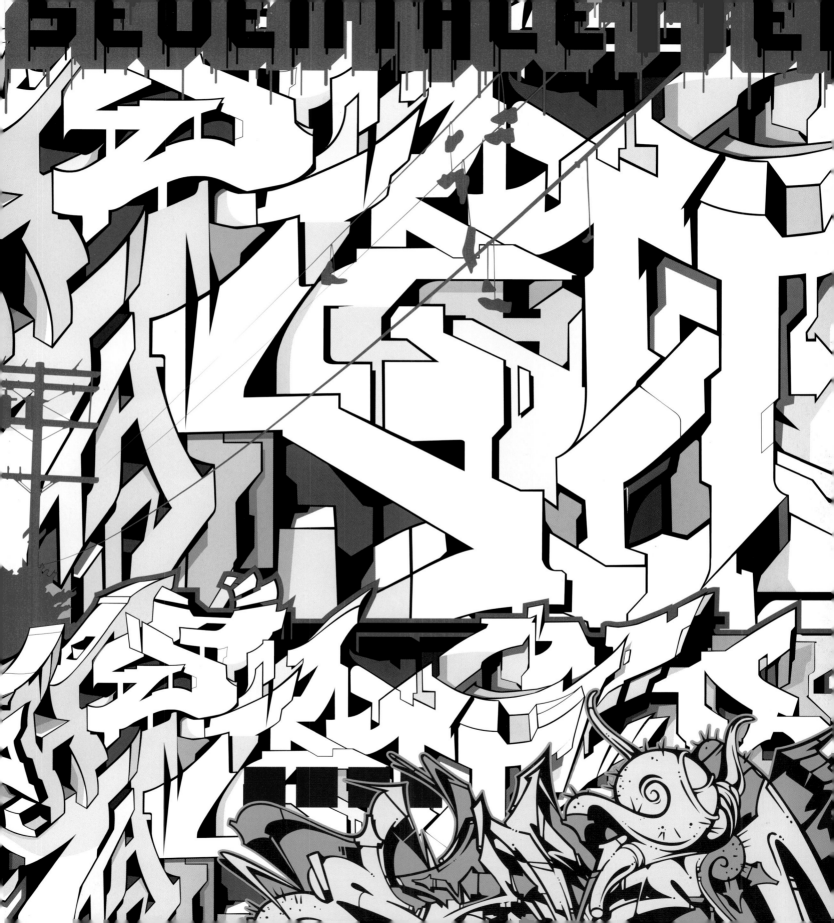

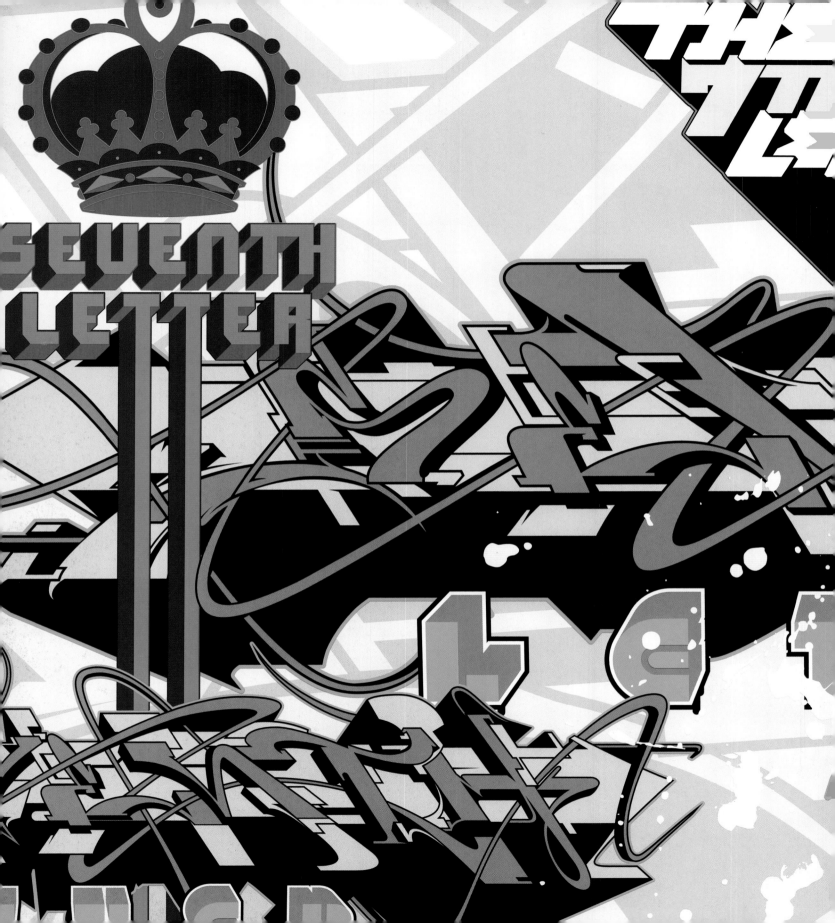

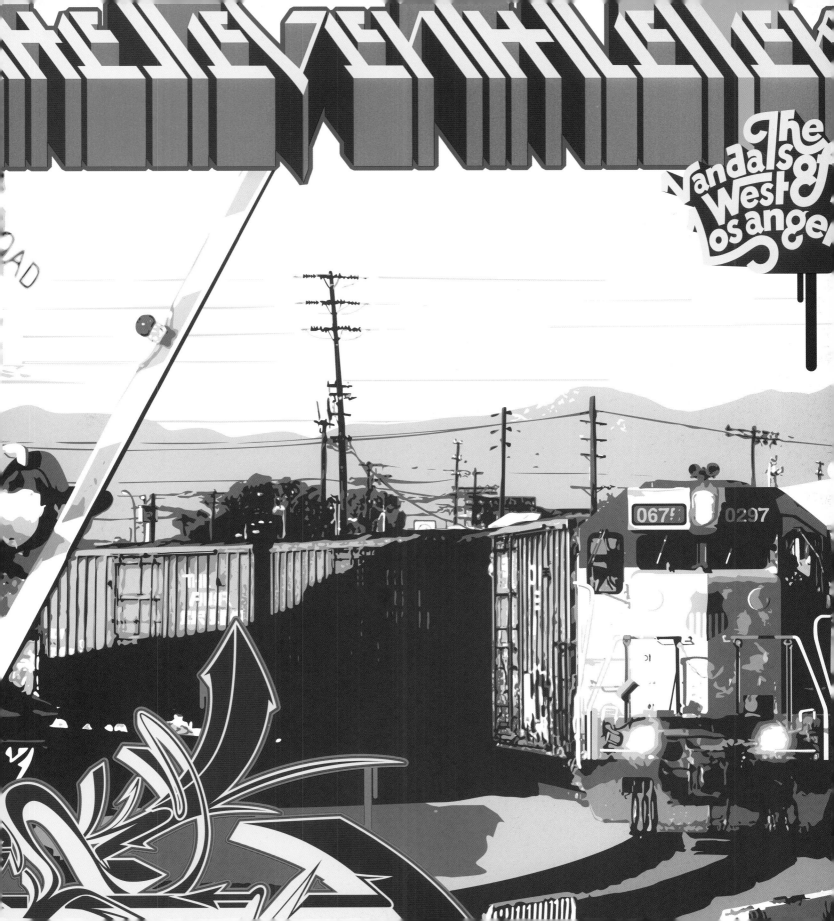

Chris Yormick:

Chris Yormick's art still shows traces of his graffiti upbringing. As RUST, Chris was a pioneer of the Washington, DC graffiti scene and certainly not what you would have considered your typical graffiti writer. "When I was a freshman in high school back in 1988, I used to go to hardcore matinees on the weekends. This guy MESK used to do the flyers in a graffiti style like the ones in New York. That was my first exposure aside from visiting NY and Philly. The mystery of it was very appealing because I didn't know anybody at the time doing it except MESK and a select few. Graffiti has a strong connection to hip-hop, but I never really thought of it as a purely hip-hop entity. It was more a state of mind and a reaction to an urban environment. I have always been into hip-hop; I just don't like to think in such specific terms. There's the hip-hop element, but a lot of kids that did a lot of damage in New York came from the Hardcore scene. It's just not 'Oh, I breakdance and rhyme and write graff, I'm a true B-Boy.'"

"Graffiti is just a part of me so it shows in my art. A lot of stuff influences me. It's hard to put your finger on specific things because it's so vast and overlapping. Recently I have been more influenced by literature and conceptual art than the obvious influences like graffiti, Picasso, Miro, Rauschenberg, or DaDa that you can see in my stuff. I just kind of encrypt the things I deal with on the day-to-day, be it bad or good, and try to make it harmonious. So when I look at my work, it reminds me of when I made it, but that's not always the case."

chrisyormick@hotmail.com

Fuck The Dumb Shit.

Light 2000

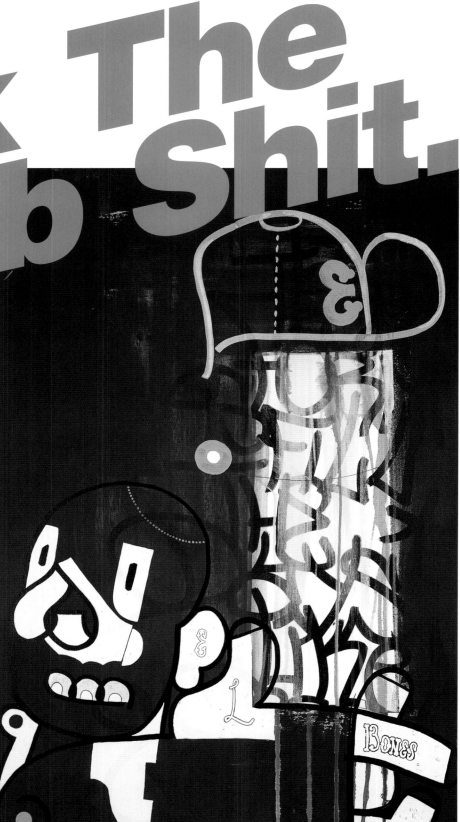

Untitled 1999

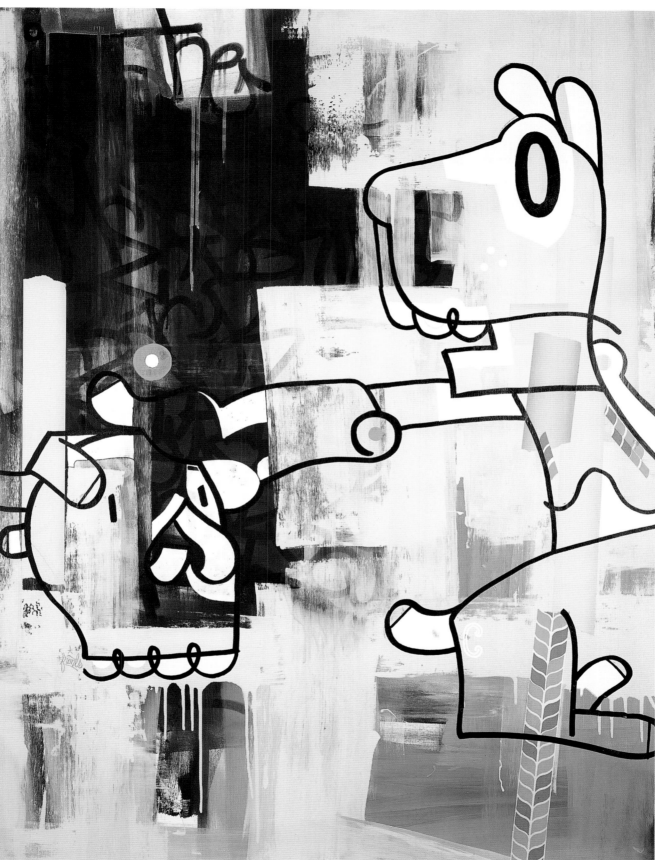

Held High 2002

Hull 2002

Untitled 2001

The Plan 2001

Untitled 2000

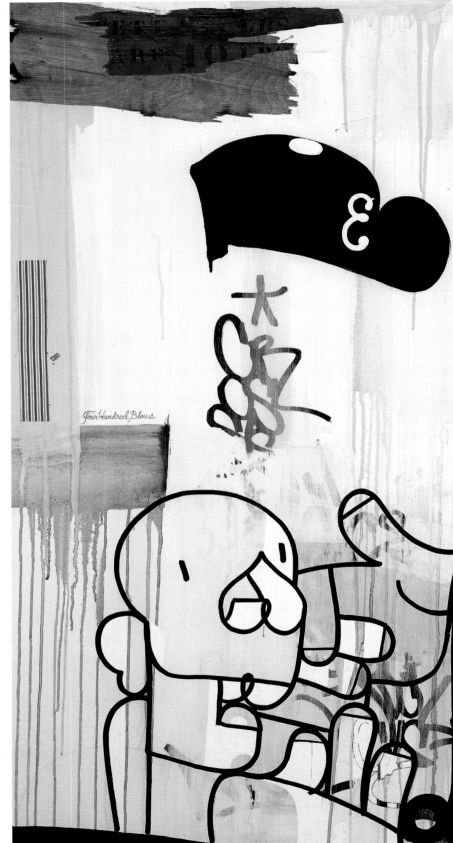

The 400 Blows 2003

Broke 2002

...Because I Care.

Ron English:

Ron English is truly one of the most provocative artists in America. He has created about a thousand "outlaw" billboards in which he clandestinely reworks the existing advertisements, replacing them with a message concerning the true intentions of their corporate sponsors. Creating these "liberated" billboards is a risky venture as each one carries a felony penalty if English is caught. After 20 years as a billboard liberator, English is still at work today, but possible jail time isn't the only frightening thing about his adventures high above the city streets. "Imagine a billboard eight stories above a crowded New York street. Imagine a rotted plank. Imagine a naked woman splashing blood balloons on a painting of a giant coat hanger. In terms of the scariest situation my art has placed me in, that stunt would be a close second to having a bunch of drunk rednecks with baseball bats trying to avenge their God after watching me post a billboard of myself as Christ on a cross. The caption read, 'Let's Get Drunk and Kill God!' It was a reference to Nieszche, but somehow I don't think they got it."

The impact of English's work can not be understated in terms of changing actual corporate practice and opening up the public dialog between citizens and the mega-marketplace in which they live. English's relentless and hilarious mission to expose the Joe Camel character for the penis-faced pedophilic drug pusher he was surely played some part in the eventual demise of that ubiquitous RJ Reynolds campaign. And passersby who never before thought critically of the imagery may change the way they look at advertisements after being exposed to the "English Spin." All of this isn't even counting the more legal work he finds time to create. When you hear him describe his past projects, it's hard to believe that one man could be involved in so much, but English ticks them off without fanfare. "I created a mural on the Berlin Wall at Checkpoint Charlie before the wall was torn down. I did anti-drug billboards in the former Soviet Union, commissioned by the local communist authorities. I went on shows like Jenny Jones with my wife Tarssa and made up problems. That was my idea of performance art. At the time it seemed pretty cutting-edge. I've also done art and sets for movies, international arts festivals, and youth funds. Oh, and lately I'm the official artist for the rock band The Dandy Warhols."

These oil on canvas paintings by English represent a large body of work that has been widely acclaimed and influential. In his painting Guernica, Red Air Raid, he explores Picasso's painting from an aerial perspective, from the point of view of the bombers. Using Mickey Mouse as the pilot adds the dimension of American pop-culture carpet bombing other societies. The painting Cartoon Guernica explores a similar concept; however, this time the Picasso masterpiece is "Disneyized" into a more palatable image. The figures retain the exact poses of the original terrified Spanish citizens in the midst of slaughter, but here their little cartoon faces are just so darned cute. And the painting Starry McNite addresses the concept of a branded and franchised culture by infiltrating a beloved painting with America's two favorite franchises, McDonalds and the Church of Christ. It's a powerful exploration of the corporate branding of history and cultural identity. Nice brush of strokes too.

www.popaganda.com

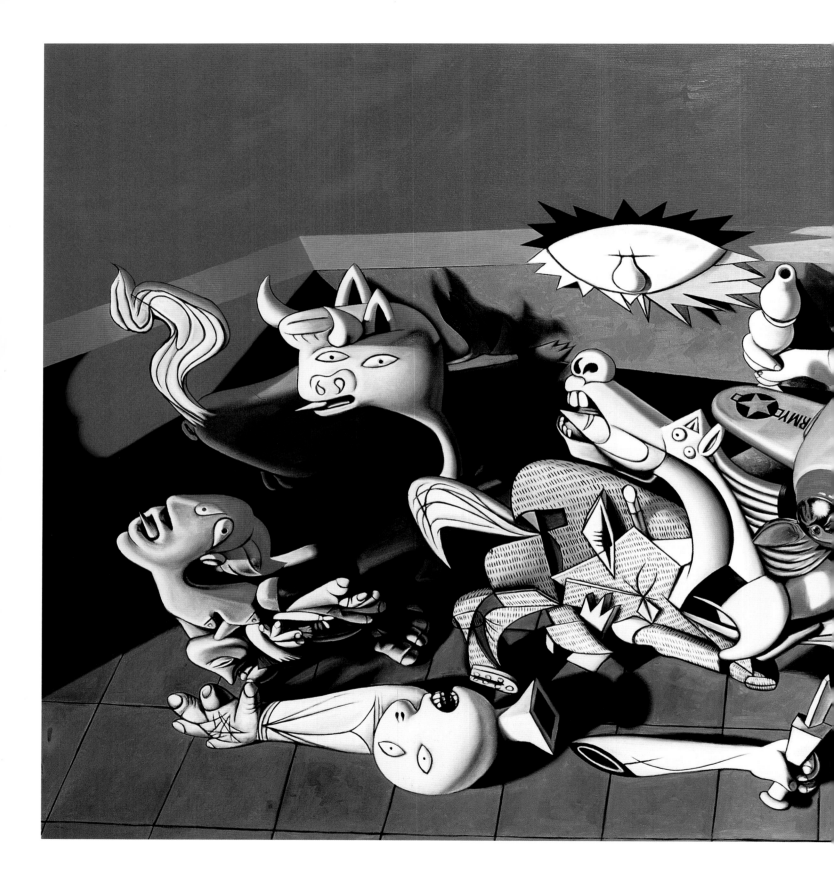

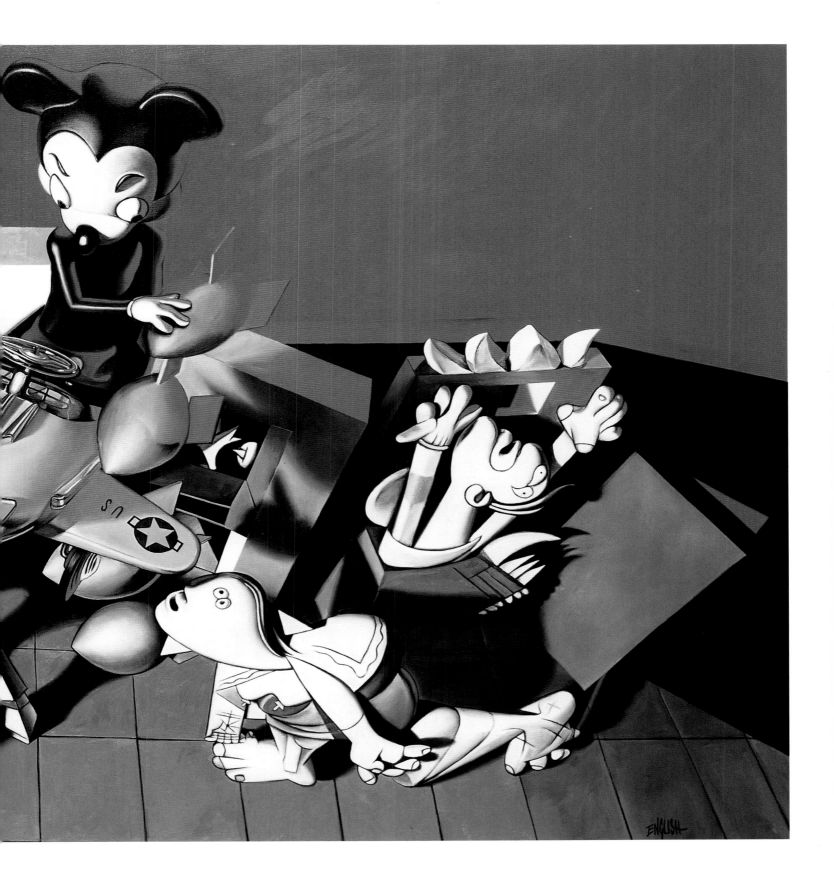

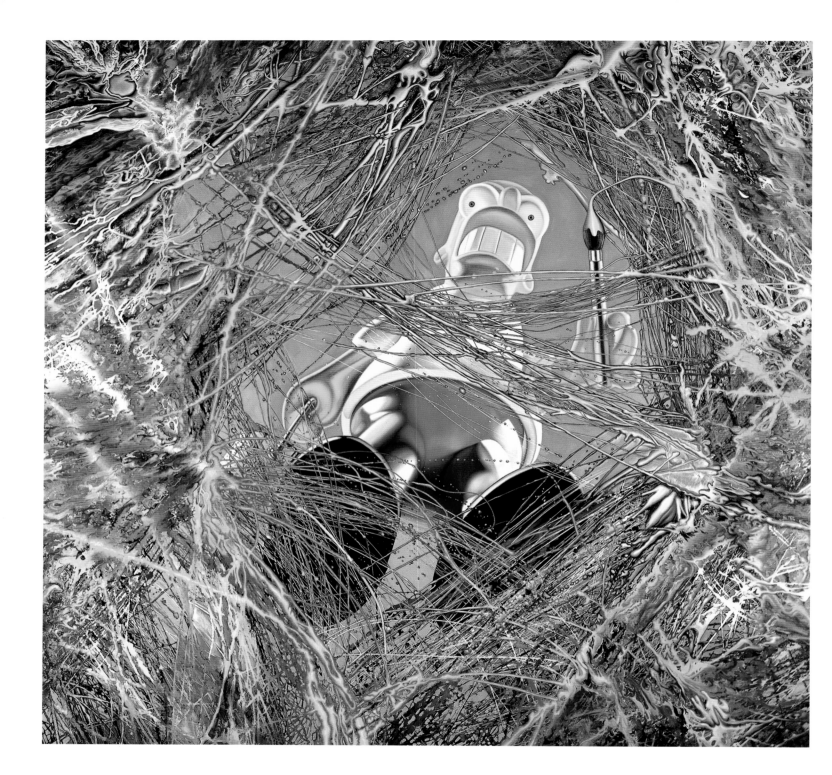

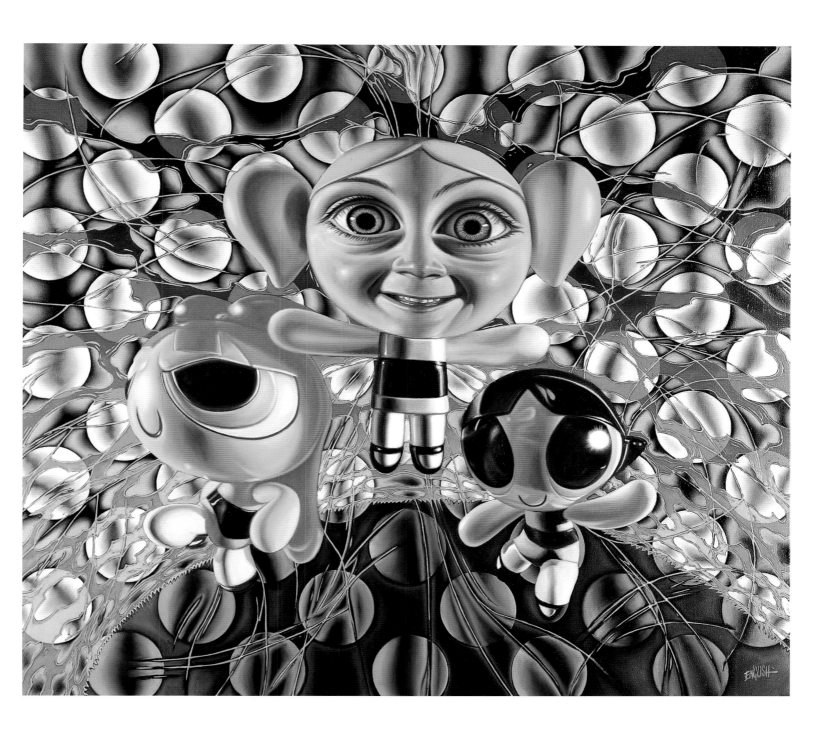

JOKER:

"I came up thinking that the goal of every graffiti writer was to have the sickest wild-style pieces," says JOKER, who began writing graffiti in 1985. "The older I got and the more knowledge I gained, I realized how absurd that was. But by the time I came to this realization I had already reached a certain point of creating wild-style type pieces. I started working closely with RAEVYN TWS in San Francisco and learning a lot from him. Letting go of boundaries and doing what feels right instead of what I've been told is right. I still worked fairly wild in my styles but over time I've worked really hard to break them down to their simplest forms and still have them be wild. What I do has been labeled 'abstract' and I guess that's okay. As much as I hate the term, it's better than 'shit'...."

That abstract style is on display in JOKER's pieces, and you can be sure that they really do spell out "Joke." "Everything I do says something, and if it doesn't say something then its one or two or three letters. I still very much work within the realm of graffiti. Though within the past two years or so I haven't done a single JOKER piece, everything has just been a 'JOKE' piece instead. I'm not so sure why I dropped the 'R'... I have no idea."

The missing "R" isn't the only thing baffling JOKER these days. "How about all the nutbags going ga-ga over the new Krispy Kreme™ donut shops in Washington State? People from Oregon are driving up there and buying tons of these things and selling them out of the back of their cars for an inflated price. And people are buying them! It's like crack over here. I heard of one guy selling a dozen for $25. He had a whole mini-van full of 'em and sold out in two hours! At $25 a dozen! For a few fucking donuts!!! Sorry, but that's retarded."

silenceinshadows@hotmail.com

STAK:

All graffiti artists are adept at the art of stealth, but Brooklyn artist STAK is a true master at staying mysterious and under the radar while continuing to get his name out there. You may get a glimpse, but you don't get a long stare at STAK or most of his work. First introduced to graffiti in the late 70's by his cousins, STAK is prolific as both a graffiti artist and a painter on canvas. For STAK, both these mediums are part of one whole.

"I don't think there really was a transition from graffiti to my canvas work because I was drawing all the time regardless of anything else. Even before graffiti I was sitting at home drawing nonsense, looking at my TV drawing I Love Lucy on the screen. Drawing stupid shit with my friends from school like throwing a bunch of rice and trying to draw it before it hit the ground. This was before graffiti even came into the picture, so each step in my art hasn't really been a transition but more of an evolving style. I've always been serious about my art. With the canvas stuff I figure at least if nobody else likes it at least I can hang it in my house because I like it. I do it all for me. There are a lot of gimmicks out there right now and I try not to get into that."

Displayed on these pages are examples of both STAK's graffiti work and his canvas work, a mix that was intentional on the part of the artist. "A lot of dudes come into the art world saying they're graffiti artists and a lot of it is just perpetrating. I'm not trying to knock nobody's hustle, but I see a lot of frauds out there. A lot of people have never seen my old graff stuff. I wanted to stand out a little bit, ya know, show and prove.

STAK's philosophy about the changes in his art style carries over to the inspirations for his work. Or more to the point, what doesn't inspire his work. "At this point, I only paint illegally for fun, and for the kids. Me and my boys will be hanging out, kicking back, having a few beers and looking at photos.... It's personal stuff; we can look back and laugh at the nonsense. Unless you're a writer, you just won't get it. As far as my art stuff, I don't feel any specific inspiration it just comes freely. It's not like I need to feel in a certain mood to get inspired, it's just like blinking to me, it comes naturally. If you feel it you do it."

info@graffsupply.com

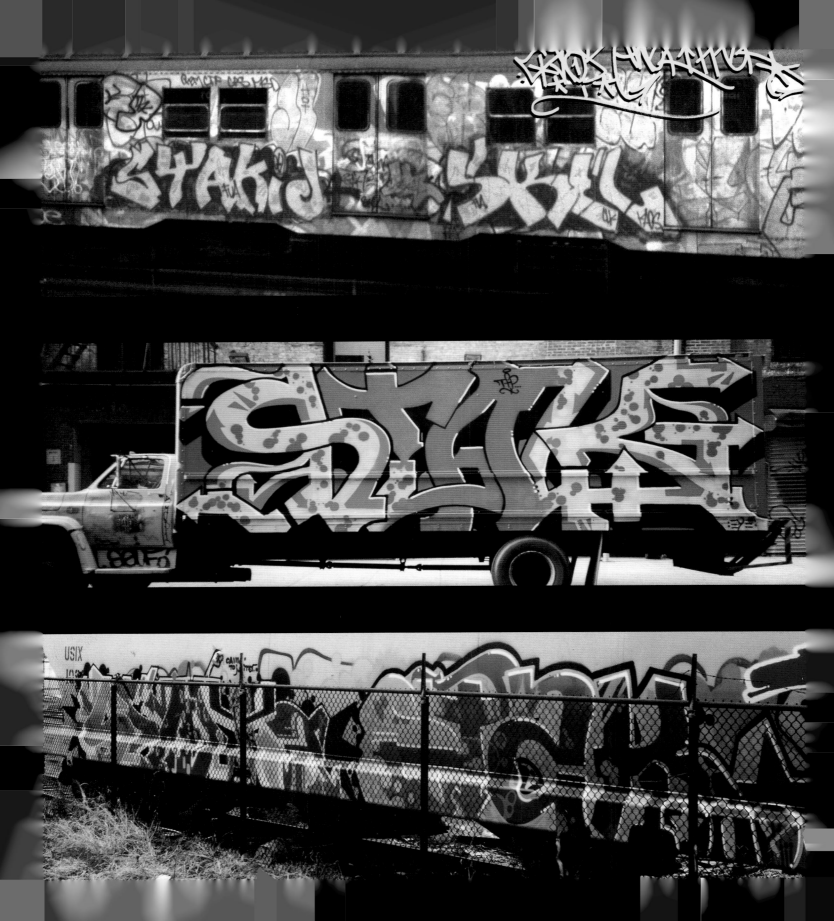

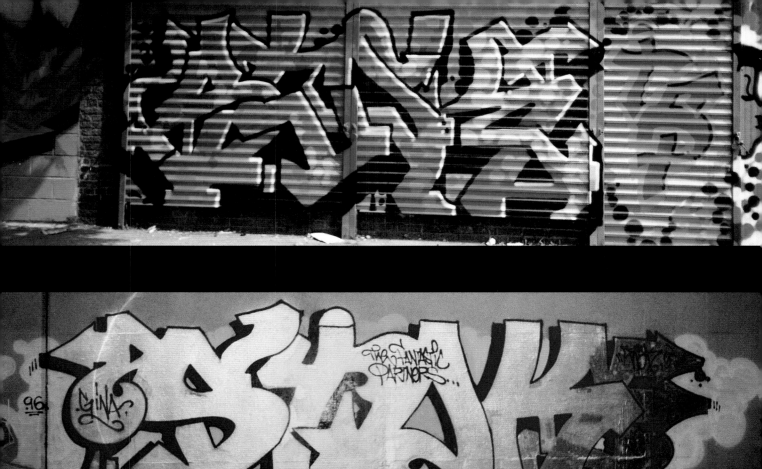

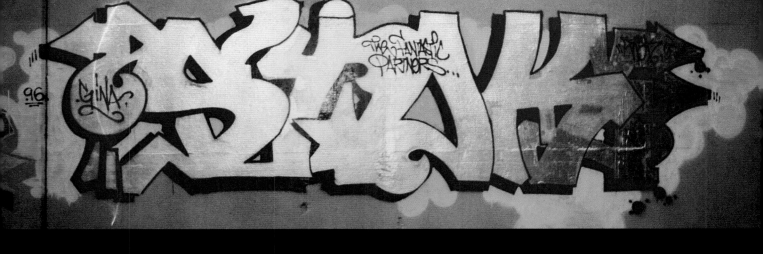

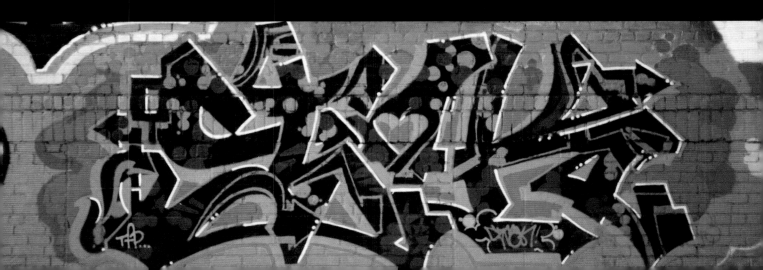

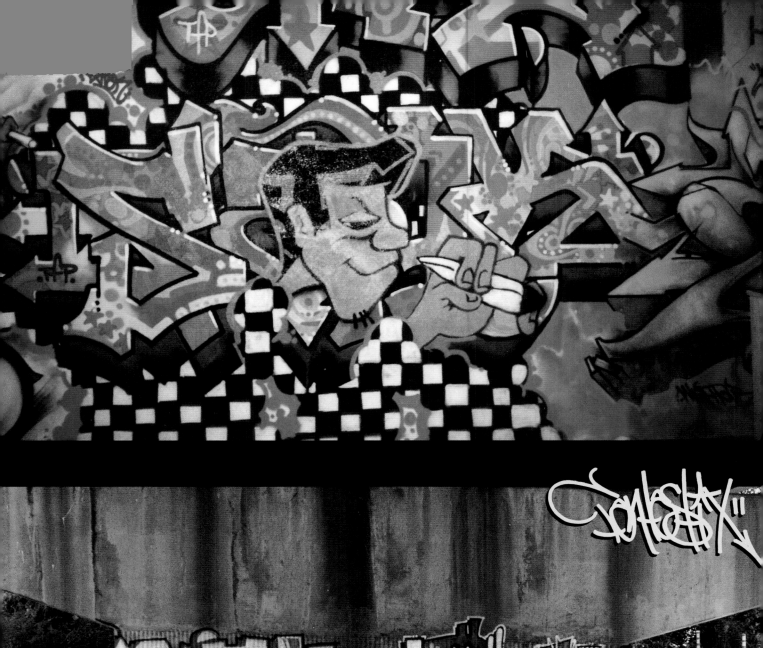
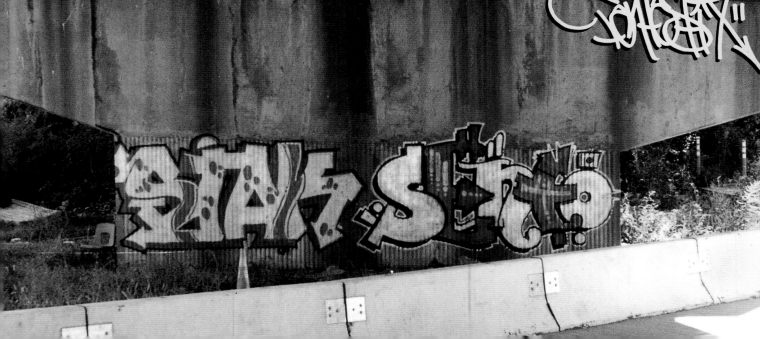

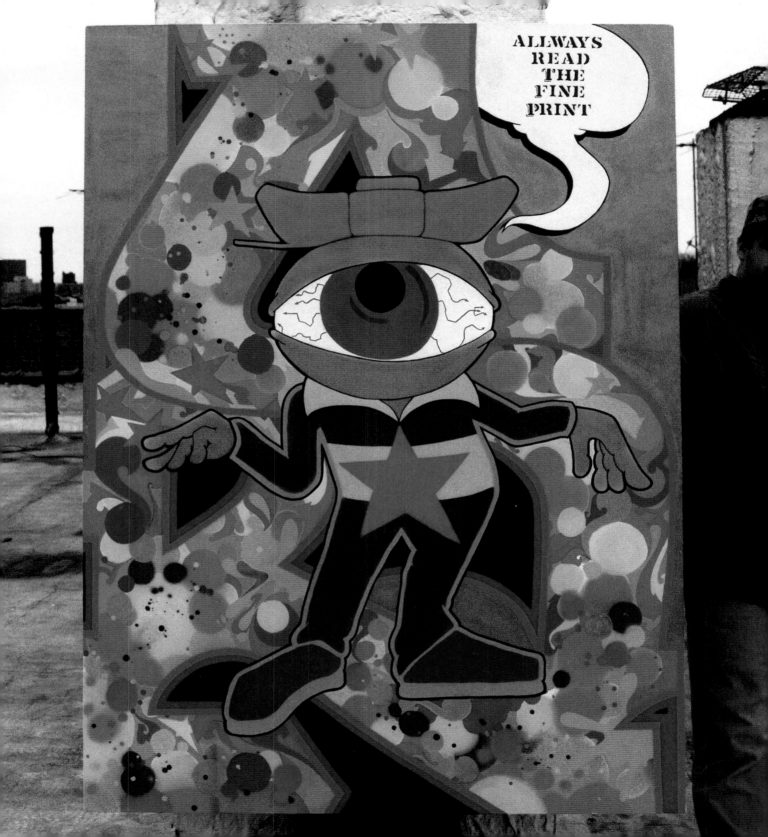

Ricky Powell:

Sports, celebrities, crazy people, and trend setting styles. These were the things that made New York City the epicenter of world culture for decades. While a lot of the shine and true grit may have been wiped out of the city by MTV studios, the Disney Store, and a crackdown on adult entertainment, we can still catch a glimpse into this storied past through the photographs of Ricky Powell, a.k.a. The Rickster. Spanning the 80's and early 90's, Ricky's photos reflected the pure soul of NYC as he captured the people you would normally see on TV and in the movies out on the streets interacting with everyday life. Ricky's work is so unique and so personal that when viewed, one can't help but feel as if they were there when the picture was taken. Whether its Marv Albert in the stands of the Garden before a Knicks Game, or Run DMC waiting for the M104 bus outside the UN, Ricky has preserved a New York so real, that it is hard to believe things were ever really like that in the Big Apple.

A rabid sports fan, Ricky sees a strong connection between his photos and athletic competition. "Sports and life are extremely analogous. You gotta minimize turnovers in life to win. My thing is strictly street photography now so I have to be prepared and let the game come to me. I have to hit my foul shots and free throws, and when I do come across something and I don't have my camera, that's like a turnover."

Still going strong today, Ricky's work continues to focus on New York, specifically the daily lives of ordinary citizens. His books, OH SNAP!: THE RAP PHOTOGRAPHY OF RICKY POWELL, and THE RICKFORD FILES are available from St. Martin's Press. In addition his photography has been on exhibit around the world, he is a regular contributor to magazines, and has a clothing line featuring his work through Upperplayground.

Hated on by Madonna herself, this "Fourth Beastie Boy" was immortalized in their 1989 song "Car Thief" with the line, "Homeboy, throw in the towel, your girl just got dicked by Ricky Powell." He is truly an icon of NYC and has seen more on the streets than most people could ever dream of.

He wants you all to know that, "Shit is whack, I hate cornballs, and anyone who abuses an animal should be shot on sight."

www.rickypowell.com

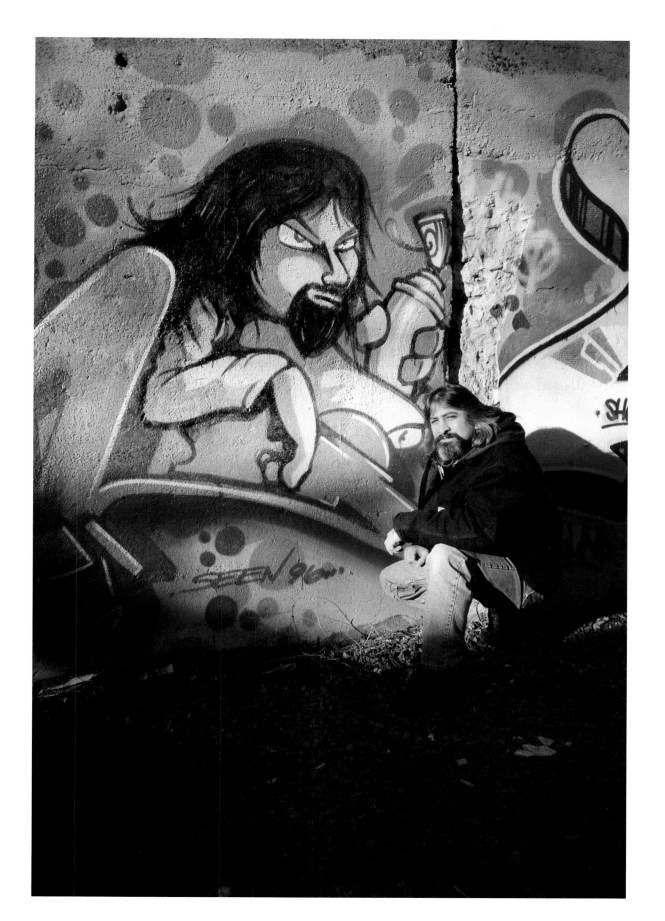

ZƐPHYR:

ZƐPHYR is a true original. As a key presence during the formative days of New York's graffiti culture, ZƐPHYR never fit a cookie cutter profile of what outsiders would assume such a person should be like. Attending Riverdale Prep and taking his name from a West Coast skateboard team didn't keep ZƐPHYR from finding his place in such influential graffiti crews as The Soul Artists and The Rolling Thunder Writers and becoming one of the most influential graffiti artists in history.

This lineage has given ZƐPHYR a unique perspective on how graffiti has changed over the years. "I've had the great fortune of watching NYC graffiti evolve since its inception in the early 70's. Graffiti is emblematic of the social constructs from which it comes. Therefore, a social overview of New York City in, say 1972, compared to an overview of present-day New York would expose dramatic differences. The changes in graffiti, and the graff culture, go hand in hand with those differences. In other words, as the world changes, so does graff."

"In the beginning, the writers represented a relatively small group of individuals, even after the NY movement 'exploded' in '72 (the year anti-graffiti laws were first enacted). Therefore it's interesting to realize that the original graffiti 'fad' in NYC, if we date it's inception as approximately the summer of '70, existed for two years before it was even technically punishable. Many girls were writing, and it was a form of youth expression that had a free-spirited, innocent energy. Today, the broad expansion of Agnomen (or 'nickname' style) graffiti writing, both geographically and in terms of sheer numbers of 'practitioners', come to mind immediately as significant differences. As for graffiti itself, it has been suburbanized. In other words, its practice is no longer confined to the inner cities. Culturally, it's been somewhat accepted into the main-stream as a 'legit' form of visual expression, although graffiti still often produces controversy and polarized responses."

"I've been a professional artist since 1979, but people don't refer to me as 'ZƐPHYR the poster artist' or 'ZƐPHYR the logo designer.' I'm most often referred to as 'ZƐPHYR the graffiti artist,' which is fine with me because I think graffiti is great. It's certainly a style of art I do and it's a culture I've been involved with for a long, long time. If I had to sum up the other non-graffiti work I do, I suppose I'd call it 'post-sixties-psychedelic-inspired-visual-meandering.'"

www.zephyrgraffiti.com

ZEPHYR ART

Shepard Fairey:

There is a good chance that somebody — your girlfriend, your moms, somebody - has asked you what the deal is with those "Andre The Giant Has A Posse" stickers or those "Obey" posters that look a lot like the confusing stickers. None of this is really surprising considering the almost inconceivable number of these images that are up all over the world. Stoplights, benches, video games... everywhere you turn you see Andre's face staring back at you. So here, in Shepard's own words, is the explanation of Andre the Giant's posse and just who you should Obey.

"I saw his picture in the newspaper and saw it as something that I could show my friend how to cut a stencil. I was just amused by it and we decided to make it our inside joke, that it was going to be the new cool skate posse. It makes fun of the popular culture, but it is a popular culture phenomenon. It makes fun of consumerism, but then I encourage people to buy a t-shirt because it funds me making more stickers. This was around 1989. We put the stickers around town. I thought it would just be a joke that lasted a few weeks. I made the original sticker with a ballpoint pen and a photo copy machine. For some reason people kept asking where that sticker came from. Was it for a band, a cult, or what? I was even in line at the supermarket and heard people talking about it. That's when the plan started to unfold. The more you put it out there, the more people are going to think it means something important. The local indie paper had a contest that anyone who wrote in and said what the Andre The Giant sticker campaign was really about would win tickets to a show. This was going on in Providence, Rhode Island. I had a few friends who were doing it for me in their cities. It's just the power of propaganda."

"There were a few reasons that I made the transition to the icon face. First of all, I could see the exposure of the project growing and I didn't want to get sued for using an image that was too close to Andre The Giant because he was a real public figure with an estate and everything. I wanted to make it more abstract so it was still connected but not so close that I could be sued for copyright infringement. Probably a more significant reason for the change was that I had really gotten into Soviet graphic design and a lot of the simplified constructivist images, and I wanted an image that would work with that design style. I also wanted an image that would function as an Orwellian style big brother image. I wanted something that would still be creepy, but that would also retain some of the goofiness of the original. It was also good to get away from the wrestling association because I had all of these people who thought I was just some crazy wrestling fan."

Shepard has parlayed his skill for getting people to take notice of things into a successful design company. He was named "Guerilla Marketer of the Year" by ADWEEK magazine and has had his work branch out into clothing, music, stationery, and books.

www.obeygiant.com

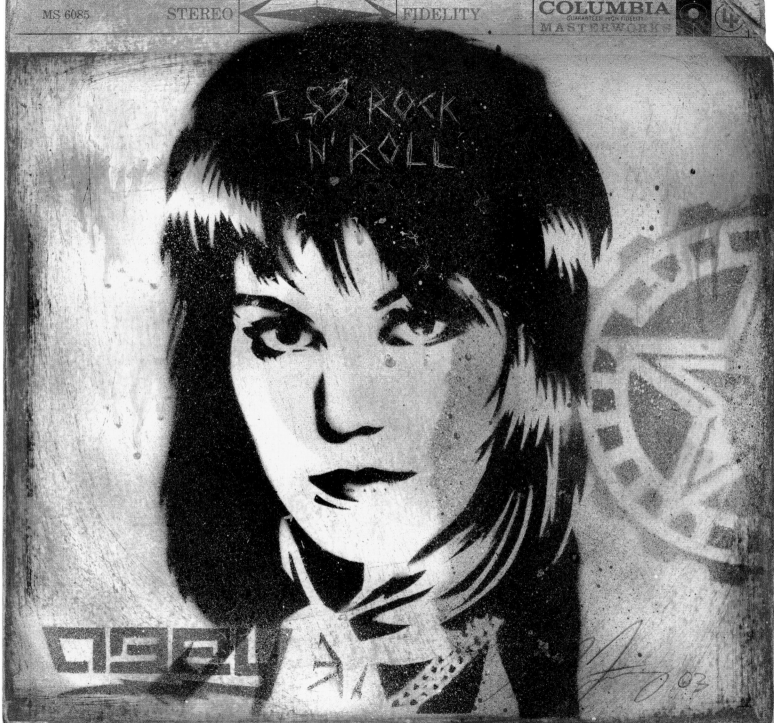

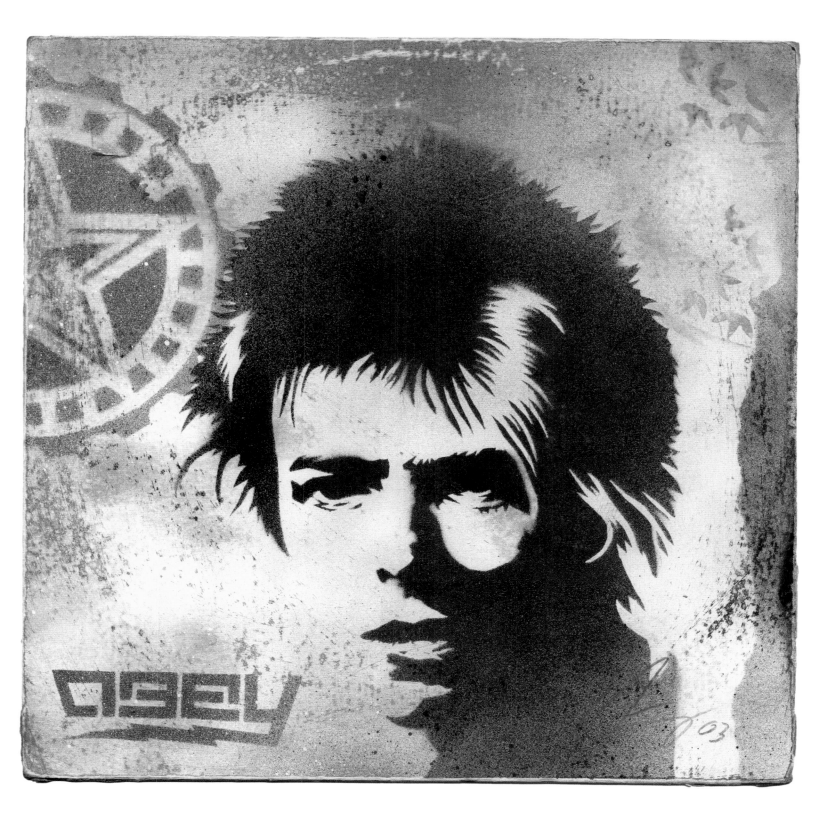

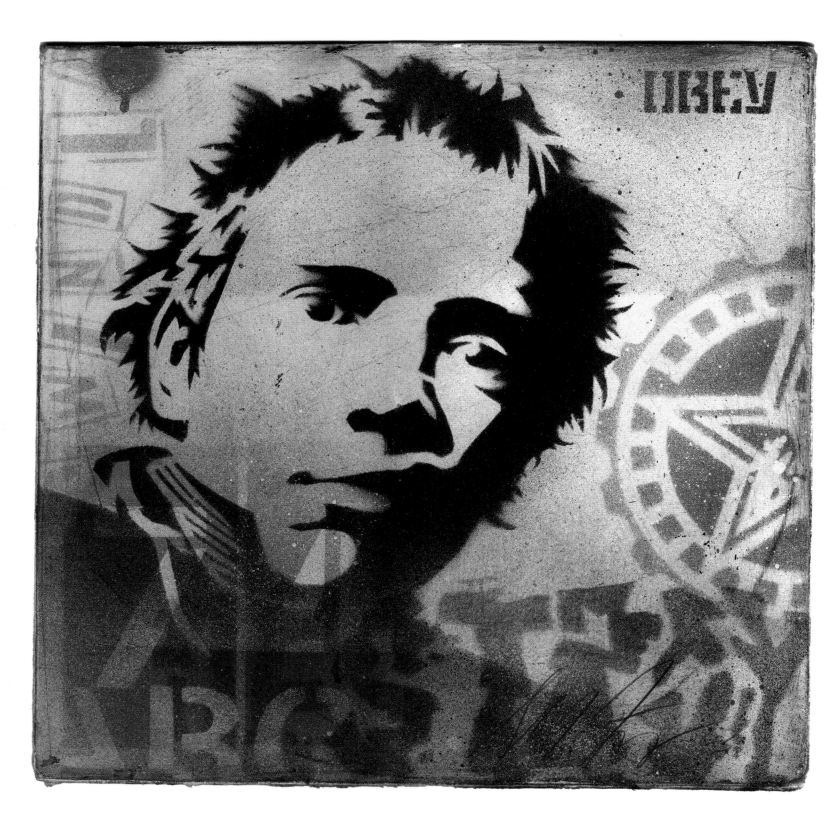

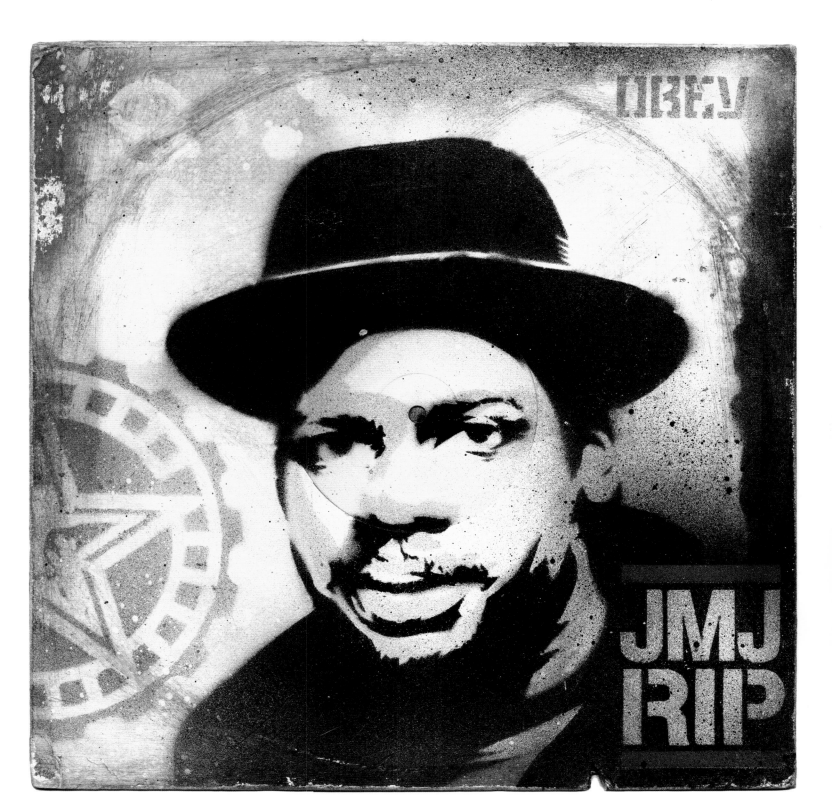

Neasden Control Centre:

Named after their headquarters, Neasden Control Centre is a visual design agency that was formed in London in 2000. This collective of young British illustrators has become very active in a short period of time, producing work for art galleries, ad agencies, book publishers, bars, clubs, charities, design agencies, shops, musicians, and magazines. Their client list includes groups ranging from Esquire to MTV. Neasden members have participated in gallery shows in London, Barcelona, Berlin, Ecuador, and San Diego.

Neasden is a true collective with each member adding a little something to each design, making great use of space in their art and placement of images in their pieces. Their cutting edge design and punk rock energy is on full display in their self-titled book, Neasden Control Centre. Split into twelve chapters based on different parts of the human body, the volume included a selection of works by all Neasden artists. Their distinct, hand-drawn style can be seen in a variety of media including photography, writing and found objects.

The voice of the group explains that, "These pieces are about factory vs. landscape. They are mixed media on paper and screen and were inspired by being able to get out of London for the day."

The members of Neasden claim their varied influences as, football, Pink Floyd, David Lynch, DJ Mook's mix tapes, The Stone Roses, the Minutemen, yellow Labradors and Swiss girls. They also share the universal frustration of rowdy neighbors. "The mental kids from next door are savage. They've been arrested and break windows listening to bad bass tekno."

www.neasdencontrolcentre.com

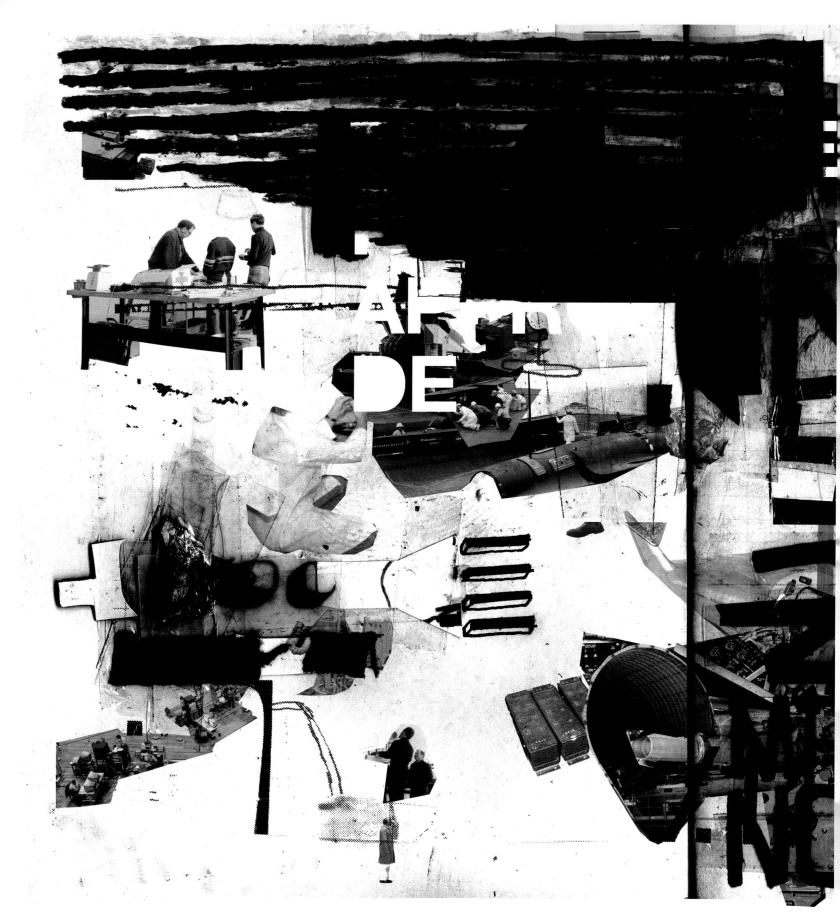

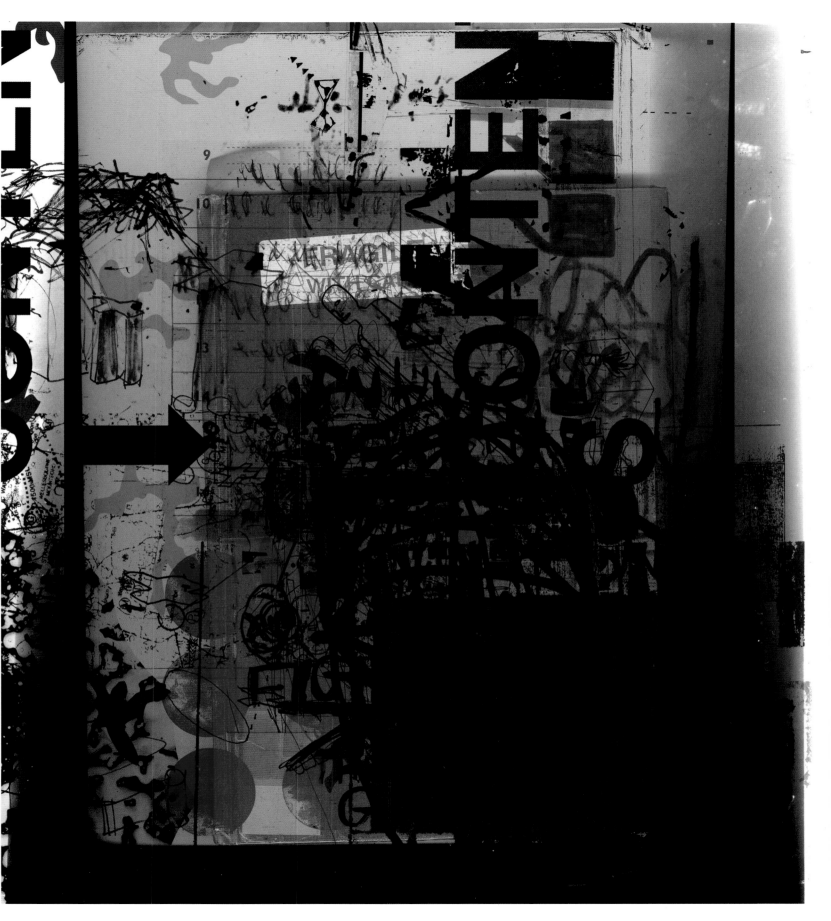

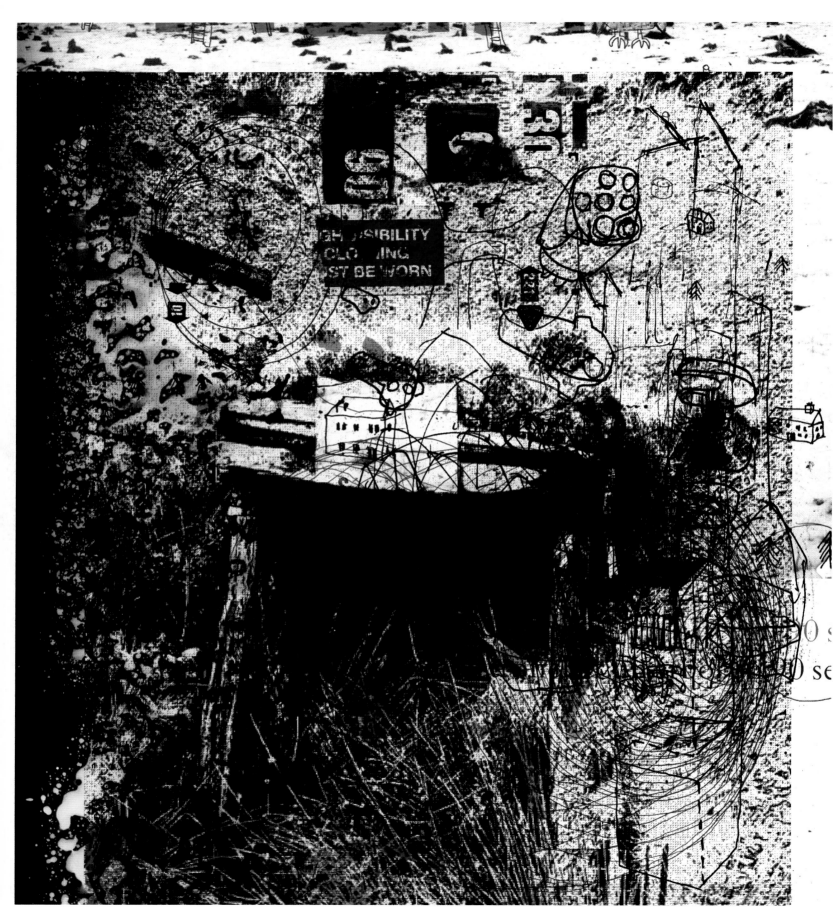

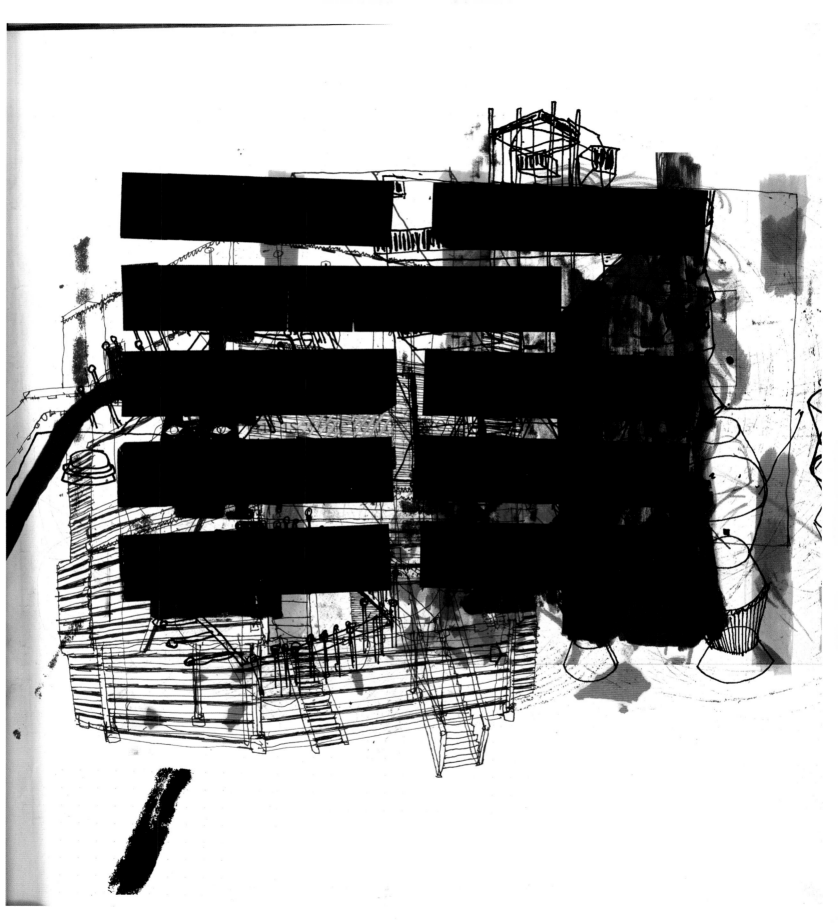

Shawn Wolfe:

Shawn Wolfe is best known as the man behind Beatkit™. The so-called "brand without a product" has served as inspiration for the improbable Removerinstaller™, as well as the artist's global "Panic Now" campaign, paintings, t-shirts, comics, sculpture, and performance. A practicing designer and illustrator for over fifteen years, Wolfe currently makes his home in Seattle where he works and teaches at Cornish College of the Arts.

In terms of these images Wolfe says, "I thought they went together in a kind of swinging 60's way, through the filter of our current Bush-O-Nazi apocalypse. There's some escapism and nostalgia lacing through most all my work, but always cut with a trace of strychnine. I guess this feeling of bright cheery shapes and tasty colors used to paint a picture and articulate a feeling of broken trust, lowered expectations, paranoia, panic, gloom... it is an accurate representation of my state of mind, and an apt reflection of what I see around me. Anesthetized, almost numb folks trying to go about their lives, trying to make a go of it, trying not to despair. Looking for candy but finding only bitter pills."

In addition to providing design and illustration services to record companies and magazines, Wolfe has also contributed to several proactive social groups. He designed the "AWAKƐ" campaign to promote the Center for a New American Dream, a group that advocates reducing consumption, shifting consumer behaviors and generally waking up from the mass trance of habitual consumerism. "I produce things to help balance out my consumption of things, ultimately. Most of us spend every minute of our lives on the receiving end of the production chute, just consuming and using. We hardly make or create anything that is of any use to us. We don't even form our own opinions anymore - it's all manufactured, distributed, propagated, received. So that's the undercurrent to my doing and making and creating. Also, it's how I earn a living and preserve my sanity."

www.shawnwolfe.com

302

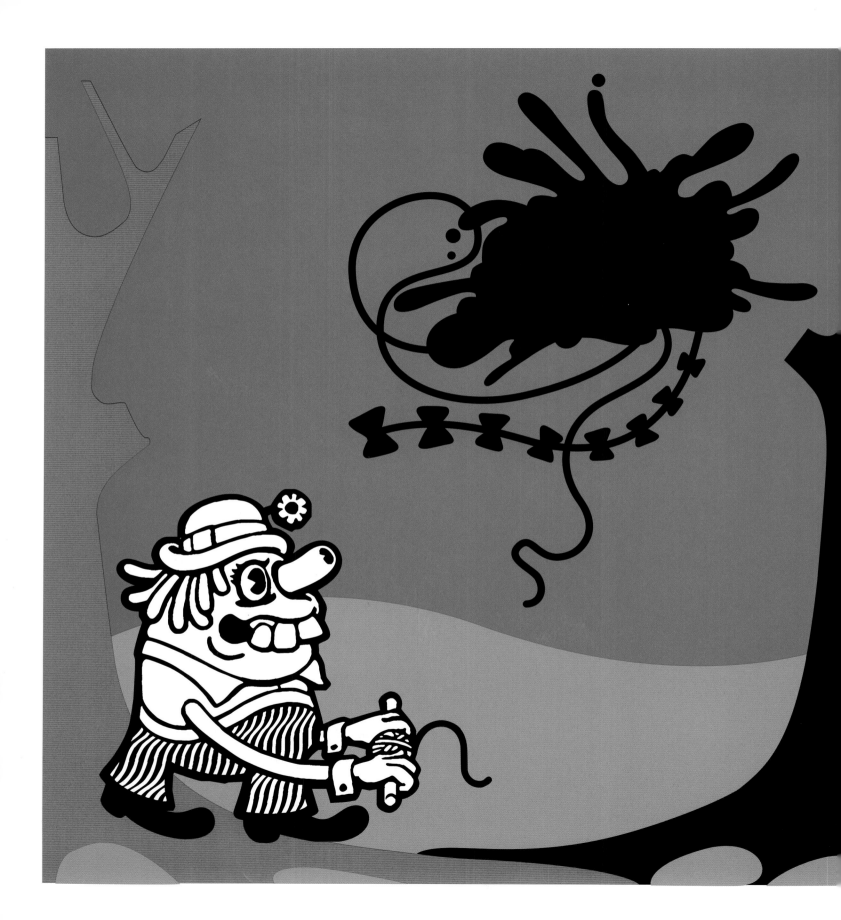

010405252

Martha Cooper

ROGER GASTMAN:

Roger Gastman has never had a real job. Starting off a career in life with his skills in shoplifting and running scams, he eventually found a path through graffiti. In the ten years that he has been writing graffiti, Gastman has painted around the world and made numerous contacts in the art world. A true entrepreneur, Gastman used these experiences to launch While You Were Sleeping magazine (WYWS), when he was 19 years old. He took WYWS from a small publication run out of his mother's house in Bethesda, MD to a full time national brand. Since leaving WYWS, Gastman has kept expanding his experiences by curating gallery shows and nurturing the growth of a publishing empire. This is his fourth book. His dog is named Harley.

Roger Gastman

IAN SATTLER:

Ian Sattler spent several years working in marketing and public relations before he got bored and set off to become a writer. In addition to his first book Pin-Up Girls from Around the World, he also produced Miss: Better Living Through Crime which was named one of the 10-best graphic novels of 2002 by Publishers Weekly. Ian served as a staff writer and resident TV expert at While You Were Sleeping and his work continues to appear in magazines on a regular basis. His dream project is to be a sniper for a SWAT team.

John Bradford

JOHN LACROIX:

At eight years old, John LaCroix appeared in the Boston Herald posed and dressed as Michael Jackson. It was a taste of childhood fame, but his adult career was still uncertain. LaCroix developed his talents "behind-the-scenes" quickly and his first critical review (Jackson's Victory Tour, 1984 at Madison Square Garden) was published one week later. John's appetite for dangerous and expensive hobbies took him to MassArt where he pursued a BFA in photography. At the time, LaCroix was also publishing a popular indie music fanzine, playing guitar in the influential straight edge hardcore band, Ten Yard Fight, and working as a freelance designer. In 2000, LaCroix left Boston for California where he's usually 15 minutes late and occasionally forgets how to get home.